# THE
# FIRST
# WORLD
# WAR
## IN PICTURES

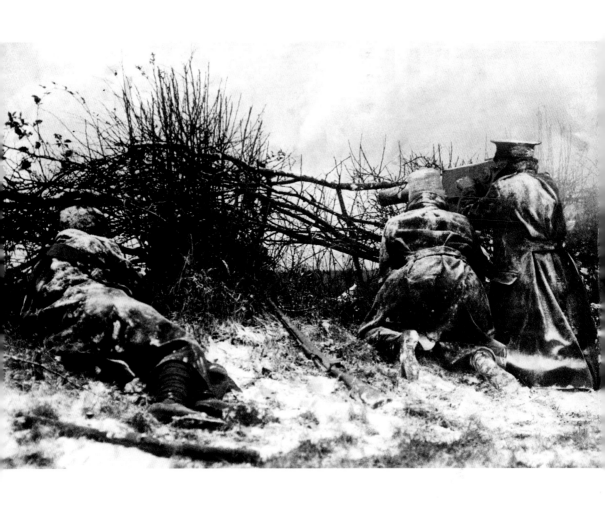

# THE
# FIRST
# WORLD
# WAR

## IN PICTURES

AMMONITE
PRESS

First published 2013 by
Ammonite Press
an imprint of AE Publications Ltd,
166 High Street, Lewes, East Sussex, BN7 IXU,
United Kingdom

Text © AE Publications Ltd, 2013
Images © Mirrorpix, 2013
Copyright © in the work AE Publications Ltd, 2013

ISBN 978-1-90770-888-6

British Cataloguing in Publication Data. A catalogue record of this book is available from the British Library.

Editor: Ian Penberthy
Series Editor: Richard Wiles
Design: Robin Shields
Picture research: Mirrorpix
Colour reproduction by GMC Reprographics
Printed in China

**Page 2**

In the depth of winter, British soldiers fire a machine gun from cover behind a hedge. At this early stage of the war, they had no protective steel helmets.
**7th December, 1914**

**Page 5**

After a successful assault, British soldiers take over a former German trench, advertising the fact with a homemade sign.
**1917**

**Page 6**

German prisoners captured during the last few weeks of the war. At this stage, the Allied advance had become relentless; within a month, the Armistice would be signed, bringing a halt to the fighting.
**12th October, 1918**

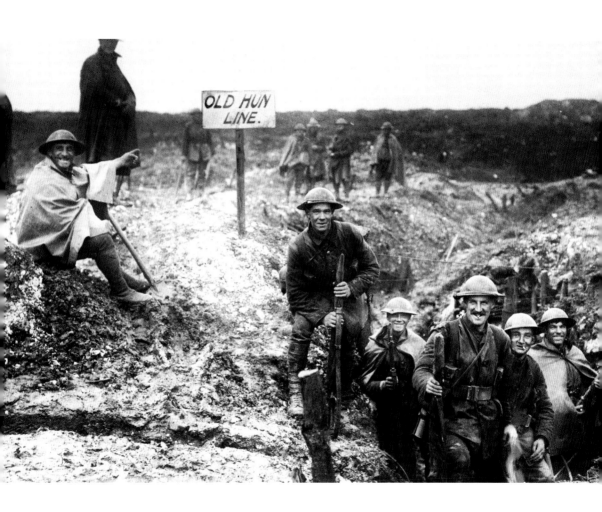

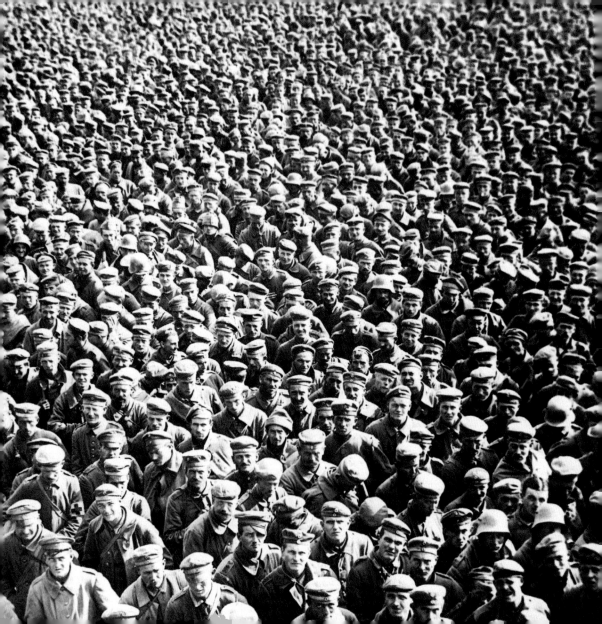

# INTRODUCTION

At the time, it was known as the "war to end all wars", but the First World War, sometimes also referred to as the Great War, was far from that, for it was followed twenty years later by the Second World War, and there have been many major and minor conflicts around the world ever since.

Although the First World War was a global conflict, involving all the great powers, it was centred on Europe. The combatants formed two opposing alliances: the Allies (originally the United Kingdom, France and Russia) and the Central Powers (originally Germany, Austria-Hungary and Italy). Both groups expanded as other nations, including the United States, were drawn into the war and there were changes to the original members: Italy ended up fighting on the side of the Allies, while Russia withdrew from the war following the Revolution in 1917. For the first time, war was fought in the air as well as on the ground and at sea.

The war broke out on 28th July, 1914 and raged until 11th November, 1918. It involved 70 million men under arms, 60 million of whom were Europeans; more than 9 million of them were killed. The high death toll was largely brought about by technological advances in weaponry, such as the machine gun, flamethrower and fragmentation artillery shells, and the move to mechanised warfare, involving (for the first time) the use of aircraft and tanks. Poison gas was also employed by both sides.

A major aspect of the conflict was trench warfare, both sides occupying complex defensive trench networks that snaked for miles across the battlefields of Europe, separated by a barren, cratered 'no-man's land' strung with barbed wire. These systems led to a very static form of warfare, with front lines not moving for months or even years.

This book looks at the First World War from a largely British perspective, based upon almost 300 photographs from the archives of Mirrorpix.

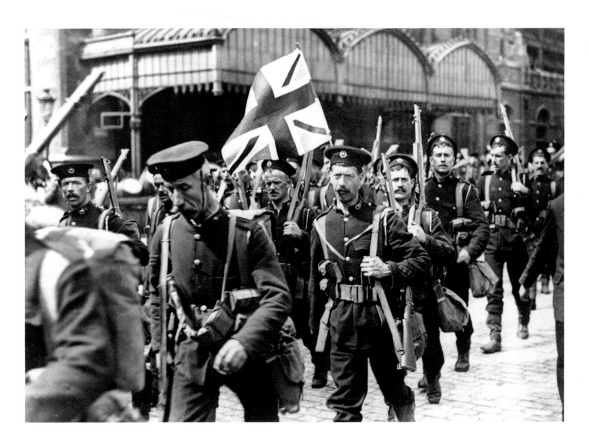

British Royal Marines arrive at Ostend in Belgium to support troops fighting the Germans. They would join with two brigades formed from Royal Navy personnel to create the Royal Naval Division, which took part in the defence of Antwerp.

**August, 1914**

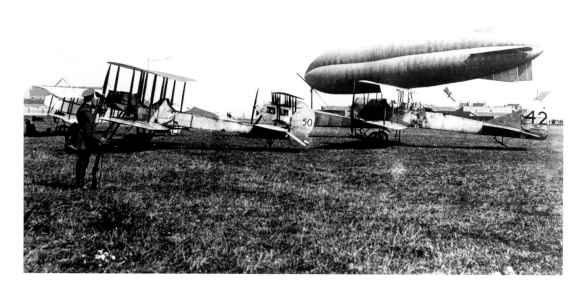

An Astra-Torres non-rigid airship and a variety of aeroplanes all belonging to the Royal Naval Air Service at an airfield near Ostend in Belgium. Throughout the war, the RNAS often received better machines before the Army's Royal Flying Corps.

**August, 1914**

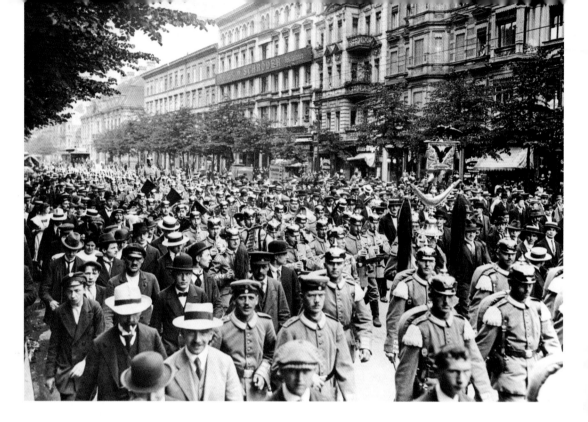

Young, enthusiastic Germans took to the
streets singing national songs on the day
of German mobilisation. Here a regiment
of the German Army parades through the
streets of Berlin.
**2nd August, 1914**

Right: The troopship *Leopold II* arrives in
Ostend, Belgium carrying soldiers from Le
Havre in Northern France.
**c.1914**

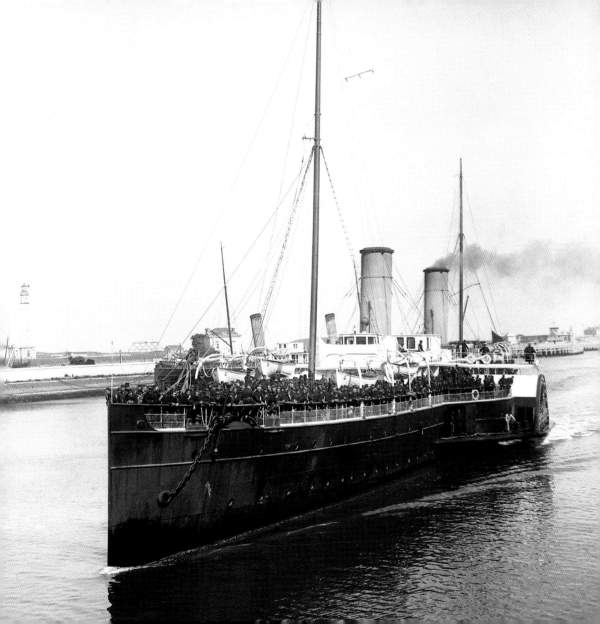

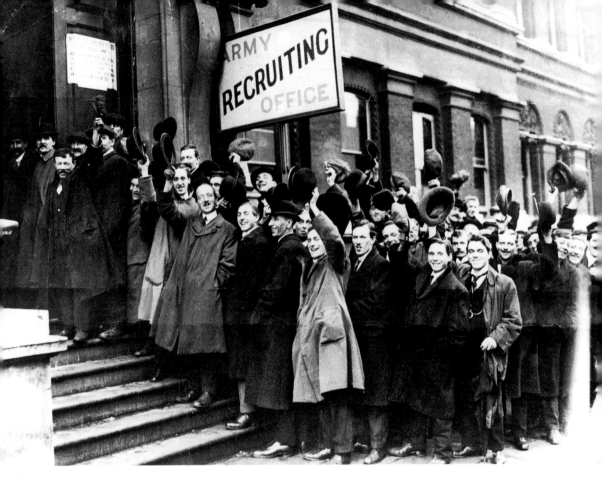

The war prompted a wave of patriotism in
Britain, indicated by the enthusiasm of these
volunteers waiting to enlist in the Army.
August, 1914

One of the harsh realities of war. Having lost her home, a woman weeps at the roadside in Antwerp, Belgium, surrounded by her few remaining possessions.

**August, 1914**

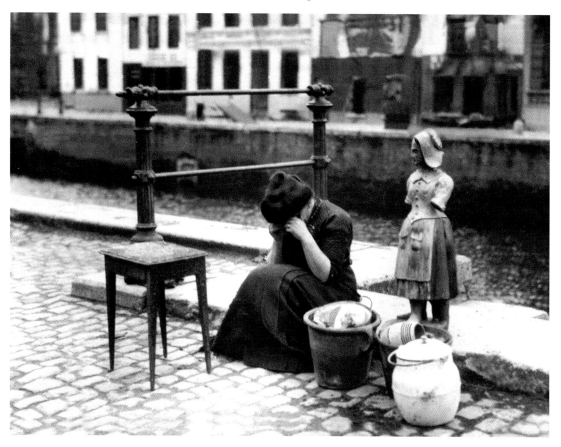

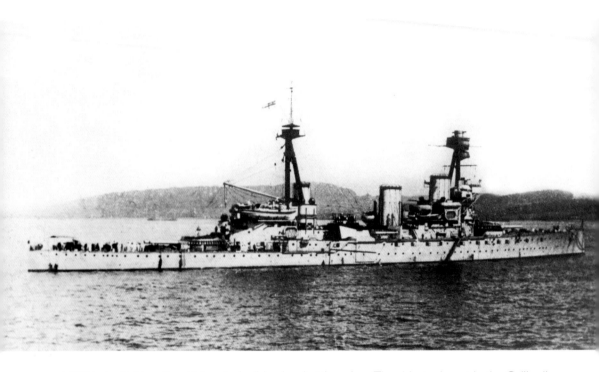

HMS *Indomitable*, a Royal Navy Invincible-class battlecruiser. The ship took part in the Gallipoli campaign, actually bombarding Turkish fortifications protecting the Dardanelles before the British had officially declared war on Turkey. In 1915, she took part in the Battle of Dogger Bank in the North Sea, helping to sink the German cruiser *Blücher*. The following year, she took part in the only major naval action involving both the German and British fleets at the Battle of Jutland, also in the North Sea, off the coast of Denmark. *Indomitable* was deemed obsolete after the war and was sold for scrap in 1921.

August, 1914

A London General double-decker bus, carrying Territorial Army soldiers and a load of ammunition, leaves the powder magazine in Hyde Park, London. Nine hundred similar vehicles were used in France to transport troops behind the front lines, each being capable of carrying 24 fully equipped infantrymen and their kit. During their wartime service, they were painted khaki and had the glass of the lower deck replaced by wooden slats.

**August, 1914**

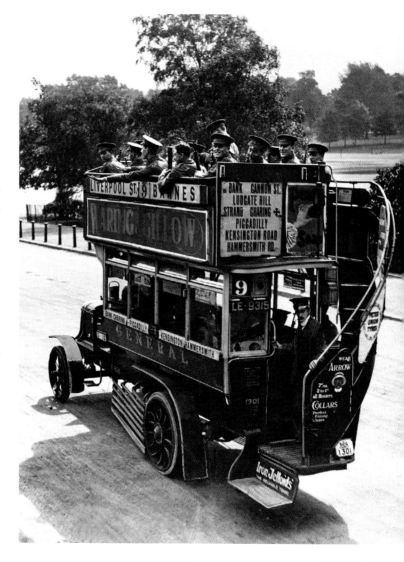

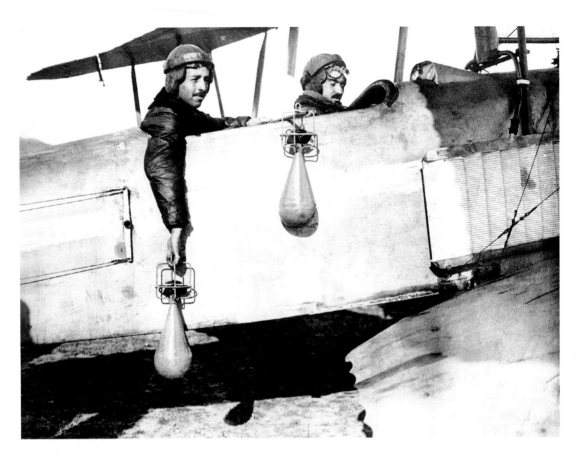

The early use of aircraft in the First World War was restricted to reconnaissance, but it wasn't long before both sides began using them to drop bombs on ground targets. Early delivery systems were, to say the least, crude, as seen here. Once over the target, the rear crewman pulled the release lever and the bomb fell away; there was no means of aiming.

**6th August, 1914**

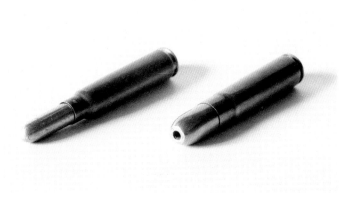

Dum-dum bullets found in a German trench. These projectiles had soft or hollow points, which allowed the bullet to flatten and expand when it hit the target, causing substantially more damage than a conventional round.
**11th August, 1914**

Known as the 'Silent Death', this steel arrow, which is about 5in. long and a little thicker than a pencil, was dropped from aircraft in batches of 500, a mechanical device spreading them over an area of about 200 yards square from a height of 1,500 feet. From that height, they would go right through a man's body. They were used by German, Belgian and French airmen during the First World War.
**31st August, 1914**

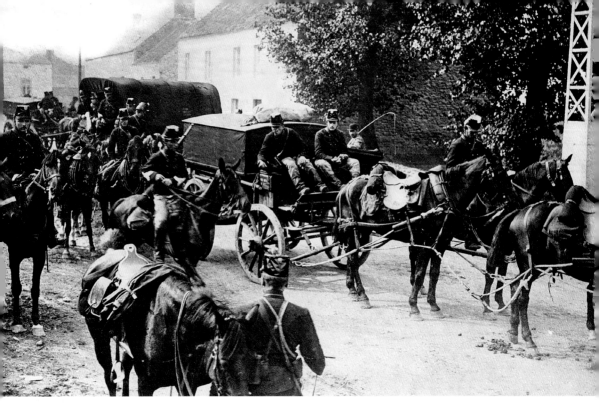

Belgian cavalrymen guard a food convoy on its way to Liège in Belgium. Although the First World War was the first mechanised war, horses continued to play a major role with the major antagonists. While cavalry units soon proved unsuitable for modern warfare, horses remained essential for moving supplies and equipment.

**11th August, 1914**

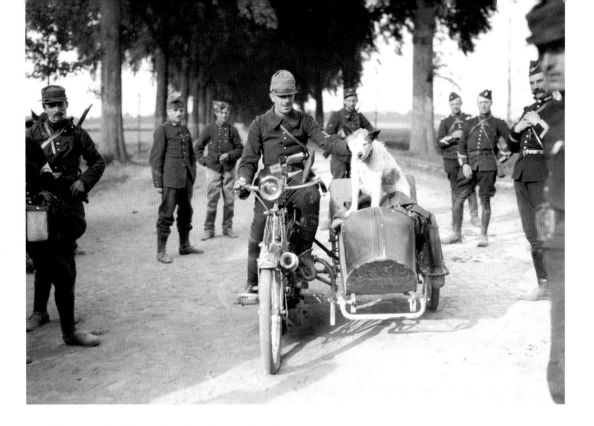

Prusco, a Belgian police dog, leaves for the front with the French Army. His duty was to carry dispatches. Dogs were used extensively for this purpose in the trenches and proved very successful. They presented a smaller target than a runner and could travel easily over any terrain.

15th August, 1914

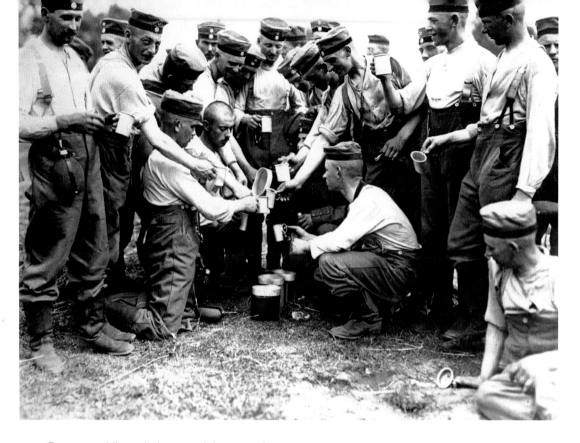

German soldiers during a training exercise
stop for a water break.
18th August, 1914

Two French dragoons talk to locals near the historic battlefield of Waterloo in Belgium. Their ornate helmets and lances had changed little since that battle.

**19th August, 1914**

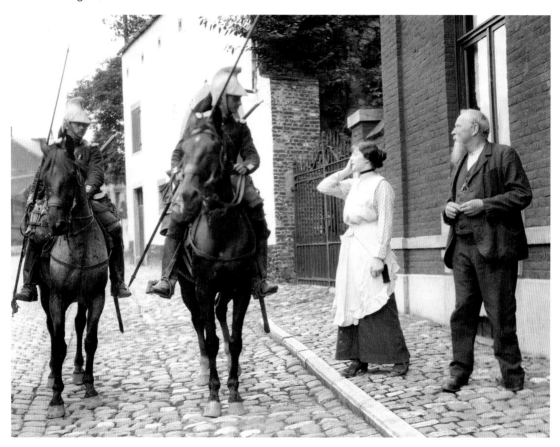

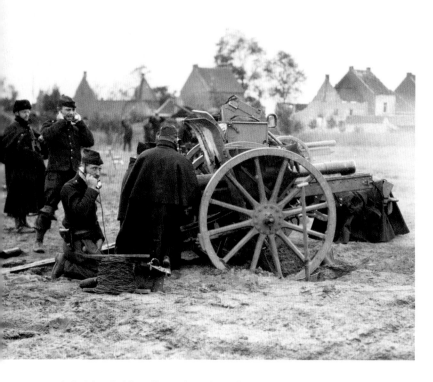

A Belgian field artillery piece in action during
the Battle of Hofstade. One of the gun crew
is receiving their orders by field telephone.
**25th August, 1914**

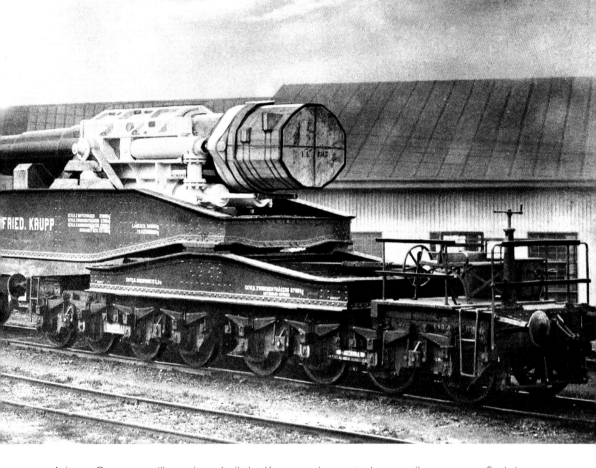

A large German artillery piece, built by Krupp and mounted on a railway wagon. Such huge guns, often obsolete naval weapons, could fire massive shells over very long distances, but were restricted in their ability to traverse for aiming. They were employed by both the Allied and Central powers during the First World War.

**31st August, 1914**

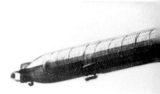

Right: An airship flies over a fleet at sea. Pioneered by the German Count Zeppelin (German airships were popularly known as Zeppelins), airships were used extensively for long-range reconnaissance over the sea during the First World War. The Germans also employed them to carry out bombing raids against targets in Britain, but with little military success.
**31st August, 1914**

Far right: Watched by curious locals, a British Royal Marine digs a machine gun emplacement close to the Belgian port of Ostend. The Marines were part of the Royal Naval Division, which also included two brigades of seamen who were not required at sea, sent to Belgium to oppose the German forces.
**31st August, 1914**

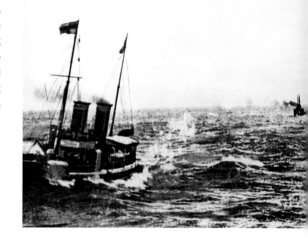

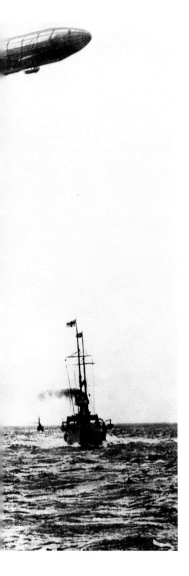

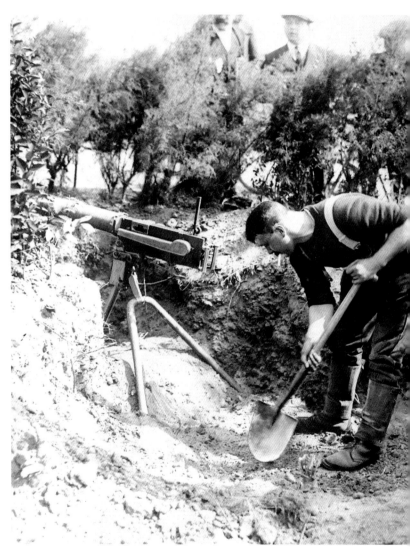

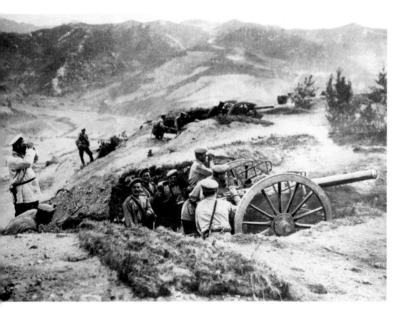 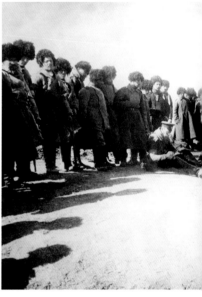

Entrenched Russian artillery during their battle against the Austro-Hungarian Army on the Eastern Front. This conflict would bring both empires to the point of collapse, and lead to revolutions and the overthrow of both their monarchies.

**August, 1914**

Above right: Soldiers of Russia's Southern Army count the dead after their successful battle with Austro-Hungarian forces to capture the town of Lemberg, the capital of Galicia in modern-day Ukraine.

**August, 1914**

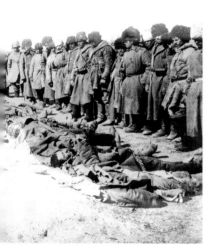
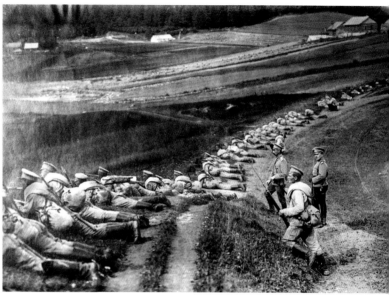

Above right: Russian infantry waiting to go into action against the Austro-Hungarian Army on the Eastern front. Their victory at Lemberg crippled Austria, killing a large proportion of its officer corps.

**August, 1914**

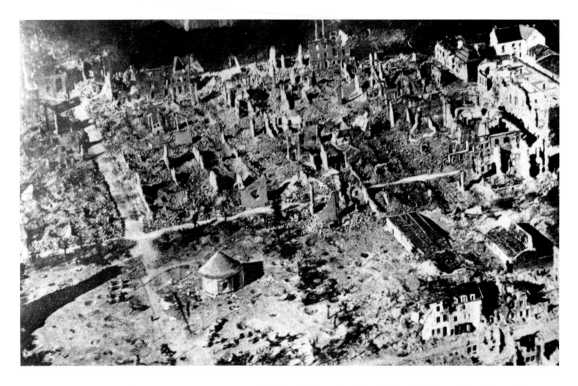

A photograph of a town destroyed by shellfire during the First World War, taken from the air. Although captive balloons had enabled military commanders to see beyond their enemy's front line during the 19th century, the availability of aircraft, which could range far and wide over enemy territory, provided a far more complete picture. The first aerial photographs of the war are believed to have been taken by Britain's Royal Flying Corps.

September, 1914

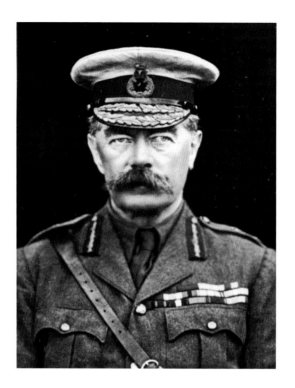

Field Marshal Lord Horatio Kitchener, who was Britain's Secretary of State for War when war was declared on 4th August, 1914, and whose face appeared on a poster urging men to join up. Unlike many, he did not believe that the conflict would be over by Christmas of that year. He thought it would last between three and four years, and that Britain would have to mobilise millions of men to win the war – a remarkably accurate prophecy. Kitchener died while on his way to Russia in 1916 when the ship he was travelling on hit a mine and sank with the loss of 643.

September, 1914

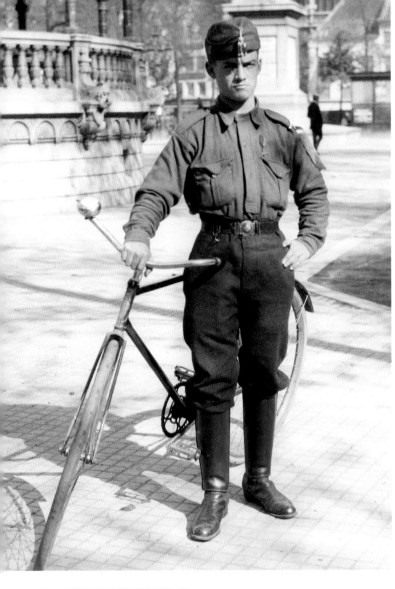

Belgian Boy Scouts carried military messages during the early stages of the war. They were issued with pistols, as their work took them close to the front lines. The photograph shows Joseph Louis Leyssen, who became famous at the beginning of the war for capturing two German spies dressed as priests near Liège. After this, he was allowed to help on the front line and more than once rode with important messages right through the German lines.

**September, 1914**

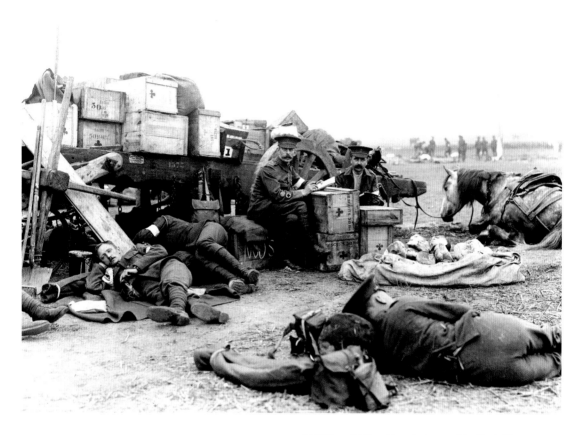

NCOs of The Royal Army Medical Corps catch up on paperwork while their men sleep in Northern France. Among their supplies is a large bag of loaves of bread.

**2nd September, 1914**

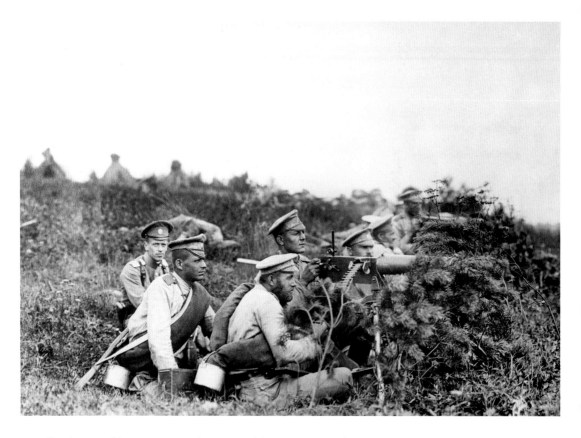

Russian machine gunners take up position outside Lemberg in the Ukraine during the Battle of Galicia.

**3rd September, 1914**

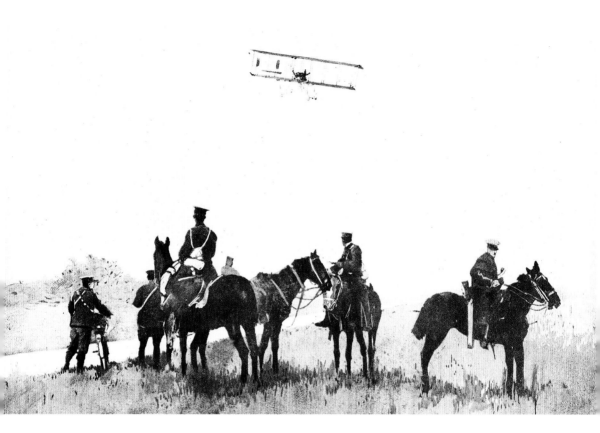

The future and the past. A heavily retouched photograph showing an early Royal Flying Corps biplane flying over a British mounted patrol. The First World War saw the advent of mechanisation in warfare and the end of the horse as a military tool.

6th September, 1914

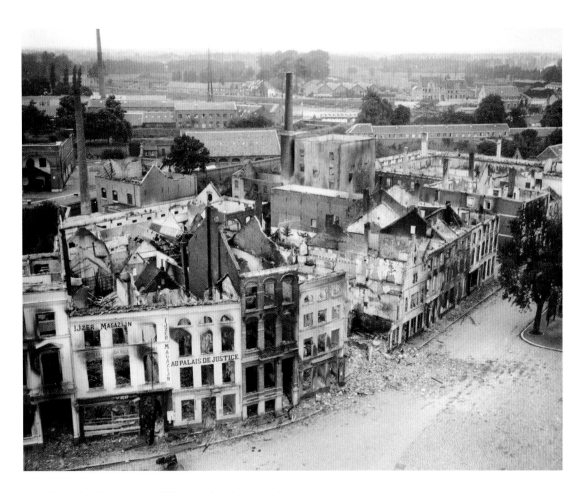

The Belgian town of Termonde, destroyed
by the Germans as they withdrew, having
occupied the town for a couple of days.
**8th September, 1914**

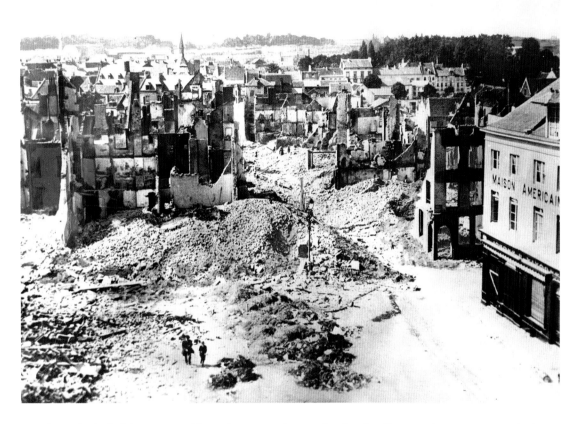

Louvain, in Belgium, was subjected to mass destruction by the German Army over a period of five days in August, 1914. A fifth of the town's buildings were destroyed and many of the inhabitants, men and women, were shot in retaliation for an attack by the Belgian Army.
8th September, 1914

In the French port of Le Havre, the wives of tramway men acted as conductors while their men were away fighting.
**8th September, 1914**

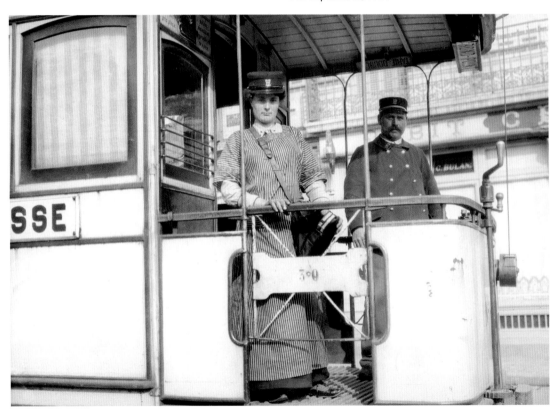

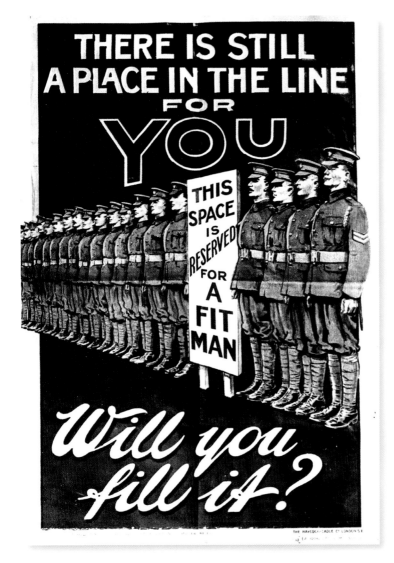

A recruiting poster urging fit men to join the Army. Such posters often appealed to men's sense of patriotic duty. 1914

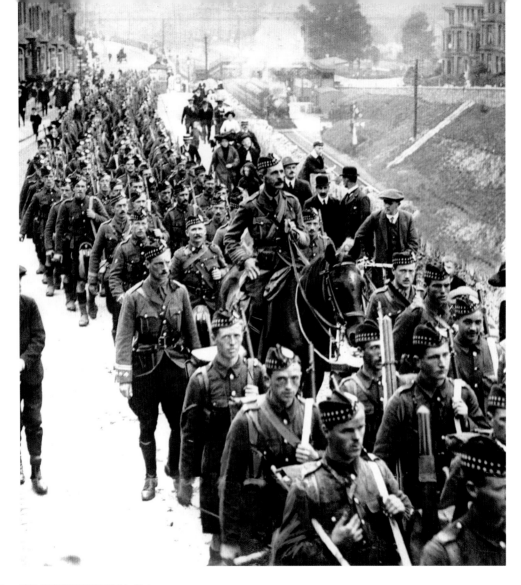

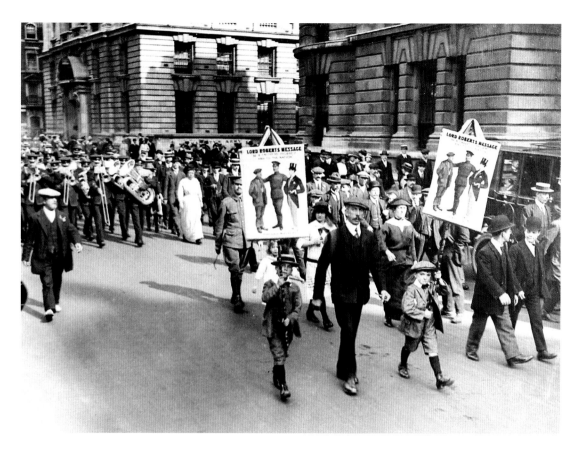

Left: The Gordon Highlanders march through a South Coast port prior to embarking for their channel crossing to France. The regiment would lose 1,000 officers and 28,000 men during the conflict.
**9th September, 1914**

A march encouraging men of all classes to join up to take part in the war.
**9th September, 1914**

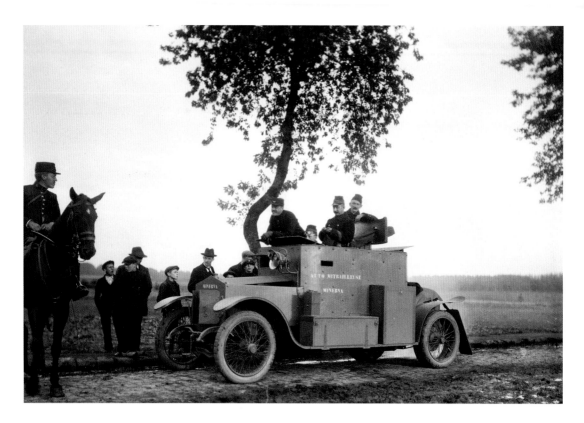

An armoured car belonging to the Belgian
Army. The Belgians were early exponents of
the armoured car, which was usually based
on a civilian car chassis and armed with light
machine guns.
13th September, 1914

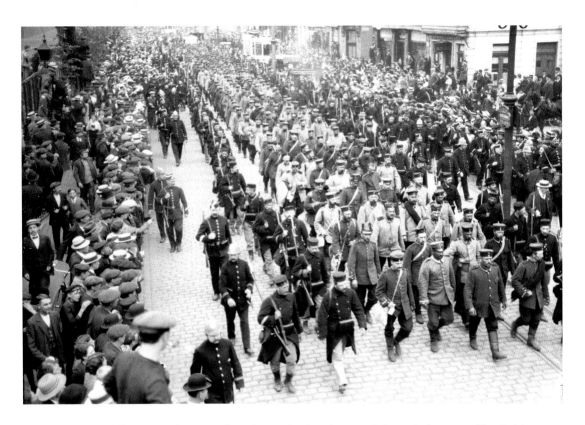

A column of German prisoners of war is marched under guard through Antwerp. The Belgian city was under siege by the German Army, but Belgian forces managed to counterattack, forcing the Germans to withdraw troops from the fighting in France to reinforce the siege. About 1,000 prisoners were taken and transported to England aboard a captured German ship. The Germans eventually took the city on 9th October, 1914 and occupied it until the armistice in 1918.

13th September, 1914

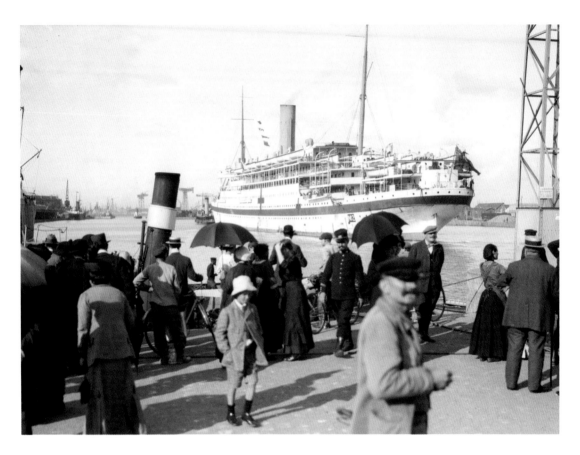

HMHS *Asturias* leaves the French Channel port of Le Havre bound for England with soldiers wounded in the fighting. The hospital ship was torpedoed by a German submarine in 1917, with the loss of 31 lives. After the war, she was rebuilt as a cruise liner and renamed *Arcadian*.
**15th September, 1914**

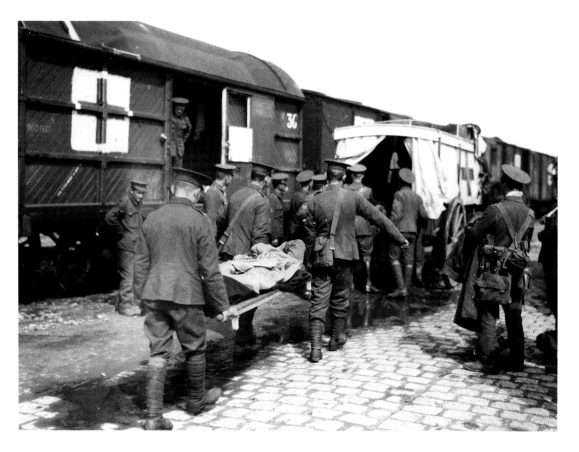

Wounded British soldiers are transferred from a hospital train to an ambulance on the quayside at St Nazaire in France.
**23rd September, 1914**

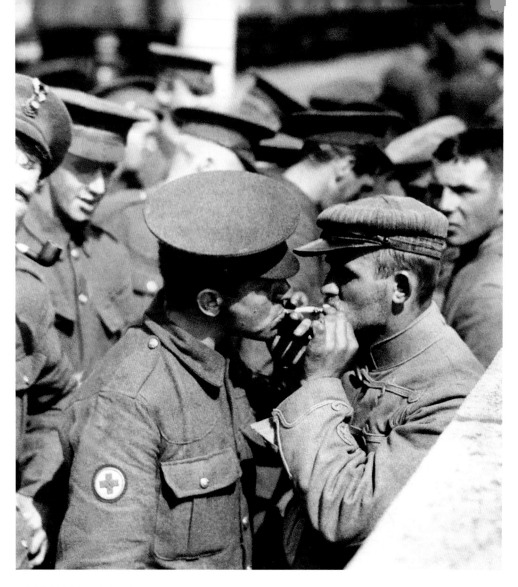

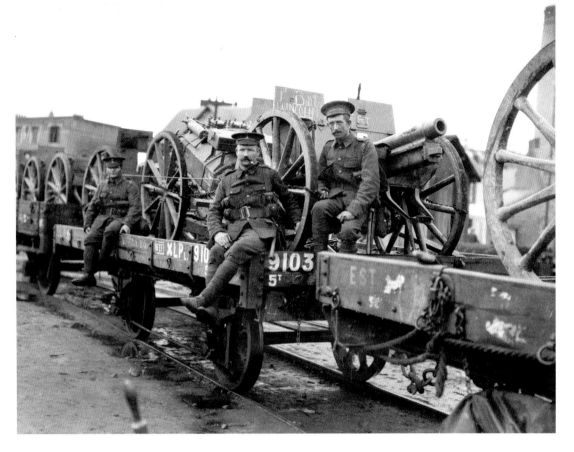

British soldiers with captured German artillery pieces waiting on a French quayside prior to being shipped to Britain.
**September, 1914**

Left: A British medical orderly gives a light to a German prisoner of war. As a rule, PoWs were treated quite well by both sides.
**23rd September, 1914**

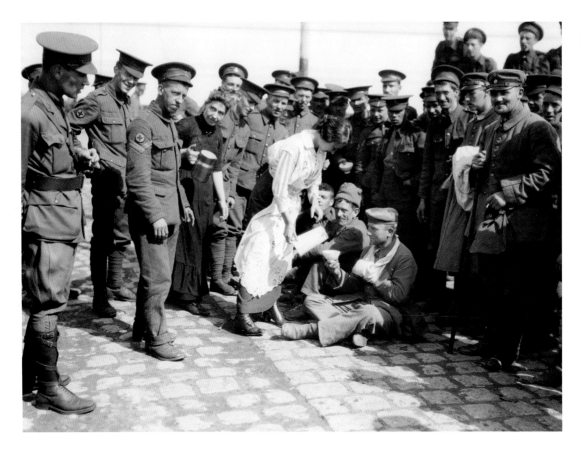

On the quayside at the French port of St Nazaire, a French woman gives a wounded German prisoner water as British medical personnel look on. They were awaiting the arrival of a hospital ship that would ferry the wounded across the Channel to Britain.
**23rd September, 1914**

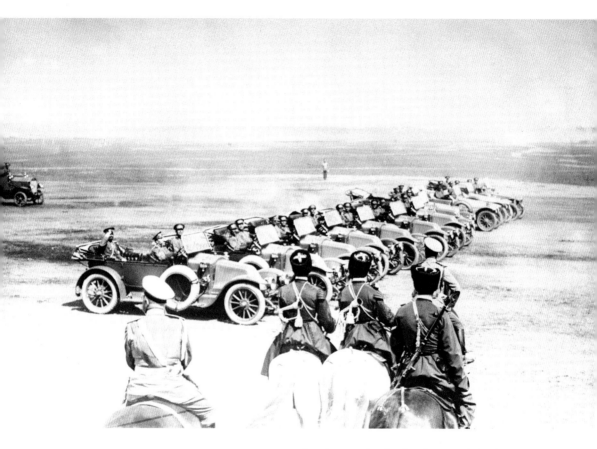

Russian mechanised units parade in front of
mounted officers on the Eastern Front.
**24th September, 1914**

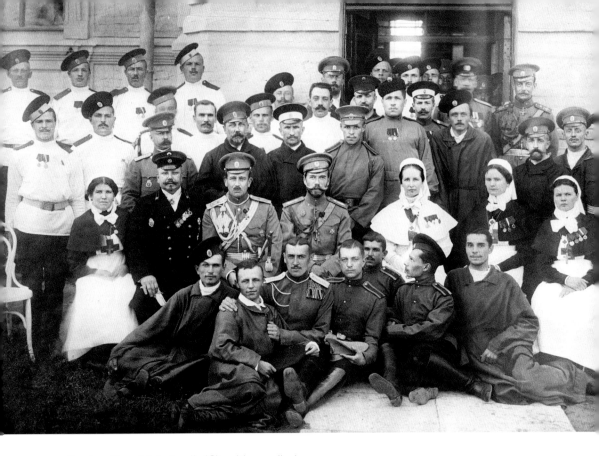

Russian Tsar Nicholas II (C) with medical personnel and patients during a visit to a military hospital in Petrograd. Within four years, the Russian Revolution would sweep away his monarchy, and he and his family would be killed by the Bolsheviks.

24th September, 1914

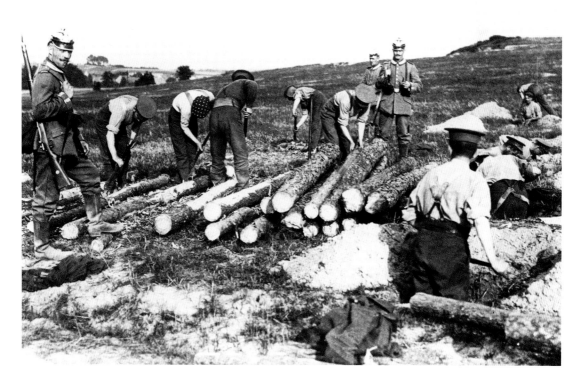

British prisoners of war digging trenches under the supervision of German guards, somewhere in Northern France. The guards are wearing the standard German Army spiked helmet (*pickelhaube*) with its highly polished fittings.

**25th September, 1914**

Mademoiselle Perichon, a Red Cross nurse, organising the evacuation of wounded Belgian soldiers during the retreat to Antwerp.
**28th September, 1914**

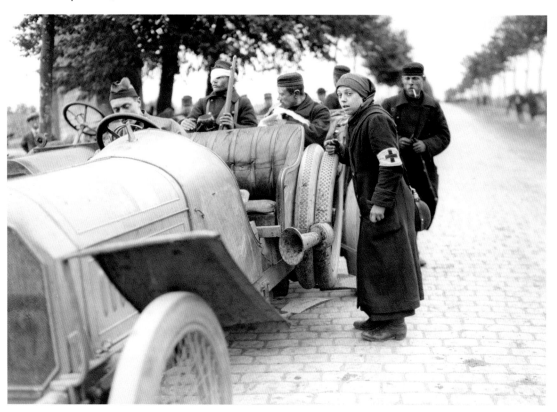

Aleksei Ilyich Kravchenko, a Russian war artist, sketches a spy brought in by a patrol during the Battle of Galicia against Austro-Hungarian forces.
**October, 1914**

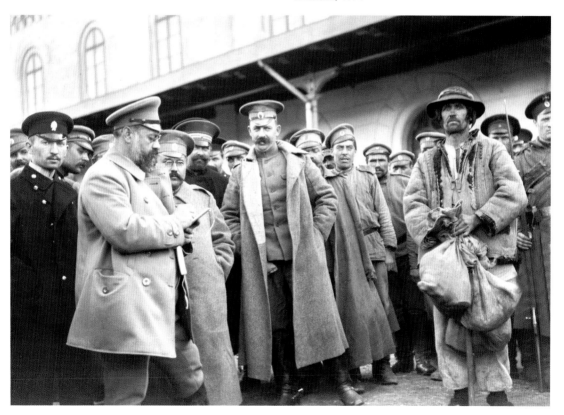

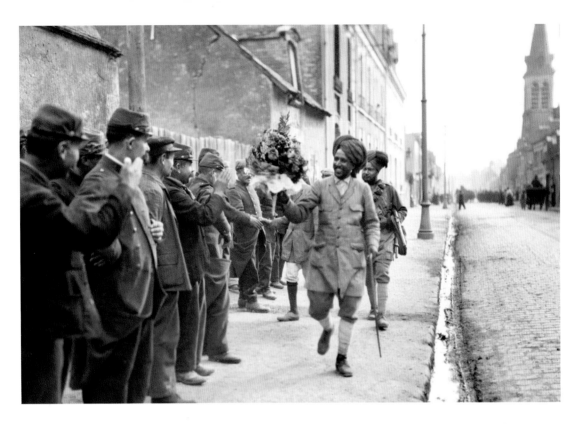

French troops shake hands and offer floral bouquets to Indian soldiers as they make their way to their camp. French admiration for the Indian troops was boundless. Wherever they went, they were given bouquets of flowers and fruit. Indian forces were in action in Europe, the Mediterranean and Middle East during the First World War. In all, a million served overseas, of whom 62,000 died and 67,000 were wounded.

**October, 1914**

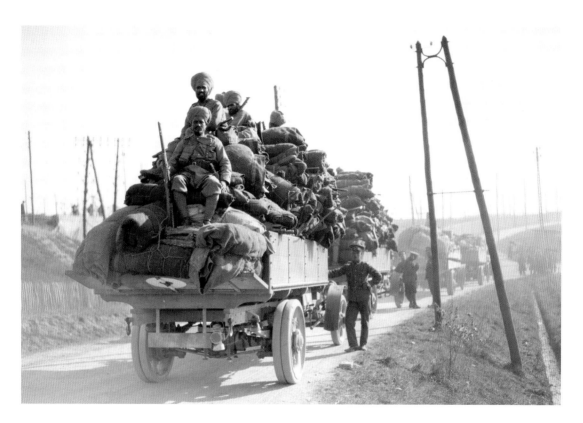

The supply train of the 3rd Lahore Division heads towards the front after the troops had disembarked at the railway station in the French city of Orléans. Indian troops were ill equipped for the European weather, however, suffering from the cold temperatures, which caused low morale, and many soldiers fled the battlefield. They were eventually withdrawn to Egypt.
**October, 1914**

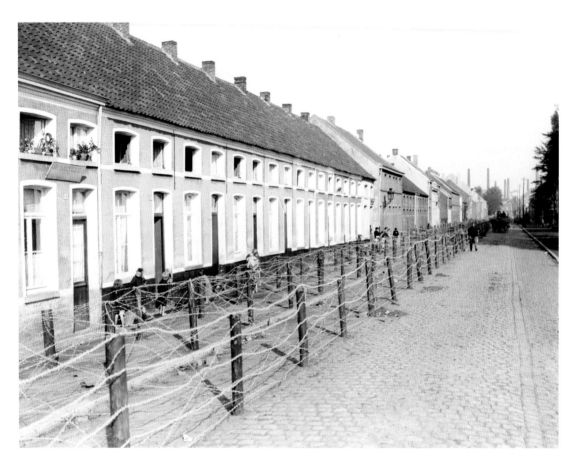

Barbed wire entanglements erected around Antwerp during the Germans' siege of the Belgian city.
**October, 1914**

Mounted French colonial troops (known as Spahis), from North Africa, escort German prisoners of war through the Belgian town of Veurne and on to the port of Dunkerque. **October, 1914**

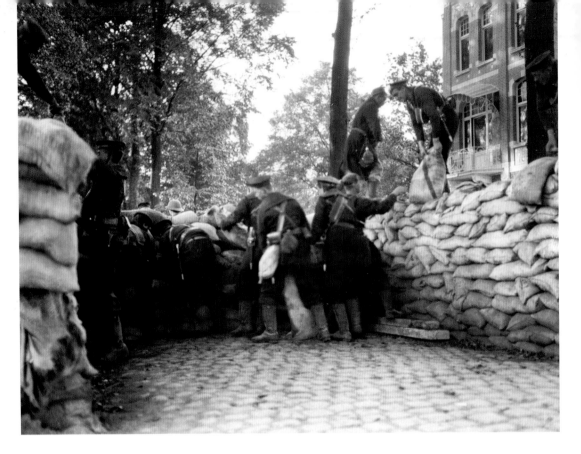

Marines from the Royal Naval Division build a sandbag barricade while they await the advance of the Germans along the road from Vieux-Dieu on the outskirts of Antwerp.
**October, 1914**

Right: Tins of bully beef (military slang for corned beef) are distributed to Royal Marines building earthworks as the last line of defence around Antwerp.
**October, 1914**

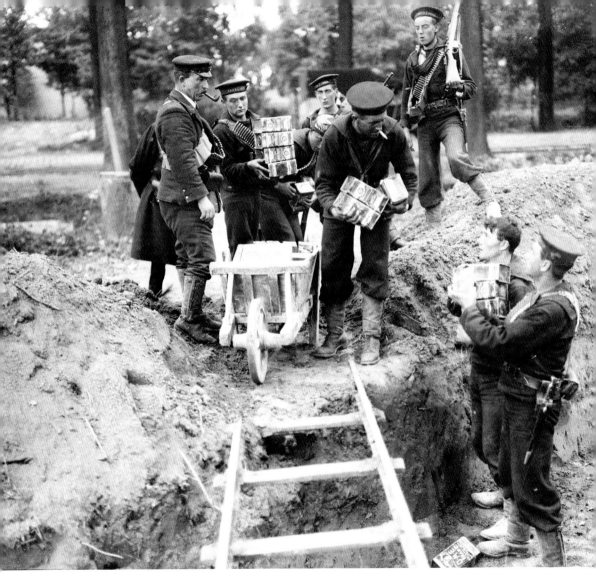

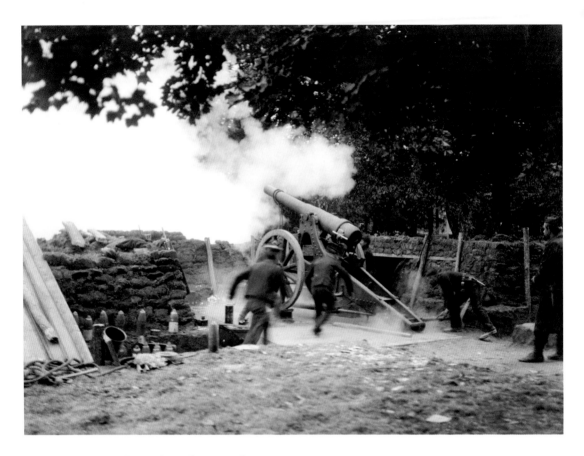

A Belgian artillery piece fires on German
forces besieging the city of Antwerp.
**2nd October, 1914**

British and Allied prisoners of war before embarking on a train for transport to the Döberitz PoW camp near Berlin in Germany. Their guard has a cloth cover on his spiked helmet, which was introduced to make it less visible in the trenches.

**6th October, 1914**

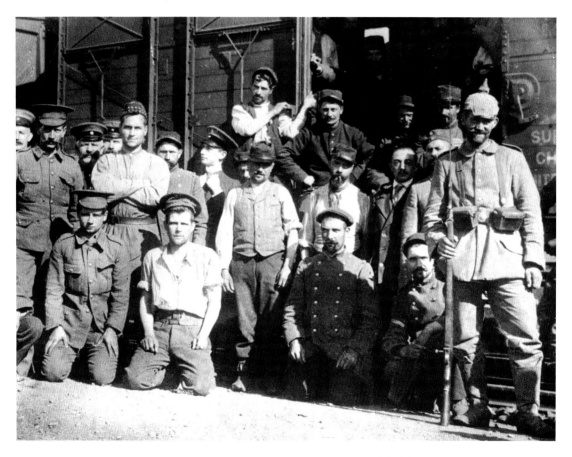

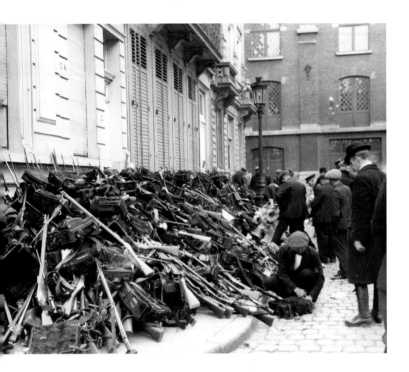 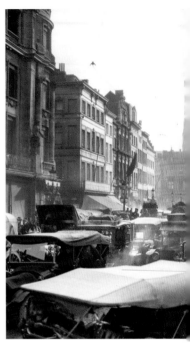

Members of the Belgian Civic Guard dump their arms and equipment before the Germans enter the city of Antwerp. They were not recognised as combatants by the Germans, who considered them terrorists.
8th October, 1914

Above right: The roads in Antwerp are jammed as cars rush to the last remaining bridge across the River Schelde and their only escape route into Belgian-held territory from the advancing Germans.
8th October, 1914

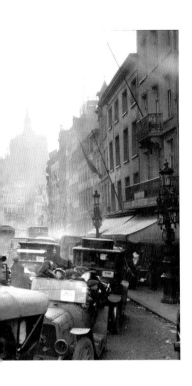

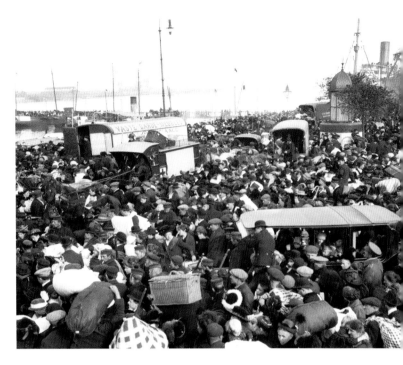

The inhabitants of Antwerp jam the quay in the hope of getting on to one of the ships evacuating the city. They had arrived on foot and in taxicabs, carts and traps, with any possessions they were able to carry.

8th October, 1914

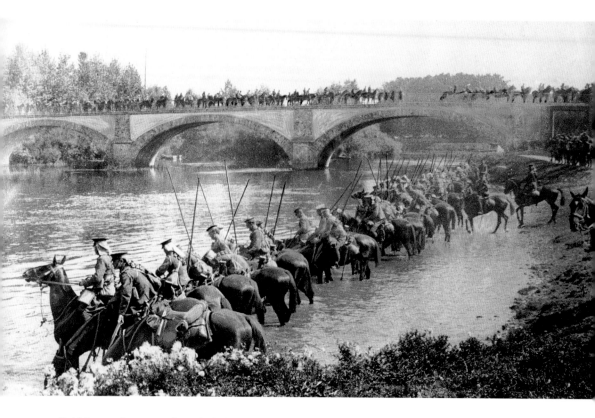

British cavalry watering their horses in a river in France. It was soon discovered that cavalry stood little chance in modern warfare, particularly against barbed-wire fortifications and machine guns.

**9th October, 1914**

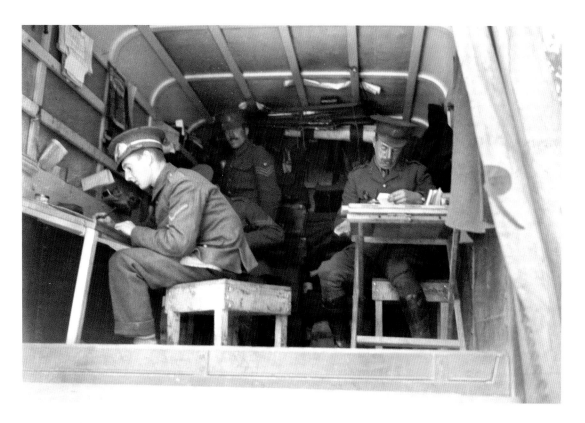

An officer of the Royal Army Service Corps (R) in France censors letters written by soldiers to their families and friends at home.

**10th October, 1914**

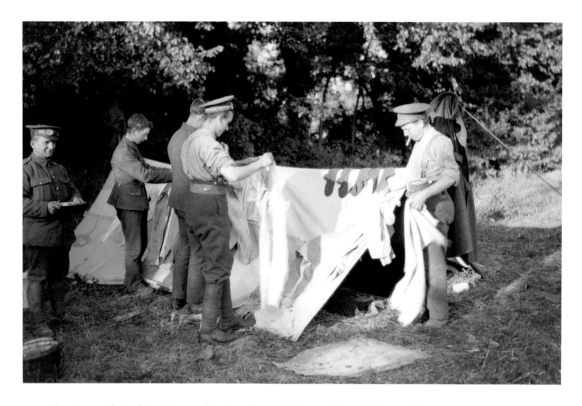

Members of the Royal Army Service Corps in France hang their washing out to dry. Known as 'Ally Sloper's Cavalry', the RASC carried out a number of support roles for the front-line troops, including providing transport, supplying food, water, fuel and general domestic stores, and filling a number of administrative roles.
10th October, 1914

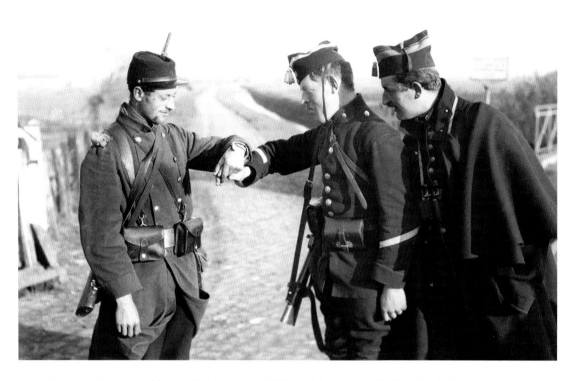

On a road just outside the Belgian city of Diksmuide, during the Battle of the Yser, Belgian soldiers check the identification disc of a French soldier. He has placed the disc around his wrist instead of his neck, making it easier to find in case of his death. The Battle of the Yser took place when the Belgian Army made a stand along the Yser Canal in south-west Belgium, preventing the Germans from reaching the French ports of Calais and Dunkerque.
17th October, 1914

British troops demonstrate a bayonet charge from the trenches for the benefit of the camera. Note their lack of protective headgear. For the first year of the war, soldiers on both sides went into action wearing their normal service caps or hats. However, the increasing number of lethal head wounds suffered by troops soon led to the introduction of protective steel helmets of various designs. The British and Americans adopted the Brodie helmet, designed in 1915 by John L. Brodie. This was a simple soup bowl-shaped helmet that could be pressed from a single sheet of thick steel.

**21st October, 1914**

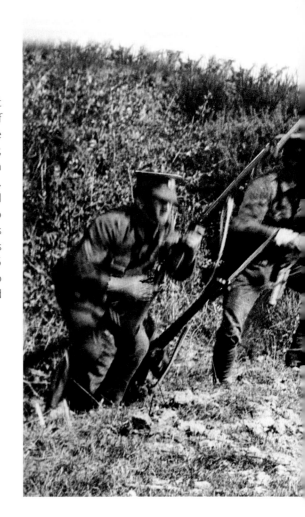

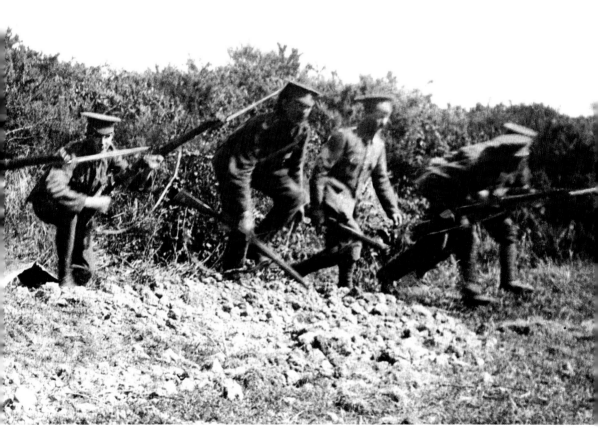

British Army recruits being trained to manoeuvre large horse-drawn artillery pieces by Territorial Army instructors.
**25th October, 1914**

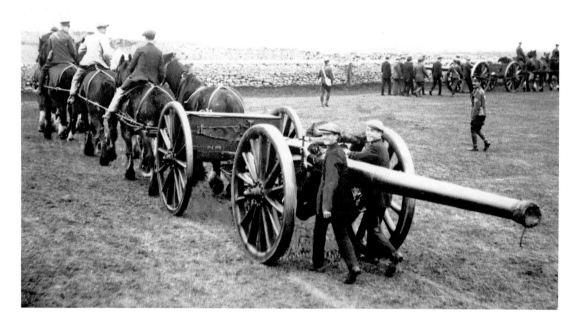

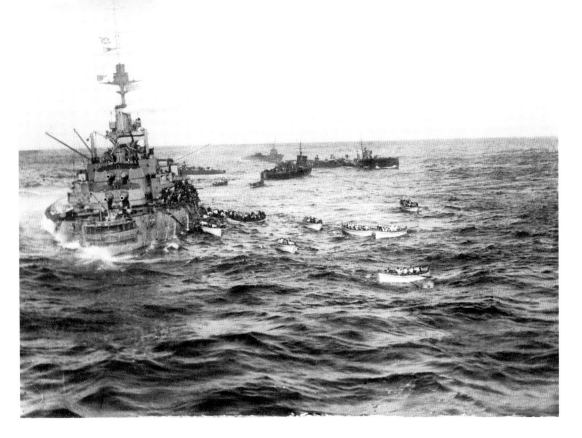

Lifeboats from the British liner *Olympic* help rescue the crew of the battleship HMS *Audacious* after she had hit a German mine off the coast of Donegal, Northern Ireland. The *Olympic*, along with the cruiser *Liverpool* and escorting destroyers, took off all but 250 essential crew members. An attempt was made to tow the stricken vessel to safety, but rough weather made salvage impossible. The remaining crew were taken off and about an hour later the great ship capsized, exploded and sank. She had only been commissioned in 1913 and had never seen action.

**27th October, 1914**

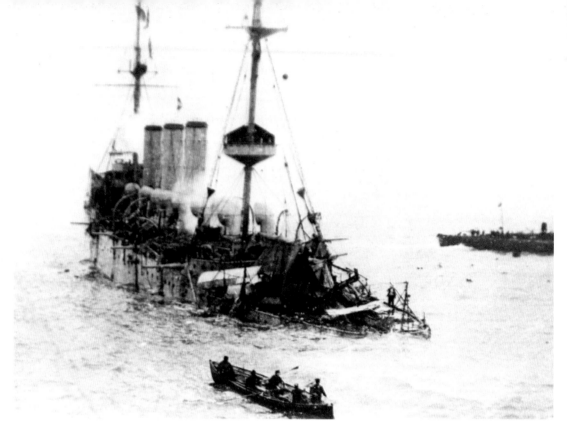

HMS *Hermes*, a Highflyer-class cruiser that had been converted as a seaplane carrier, sinking in the Straits of Dover after being torpedoed by a German submarine. The ship was returning from France after delivering seaplanes to Dunkerque; 22 of her crew lost their lives.

31st October, 1914

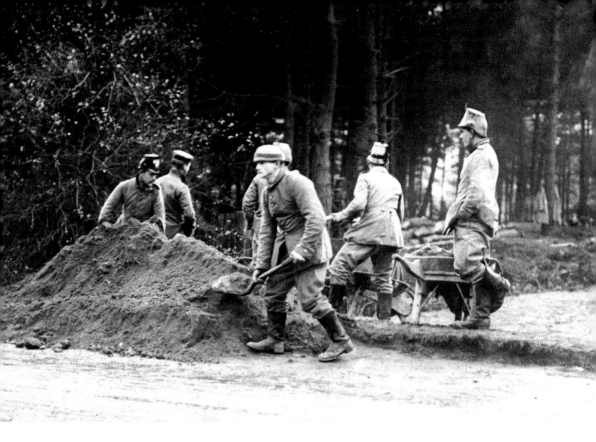

German prisoners of war constructing a road in the neighbourhood of Aldershot, Hampshire. The Geneva Convention allowed prisoners to be made to work, as long as they were paid and were not required to do anything of a military nature.
November, 1914

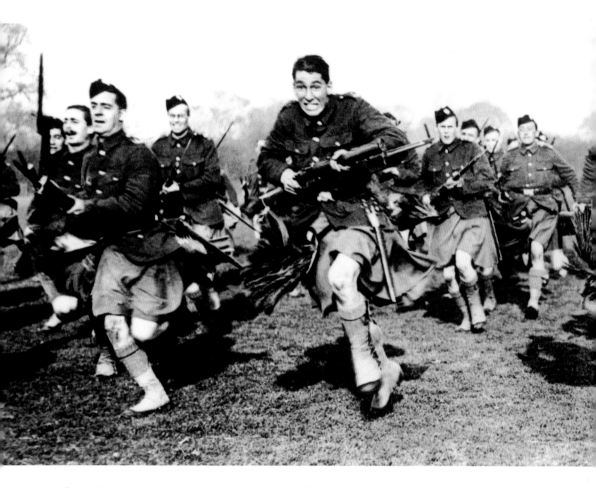

Scottish soldiers practise the bayonet charge. The manoeuvre was an effective weapon when used against infantry troops who were on the point of giving up. It was much less effective, however, against determined men who were dug in and armed with machine guns.
6th November, 1914

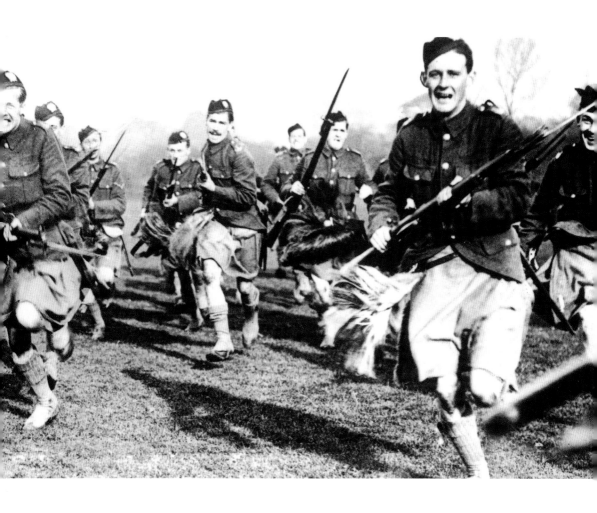

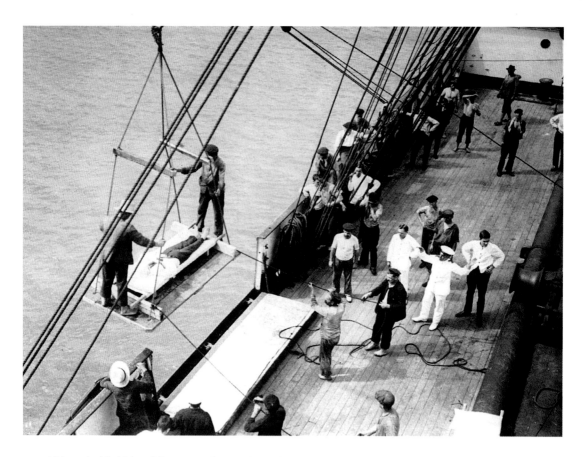

Wounded British soldiers are taken on board
the hospital ship *Pegasus*. By November, 1914,
casualty rates on both sides were horrifying
– and about to rise further with the advent
of trench warfare.
**6th November, 1914**

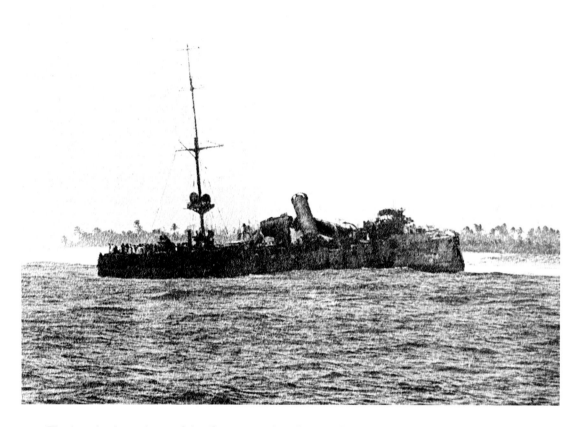

The beached wreckage of the German cruiser *Emden* after being pounded to destruction by
HMAS *Sydney* at the Cocos Islands in the Indian Ocean. The *Emden* had sunk or captured 30
Allied merchant vessels and warships in the region over a two-month period.
10th November, 1914

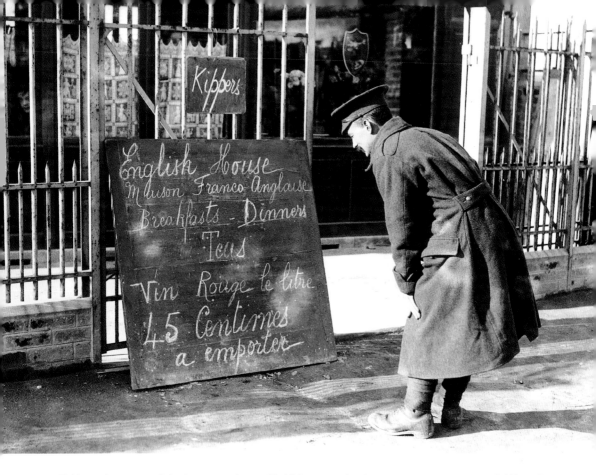

Taking advantage of the large number of British troops in the area, an entrepreneurial French restaurant owner has renamed his establishment the English House, offering breakfasts, dinners, teas and red wine at 45 centimes a litre – not to mention kippers.
**23rd November, 1914**

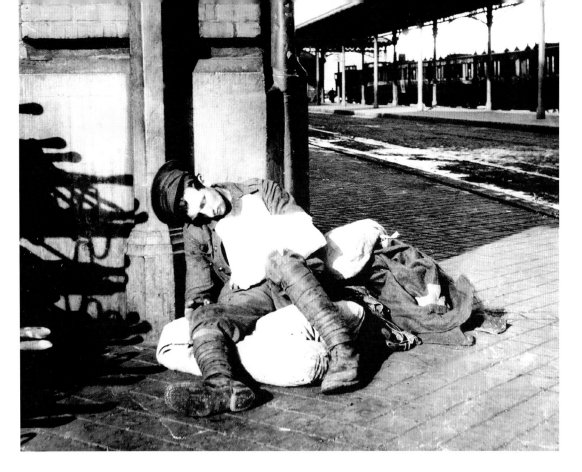

A wounded British soldier waits for a train on the first stage of his journey home to Blighty in time for the first Christmas of the war. Many thought the conflict would be over by then, but they would be proved wrong.

**8th December, 1914**

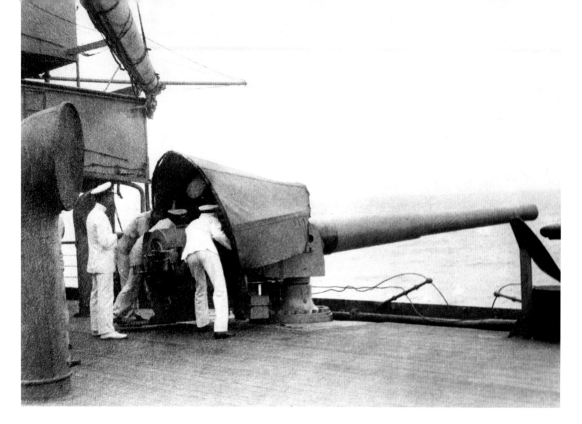

Sailors engage a target from a Royal Navy warship, using the vessel's secondary armament.
10th December, 1914

Above right: A German blockade runner is struck by shells from a Royal Navy warship.
10th December, 1914

Right: The crew of the German ship is rowed to the waiting British vessel after surrendering.
10th December, 1914

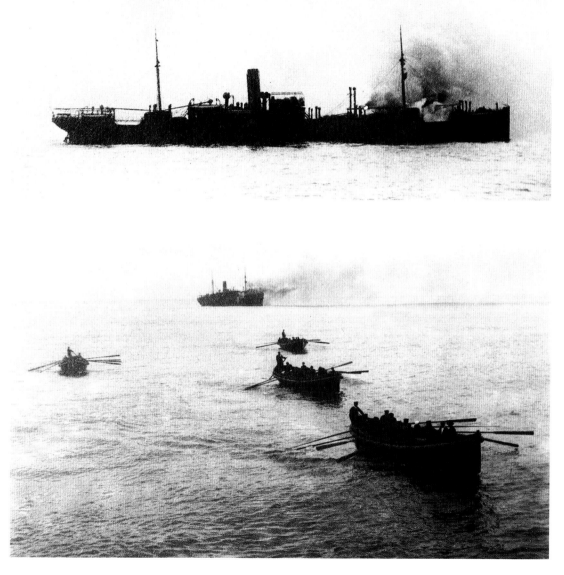

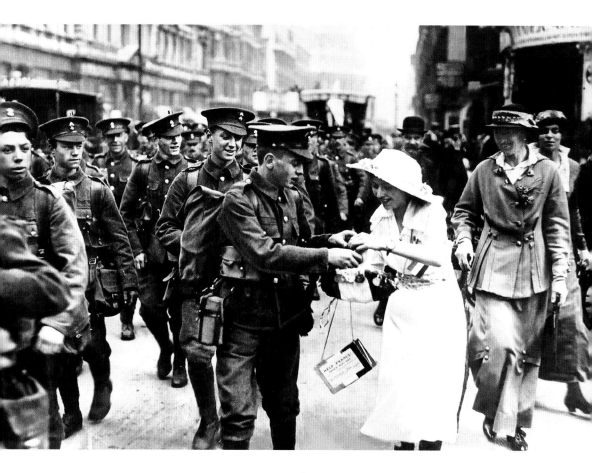

Left: A retouched photograph of Mata Hari, who was accused of spying for the Germans and executed by the French in 1917.
1915

A young woman sells 'Help France' flags to British troops going to war.
1915

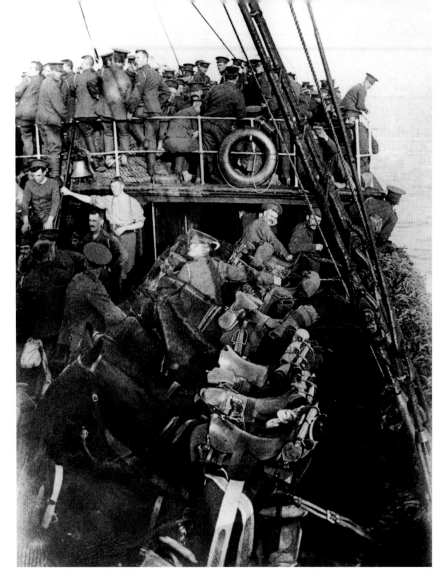

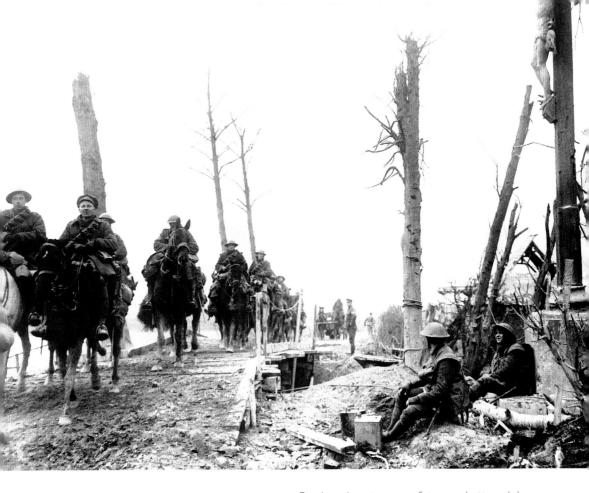

Left: British cavalrymen and their horses cross the Channel aboard a troopship.
1915

Passing the stumps of trees shattered by shellfire, a troop of British cavalry crosses a temporary bridge on the Western Front.
1915

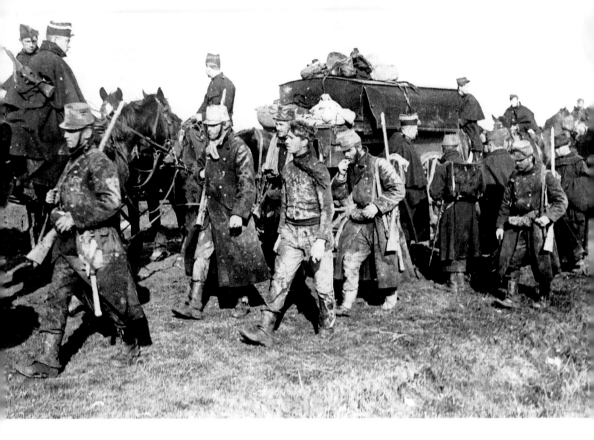

Splattered with mud, Belgian soldiers march
to take up a new position in the front line.
**1915**

Right: A Maori soldier from New Zealand
carries a tribal doll as a mascot as he arrives
in Britain. Soldiers from across the British
Empire fought in the war.
**1915**

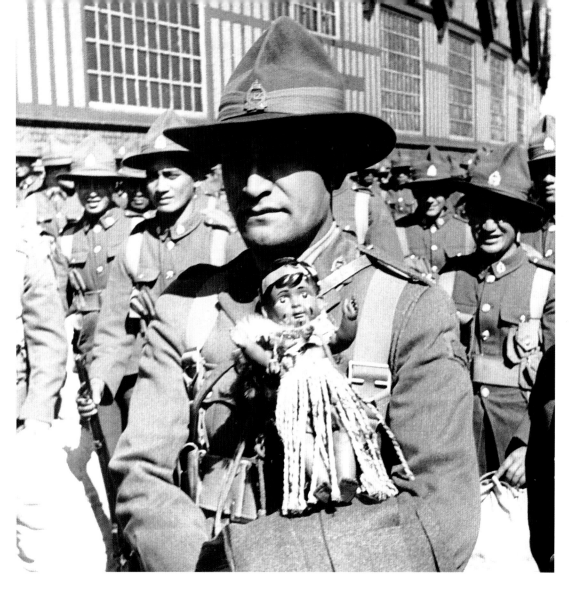

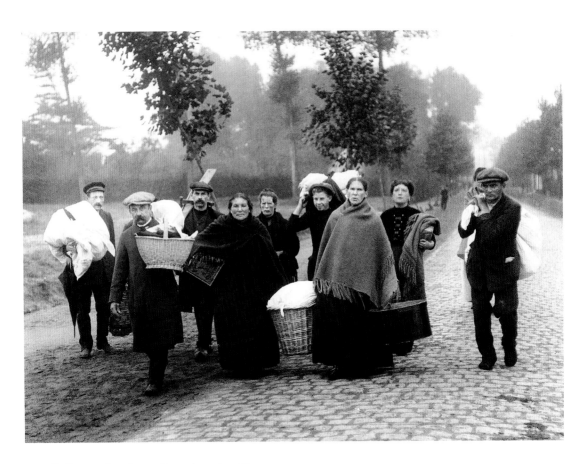

Refugees flee from the advancing German
forces with such possessions as they are able
to carry.
1915

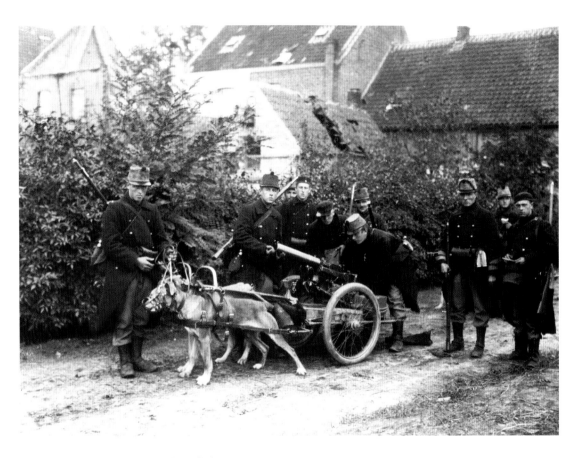

The Belgian Army employed dog teams to pull heavy Maxim machine guns on purpose-made carts. They were also used to pull wounded soldiers to aid stations.

1915

A Short Brothers Type 184 seaplane drops
a torpedo during development work. The
machine was used by the Royal Naval Air
Service throughout the war. It was the first
aircraft to sink a ship with a torpedo.
1915

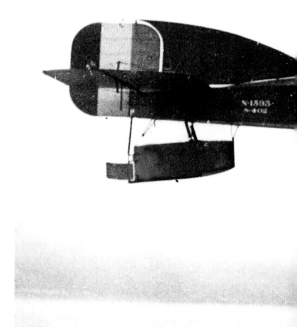

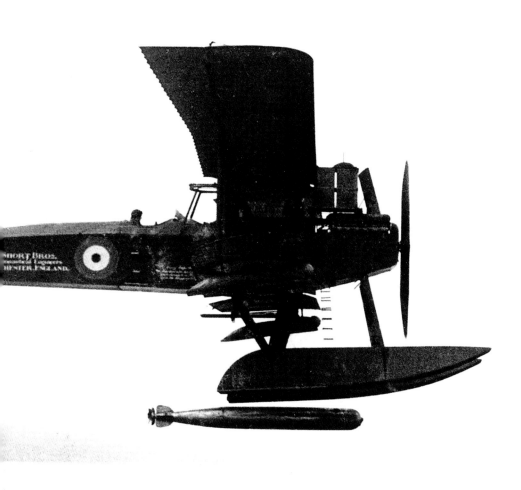

Liberal MP Horatio Bottomley urges volunteers to join the Army at a recruitment rally. Bottomley was something of a hypocrite, however. After the war, it emerged that he had defrauded thousands of small investors with a 'Victory' savings scheme. Rightly, he was sent to prison.

1915

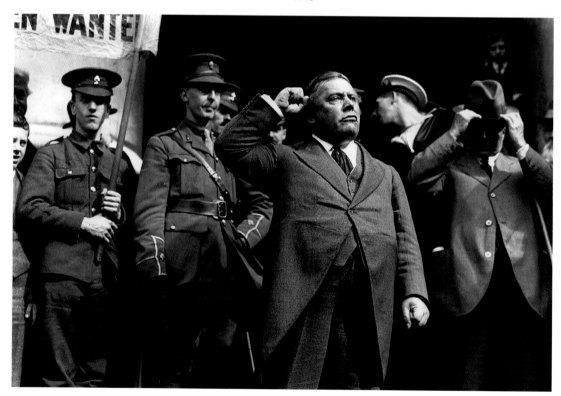

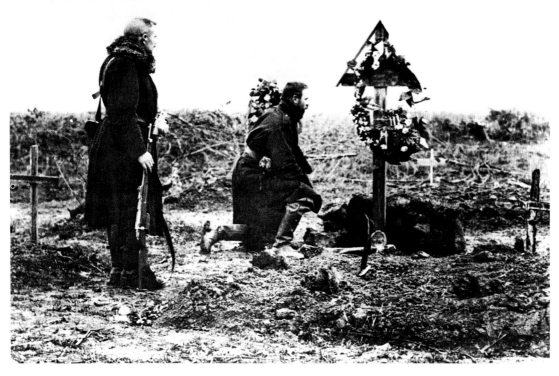

An Austrian officer pays tribute at the grave of a fallen comrade, killed during fighting around Belgrade in Serbia. The conflict between the Austro-Hungarian Empire and Serbia continued throughout the First World War and eventually involved almost all of the combatants in the war, the Allies supporting Serbia.
19th January, 1915

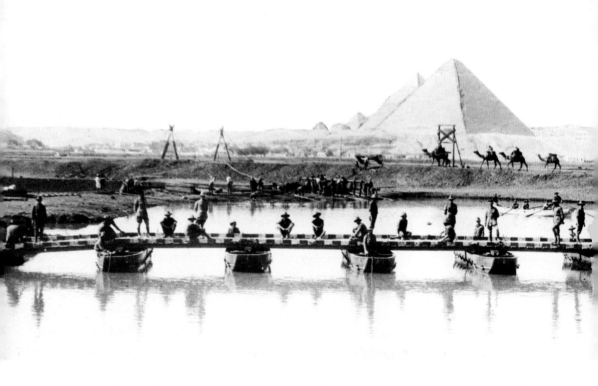

A team of Australian engineers build a pontoon bridge over a river near the pyramids in Egypt. Part of the British Force in Egypt (eventually to become the Egyptian Expeditionary Force), they were there to counter the Ottoman threat to Egypt (then a British protectorate) and the Suez Canal.
March, 1915

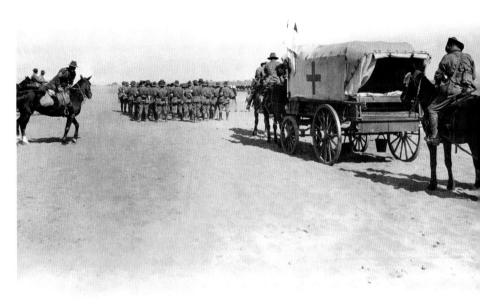

Australian troops with the Force in Egypt carry out an exercise in the desert. It was commonly thought that colonial soldiers could withstand the rigours of the desert far better than the British.

March, 1915

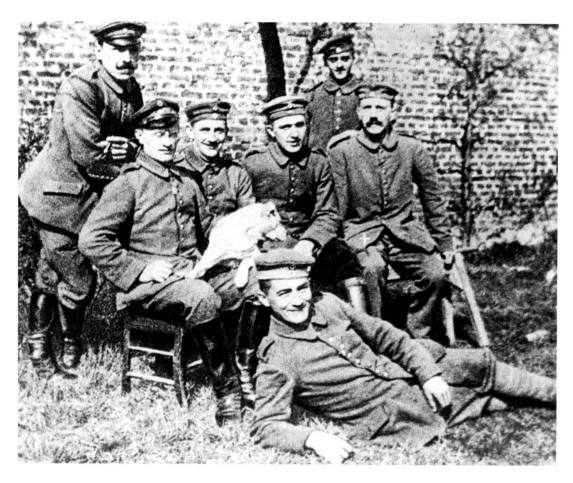

Adolf Hitler (far R), later to become the leader of Nazi Germany and the instigator of the Second World War, rests behind the lines at Comines with comrades from the 16th Bavarian Reserve Regiment. Hitler attained the rank of corporal and was decorated for bravery twice.

March, 1915

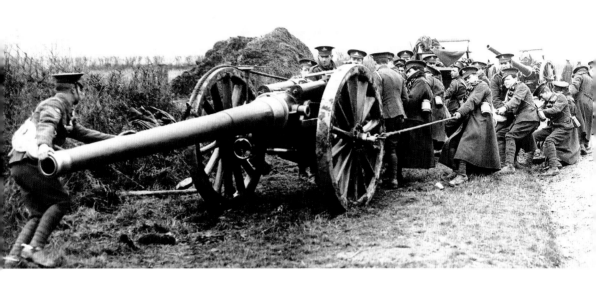

British gunners struggle to pull a field gun
into position on the Western Front.
15th March, 1915

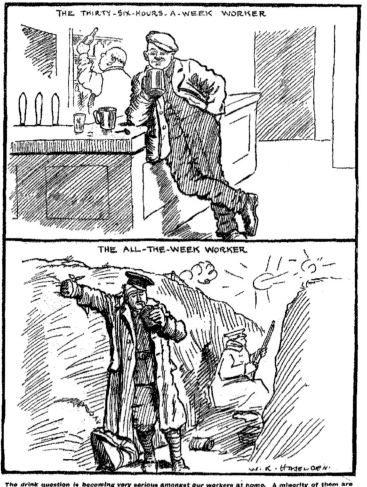

## AT HOME AND ABROAD: A CONTRAST.

### THE THIRTY-SIX-HOURS-A-WEEK WORKER

### THE ALL-THE-WEEK WORKER

W. K. HASELDEN.

The drink question is becoming very serious amongst our workers at home. A minority of them are "holding up" necessary munitions or repairs by intemperate habits. Those who do this are simply fighting our brave men in the trenches as ruthlessly as the Germans are.—(By Mr. W. K. Haselden.)

A *Daily Mirror* cartoon by William Kerridge Haseldon, contrasting the lives of men at home and at the front. The cartoon points out that the intemperate habits of the fomer were having an adverse effect on the war effort.
31st March, 1915

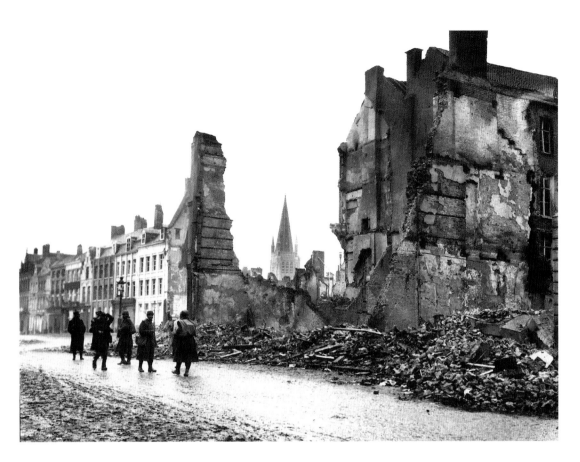

Ruins in the Belgian city of Ypres, commonly referred to as 'Wipers' by British soldiers. The area was the scene of heavy fighting in the spring of 1915, but despite substantial losses on both sides, relatively little was actually gained by either. The battle saw the first major use of poison gas, the German Army releasing chlorine gas against the Allied troops, who hadn't been issued with gas masks; instead they were advised to go into battle with cloths soaked in urine over their mouths.

April, 1915

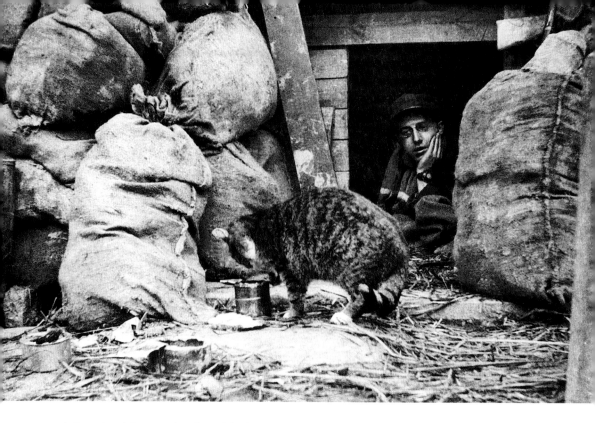

A French soldier watches from his dugout as a cat takes the food he has left out for it. In the horror of the trenches, such every-day actions did much to maintain morale.

15th April, 1915

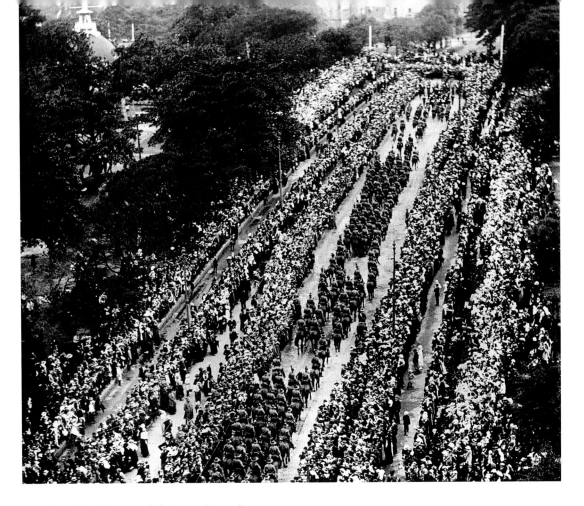

The inhabitants of Sydney, Australia, turn
out in force to bid farewell to troops before
they embark for the war in Europe.
24th April, 1915

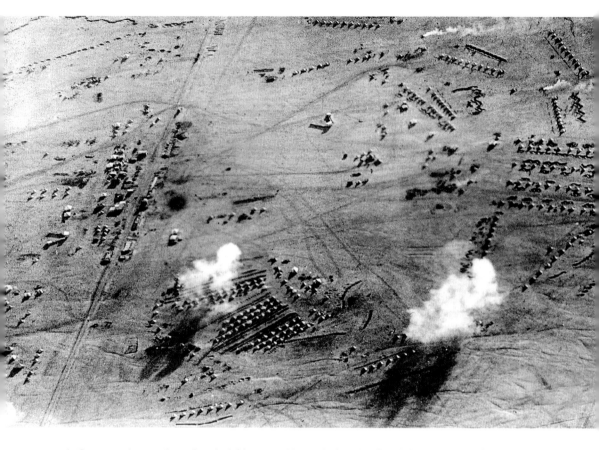

A German air attack on South African positions during the South-West Africa Campaign. As part of the British Empire effort in the First World War, forces from the Union of South Africa invaded and seized German South-West Africa in 1915.

1915

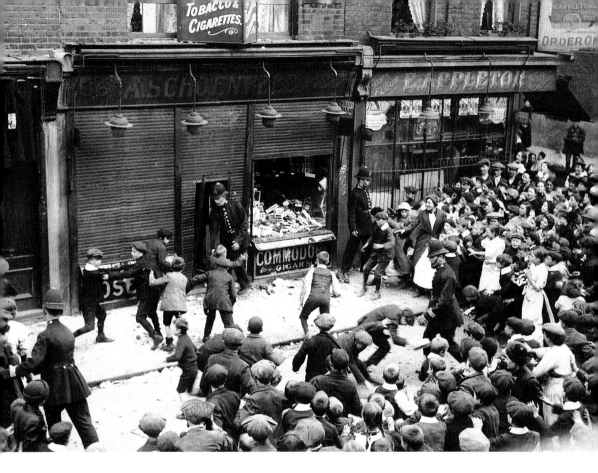

Anti-German sentiment led to this riot in Poplar, London, the mob attacking a tobacconist's shop in Crisp Street, which was owned by a man with a German name.
**13th May, 1915**

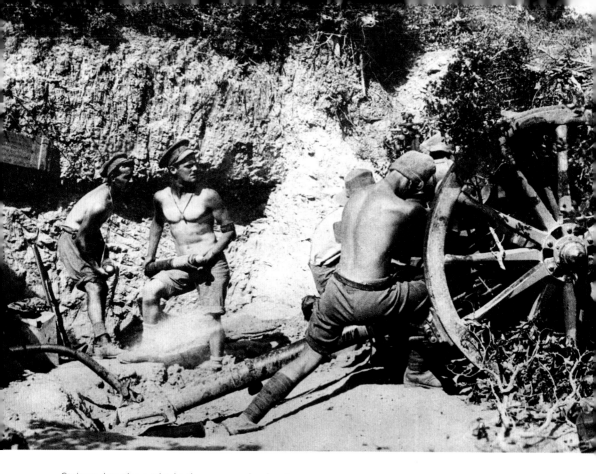

Stripped to the waist in the oppressive heat, Australian gunners of the 9th Field Battery lay down fire with their 18-pounder gun during the Gallipoli Campaign.
**19th May, 1915**

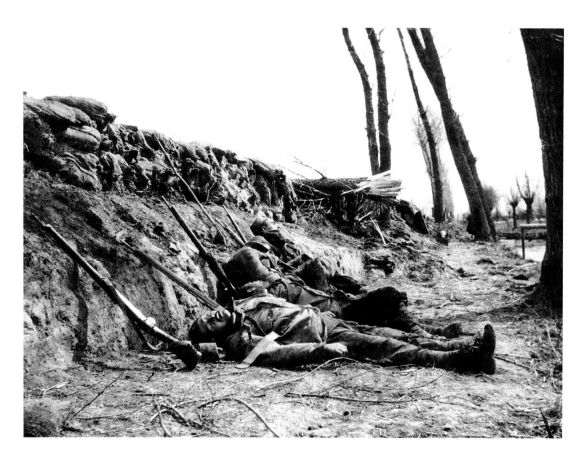

Troops overcome by poison gas lie unconscious behind their fortifications near the front line. A variety of gases, some more lethal than others, were used by both sides during the war.

21st May, 1915

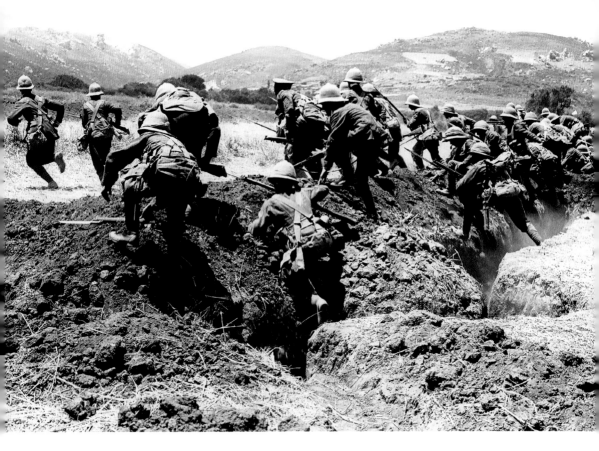

Troops of the Royal Naval Division charge the enemy from their trench on the Gallipoli Peninsula. By the end of the Dardanelles Campaign, the division contained very few naval servicemen, and it was redesignated the 63rd Division in 1916, going on to serve on the Western Front.

15th July, 1915

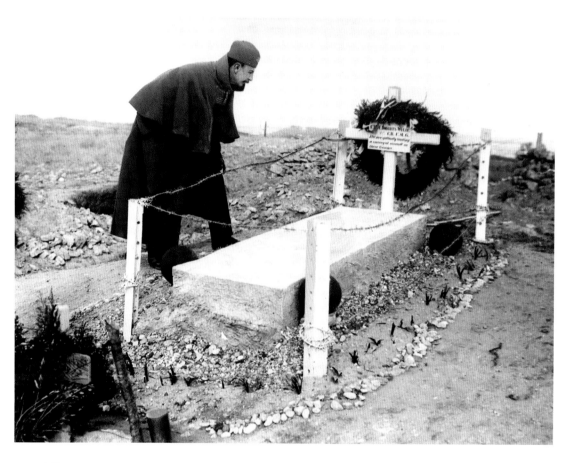

A French officer pays his respects at the grave of Lieutenant Colonel Charles Doughty-Wylie, VC, during the Gallipoli Campaign. Doughty-Wylie, with another British officer, had been instrumental in overcoming a heavily defended Turkish strongpoint during the initial Allied landings on the Gallipoli Peninsula, but both had been killed in the process.
June, 1915

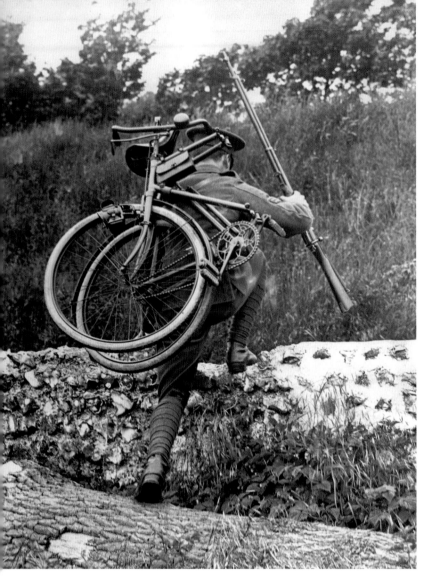

With his folded machine on his back, a soldier from the Army Cyclist Corps demonstrates the versatility of the mounted infantryman. Sadly, the tough conditions on the Western Front did not lend themselves to the use of bicycle infantry and most members of the corps were used in the traditional infantry role. After the war, the corps was disbanded.
9th June, 1915.

Young women in Rome sell a rosette to a soldier in aid of the Italian Red Cross. Although Italy was a member of the Triple Alliance with Germany and Austria-Hungary, the country did not join them on the outbreak of war. Instead, Italy entered the war on the Allied side in May, 1915 in the hope that it would gain territories held by Austria.

15th June, 1915

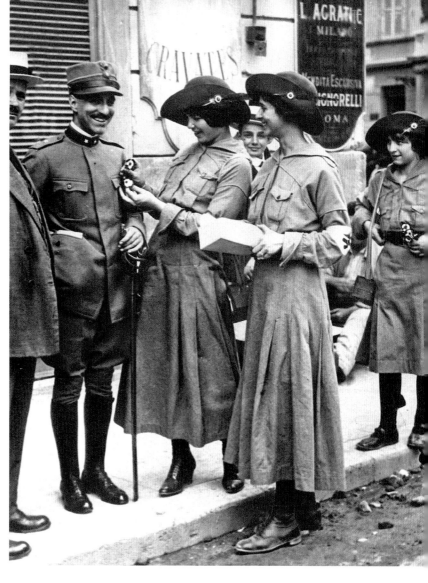

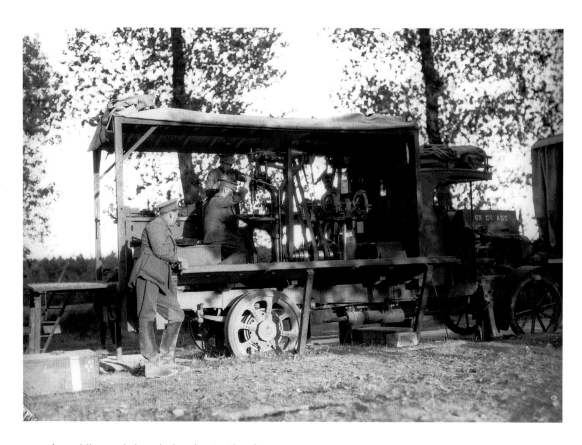

A mobile workshop belonging to the Army
Service Corps provides a light engineering
facility behind the front lines in France.
1915

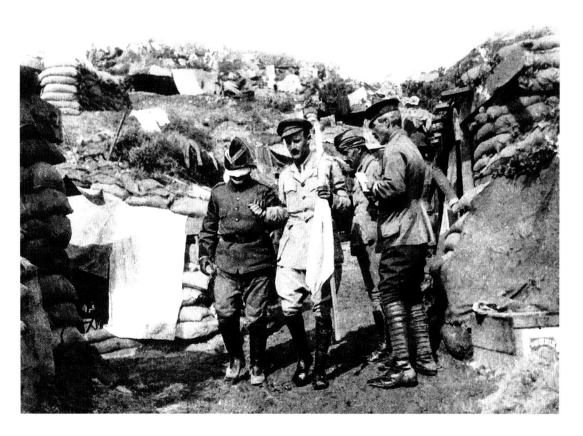

Carrying the man's flag of truce, a British officer leads a Turkish emissary to his headquarters on the Gallipoli Peninsula. The man is blindfolded so that he cannot carry any useful information back to his own lines. The purpose of his visit is unknown, but perhaps it was to allow treatment or evacuation of the wounded. Such considerate acts were well known. Certainly, during the latter stages of the Gallipoli Campaign, when inertia had set in, it was common for the men in opposing trenches to throw gifts of food to each other.

August, 1915

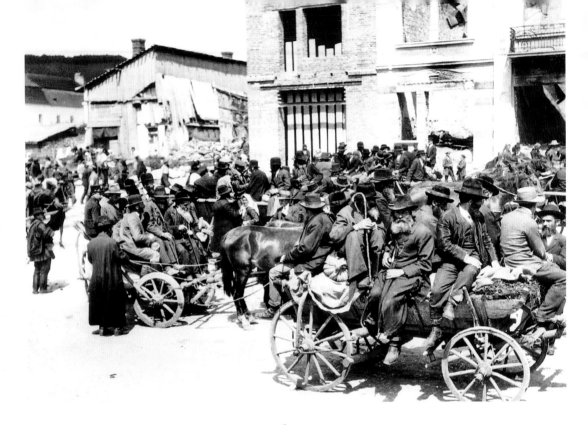

Polish refugees use every means of transport they can find as they flee from the advancing German forces. At the time, Poland was not an independent country, but rather it was partitioned between Germany, Austria-Hungary and Russia. By the end of 1915, Germany occupied the entire Russian sector.

2nd August, 1915

Right: A Turkish sniper (C) photographed immediately after capture by Anzac troops on the Gallipoli Peninsula. He is still wearing his elaborate camouflage.

5th August, 1915

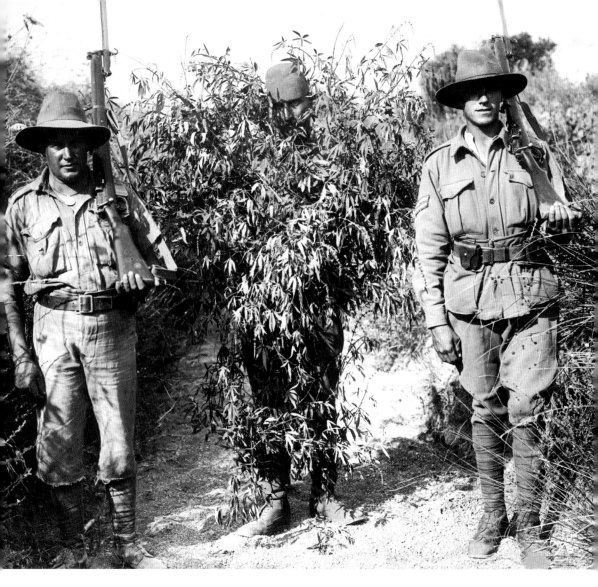

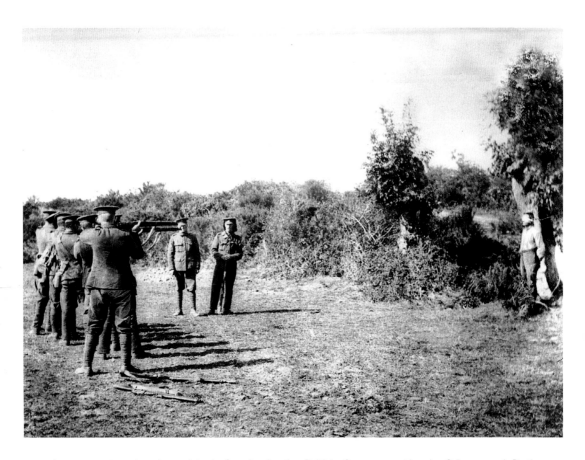

A man, captured and convicted of spying by the British, faces execution by firing squad. Both sides employed spies during the First World War, and fear of spying prompted hundreds of arrests and a number of executions, sometimes of innocent men and women.

**August, 1915**

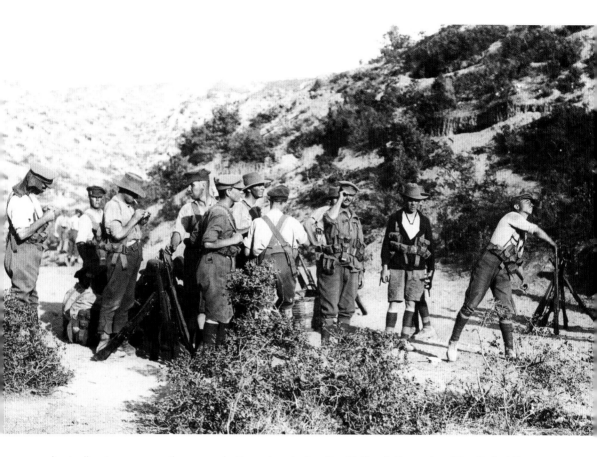

Australian troops practise grenade throwing during the Gallipoli Campaign. The *Daily Mirror* captioned the picture: *"This is how the Australians hurl bombs at the Turks. They can throw them as accurately as they can a cricket ball."*
**21st September, 1915**

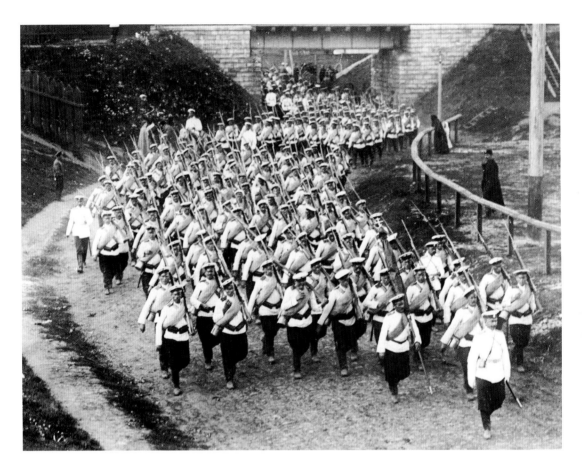

Bulgarian troops on the march. Although initially neutral, Bulgaria entered the war on the side of the Central Powers in September, 1915, hoping to make territorial gains in the Balkans. The country's location opened a route by which Germany could reinforce the Ottoman war effort against the Allies in the Middle East.

**September, 1915**

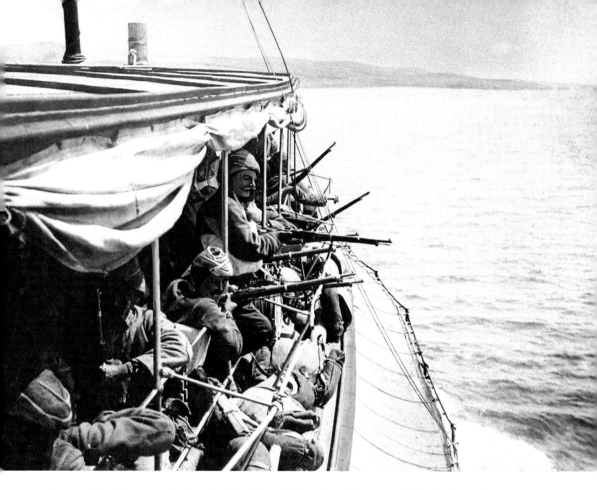

A retouched photograph showing Turkish soldiers aboard a troopship in the Sea of Marmara. They were on their way to the Gallipoli Peninsula to counter the Allied invasion. By September, 1915, the battle had reached stalemate and had degenerated into trench warfare. The Allies would eventually begin to withdraw in December of that year.
September, 1915

THE SUIT THE GIRLS LIKE BEST.

AUTUMN SUITINGS

TAILORS

A SUIT OF KHAKI COSTS NOTHING. GET ONE TO-DAY.

A cartoon taken from the *Birmingham Daily Mail*, which encourages men to join up. Rather than appealing to their sense of patriotism, it infers that women prefer men in khaki uniforms.

September, 1915

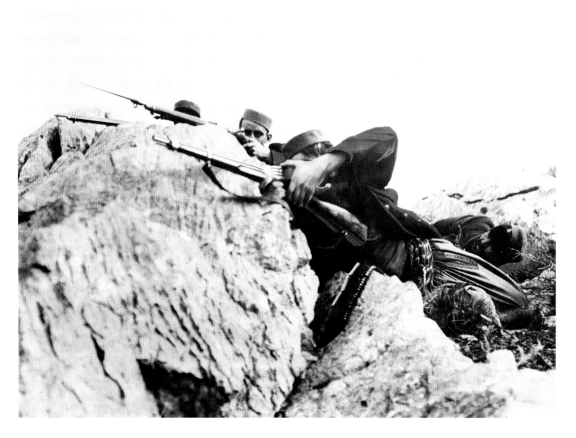

Montenegrin soldiers in action against an Austro-Hungarian invasion force. Montenegro had entered the war on the side of Serbia when the latter was invaded by Austria-Hungary in 1914. The country was crushed, however, and remnants of the army fled to Corfu.
**October, 1915**

# PROCLAMATION

Le Tribunal du Conseil de Guerre Impérial Allemand siégant à Bruxelles a prononcé les condamnations suivantes :

Sont condamnés à mort pour trahison en bande organisée :

Edith CAVELL, Institutrice à Bruxelles.
Philippe BANCQ, Architecte à Bruxelles.
Jeanne de BELLEVILLE, de Montignies.
Louise THUILIEZ, Professeur à Lille.
Louis SEVERIN, Pharmacien à Bruxelles.
Albert LIBIEZ, Avocat à Mons.

Pour le même motif, ont été condamnés à quinze ans de travaux forcés :

Hermann CAPIAU, Ingénieur à Wasmes. - Ada BODART, à Bruxelles. - Georges DERVEAU, Pharmacien à Pâturages. - Mary de CROY, à Bellignies.

Dans sa même séance, le Conseil de Guerre a prononcé contre dix-sept autres accusés de trahison envers les Armées Impériales, des condamnations de travaux forcés et de prison variant entre deux ans et huit ans.

En ce qui concerne BANCQ et Edith CAVELL, le jugement a déjà reçu pleine exécution.

Le Général Gouverneur de Bruxelles porte ces faits à la connaissance du public pour qu'ils servent d'avertissement.

Bruxelles le 12 Octobre 1915

Le Gouverneur de la Ville,
Général VON BISSING

A German proclamation, issued in Belgium to announce the execution of Edith Cavell, following her trial for treason. A British nurse working in Brussels, Cavell had treated wounded soldiers of all nationalities, but had also sheltered and helped British, French and Belgian soldiers escape from occupied Belgium. She was executed by a German firing squad.
12th October, 1915

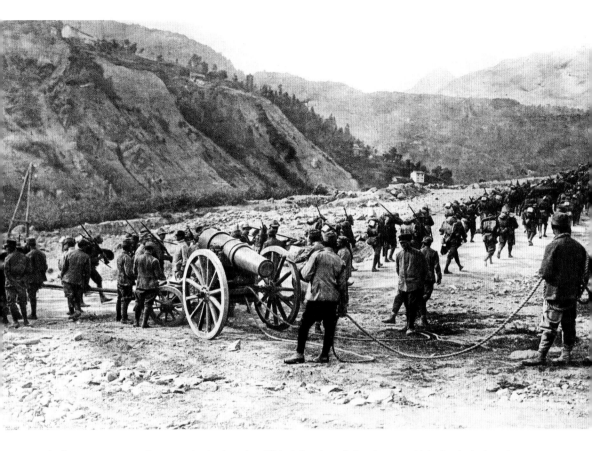

Italian troops on the march during the Third Battle of the Isonzo. Italy had declared war against Austria-Hungary on 23rd May, 1915, and had launched an attack across the border on the following day. Despite numerical superiority, poor tactics and mountainous terrain thwarted the ambitions of commander-in-chief Luigi Cadorna, and the conflict eventually reverted to trench warfare among the mountains.

**October, 1915**

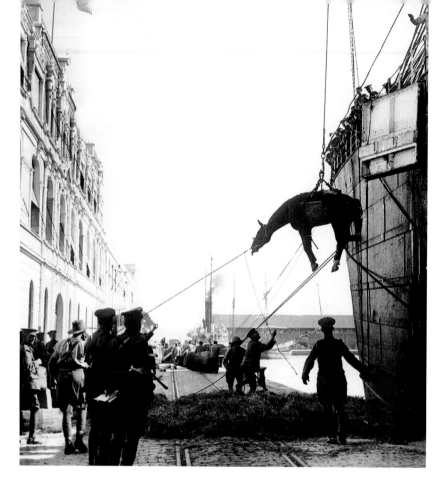

Allied cavalry horses are unloaded from a ship in the Greek port of Salonika (now Thessalonika). Although Greece had declared her neutrality, the British and French used Greek territory to send an expeditionary force to the aid of Serbia, which was under attack by Austria-Hungary, Germany and Bulgaria.

**24th October, 1915**

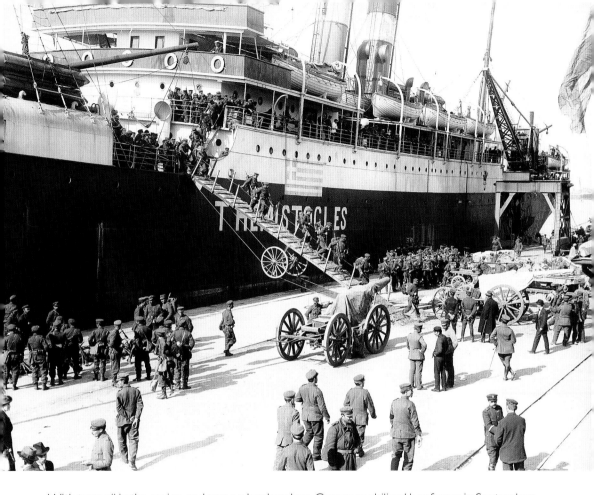

With turmoil in the region and war on her borders, Greece mobilised her forces in September, 1915. Here, Greek troops arrive at the port of Salonika. They would not join the Allied war effort, however, until 1918.

**November, 1915**

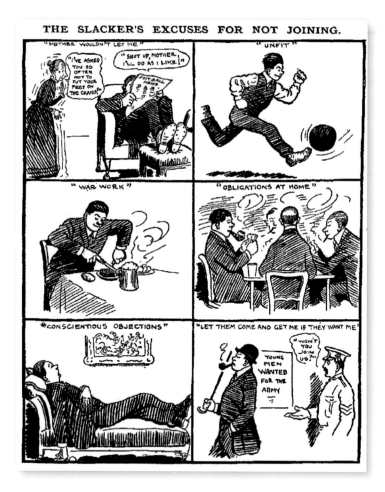

During the First World War, British newspapers frequently published cartoons that encouraged men to join up or castigated those who did not. This Haselden cartoon, published in the *Daily Mirror*, is typical.

12th November, 1915

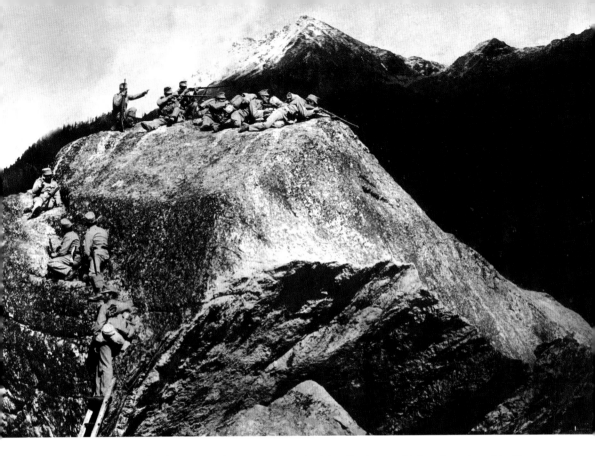

Austrian troops defend a mountain outpost overlooking the Isonzo Valley. A series of battles took place in this region between the Austro-Hungarian and Italian armies, spanning a period between June 1915 and November 1917. Some 600,000 soldiers from both sides lost their lives in this conflict on the Italian Front.

21st December, 1915

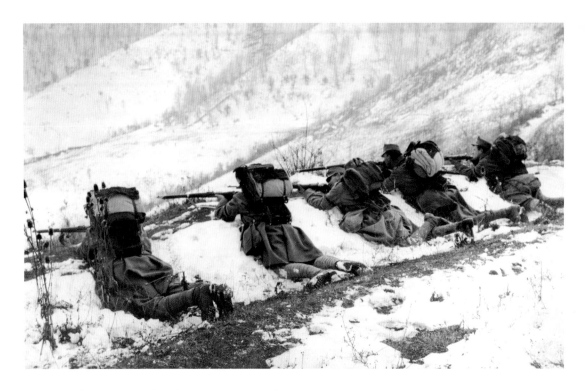

Austrian troops dug in on a mountain top during the winter campaign on the Montenegro front. Within a matter of weeks, the Austrians would crush the tiny kingdom and it would remain under their control for the rest of the war.

December, 1915

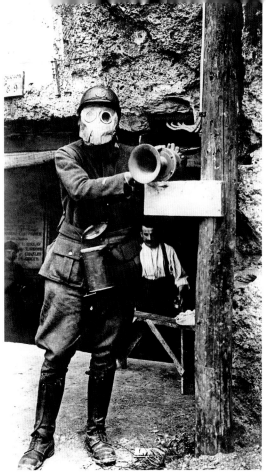

Arnold Ridley, later to find fame in the BBC TV series *Dad's Army*, sustained serious injuries while serving with the Somerset Light Infantry in the First World War.
c.1916

Wearing a gas mask, a French soldier demonstrates a klaxon horn used to warn his comrades of a gas attack.
c.1916

Although employed primarily for reconnaissance, German airships, known as Zeppelins after the pioneer of that type of craft, Count Ferdinand von Zeppelin, were also used to carry out bombing raids, mostly against Britain at night. While the intention was to hit military targets, often civilians were on the receiving end.

1916

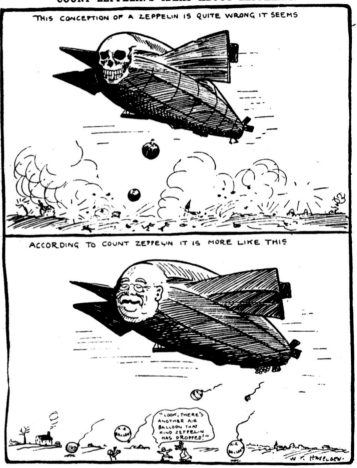

The crew of a German Zeppelin airship arrives at a French prison in Salonika, Greece, after their craft was shot down by British gunners.
1916

British Army ambulance personnel with a horse-drawn ambulance. Motorised ambulances were also employed, often being contributed by wealthy individuals.
1916

Right: Women at a British munitions factory provide a volunteer fire service. One of their number is wearing the latest in protective breathing apparatus.
1916

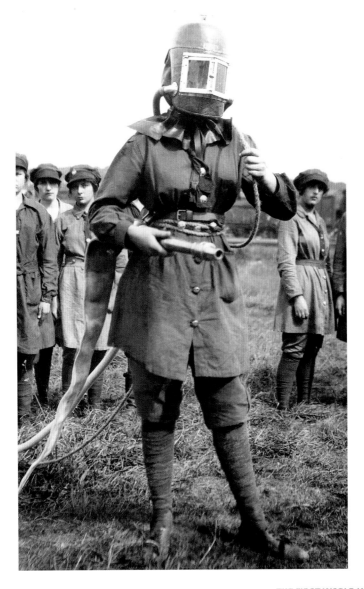

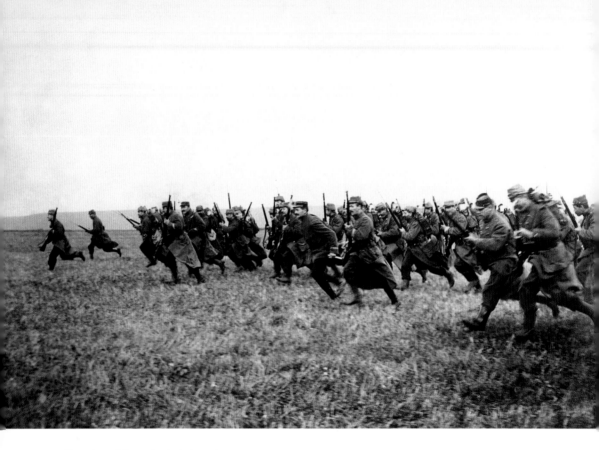

French soldiers in training charge across a field with rifles raised. The extensive use of barbed wire entanglements and machine guns spelled the end for such acts of courage.
c.1916

Winston Churchill during his time as commander of the 6th Battalion of the Royal Scots Fusiliers on the Western Front. He had rejoined the Army after resigning his post as First Lord of the Admiralty following the disastrous Gallipoli Campaign, which he had championed. He was only in the front line for a few months, however, since he returned to his political career in March, 1916.

**1916**

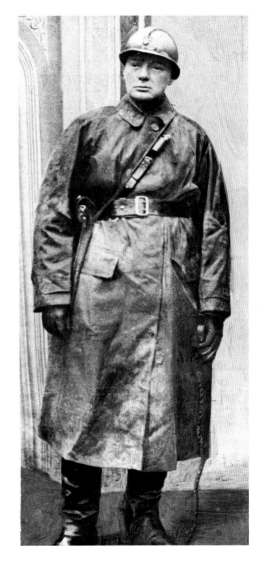

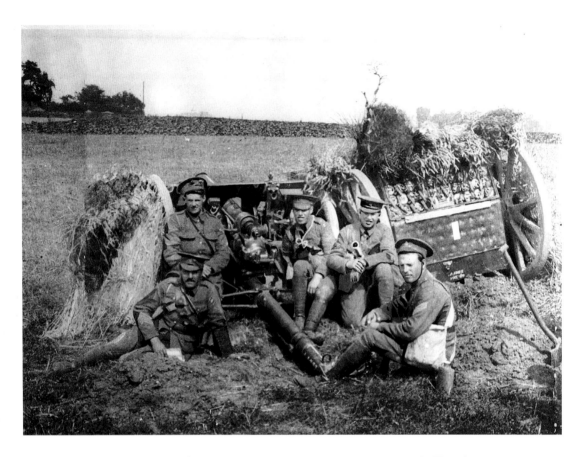

Members of a gun crew from the Royal Horse Artillery take a break. They have covered their field gun and its limber with wheat to camouflage them. Each gun had a crew of nine men. Early in the war, the guns were 13-pounders, but these were gradually replaced by 18-pounders, which were found to be more effective against prepared defensive positions.
1916

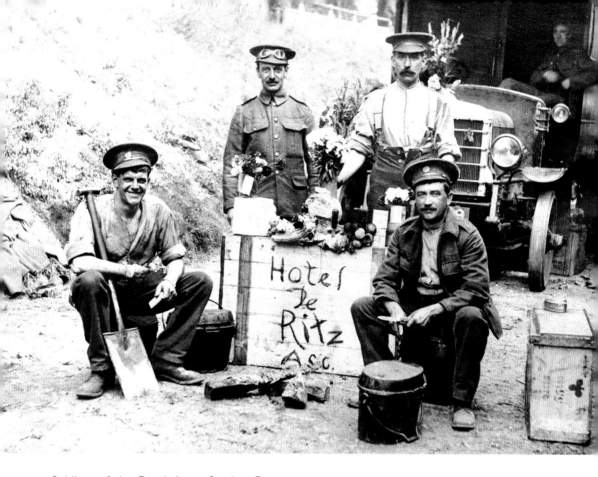

Soldiers of the Royal Army Service Corps (RASC) in France display typical military humour as they prepare to stop for the night.
1916

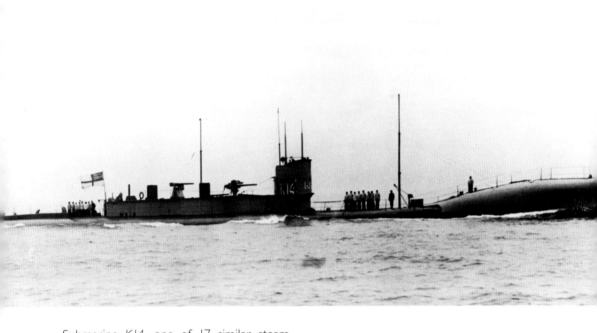

Submarine *K14*, one of 17 similar steam-powered vessels built for the Royal Navy. These large, fast submarines were intended to operate with the battle fleet, but they became known as the 'Kalamity class' following a spate of accidents, six of them sinking as a result. Only one engaged an enemy vessel, hitting a U-boat with a torpedo that failed to explode.

c.1916

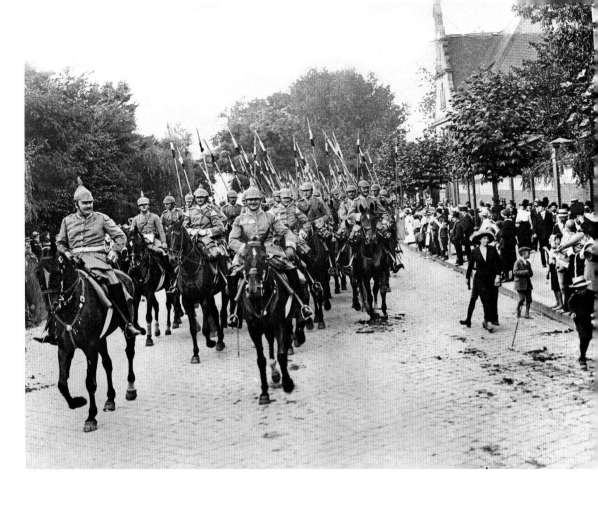

German cavalry on the march. The advent
of trench warfare saw most of Germany's
cavalry regiments redesignated as infantry.
c.1916

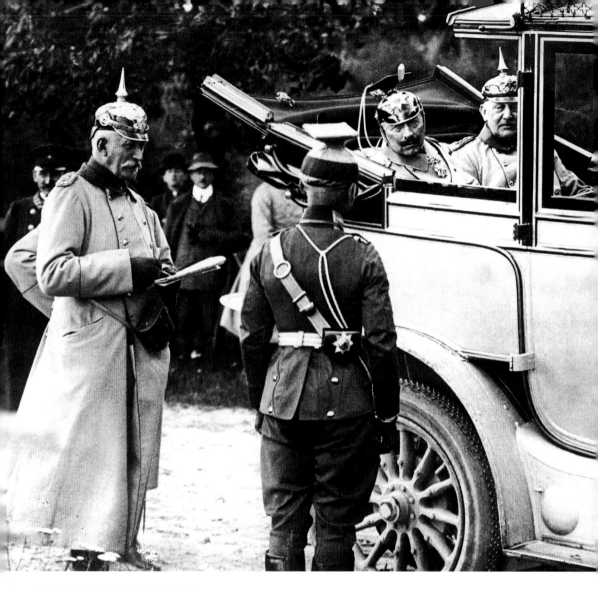

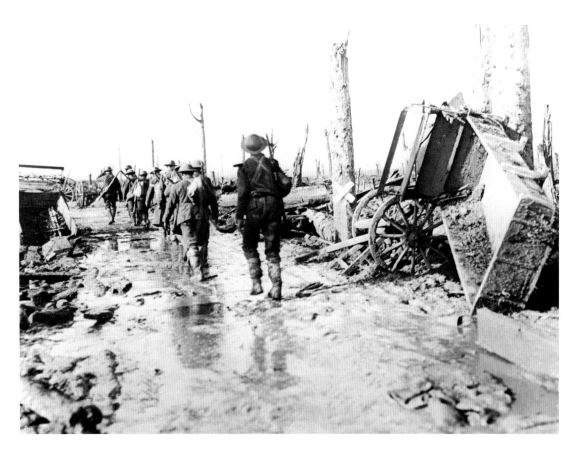

Left: German Kaiser Wilhelm II (second R), seen with General Moltke (R), receives a report from an officer.
**January, 1916**

British troops on the Western Front in France head for the front line, passing through a landscape shattered by war.
**1916**

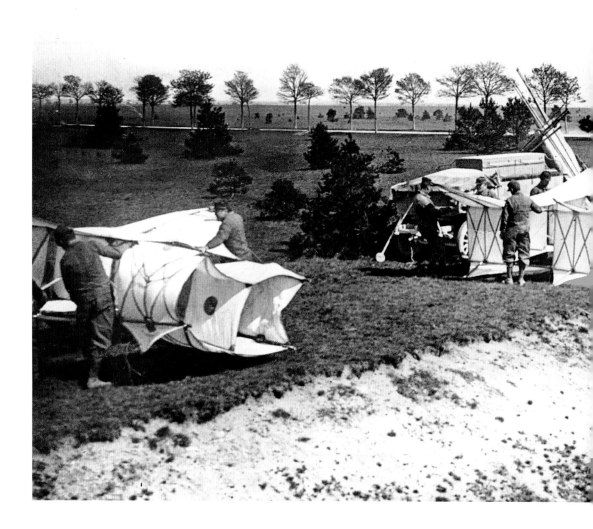

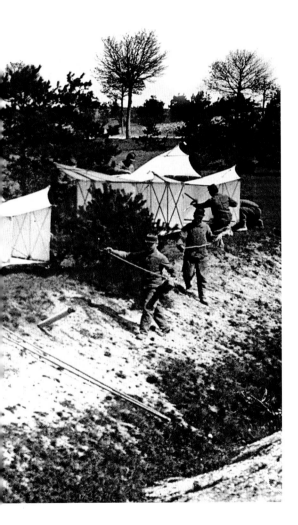

French soldiers prepare observation kites for reconnaisance work over the German lines. The kites were large enough to lift a man several hundred feet into the air, thus providing a good view of enemy activities. Aviation pioneer Samuel Cody had used such a kite to lift a man to a height of 1,600ft. The advent of the aeroplane, which was not restricted to a static position, made such kites redundant.

**22nd March, 1916**

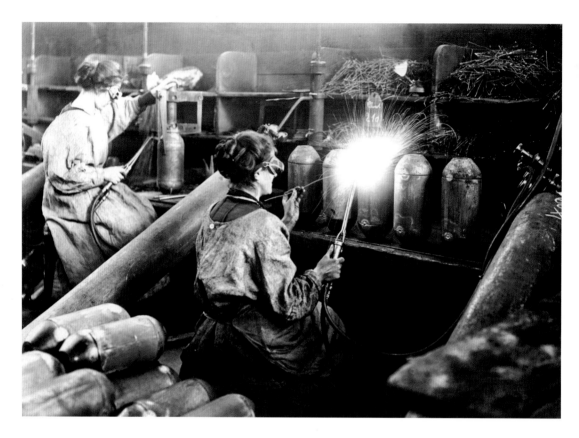

Women workers at a munitions factory manufacture bomb casings. With so many men away in the forces, many vital jobs at home fell to women.
28th March, 1916

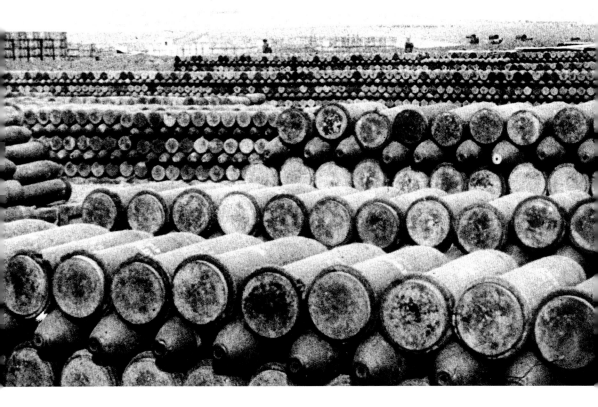

A stockpile of artillery shells at an Allied
supply depot near Salonika in Greece.
1916

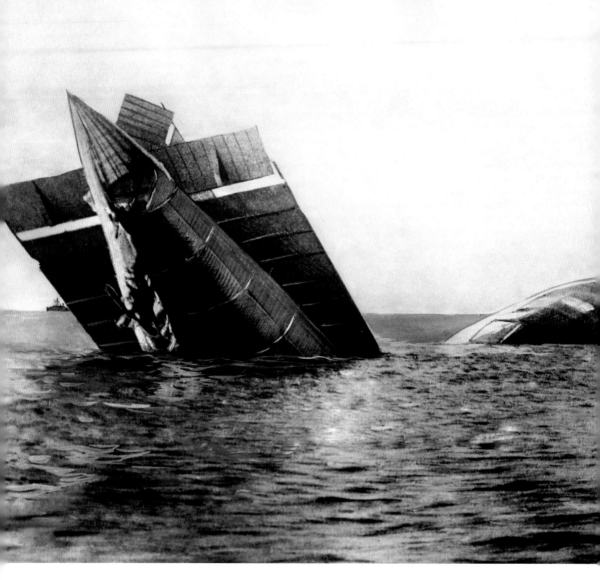

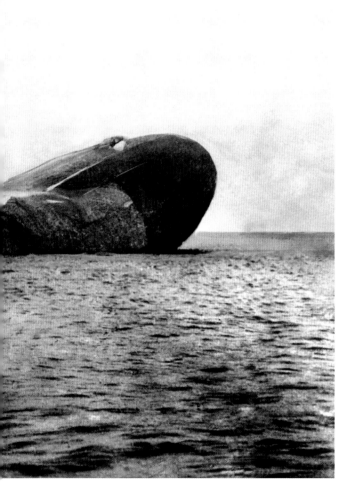

Looking like some strange gigantic sea creature, this German Zeppelin airship was brought down by gunfire and crashed into waters of the Thames estuary. The craft had been one of five that had bombed the east and north-east coasts of England. The entire crew were picked up and taken into captivity by a naval patrol boat. An attempt was made to tow the craft to shore, but it sank before this could be done.

1st April, 1916

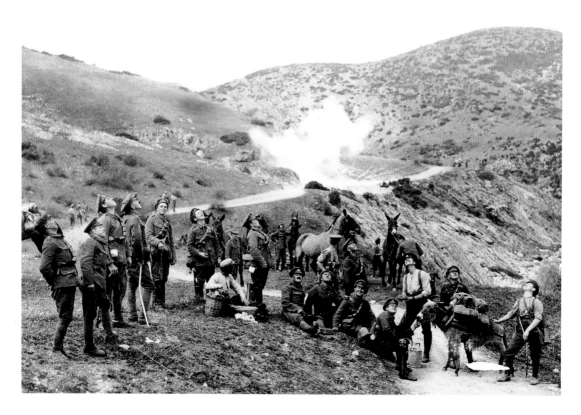

British soldiers watch German aircraft flying overhead and seem unconcerned when a bomb explodes nearby. With no accurate means of aiming bombs, the chances of hitting a target were minimal.
5th May, 1916

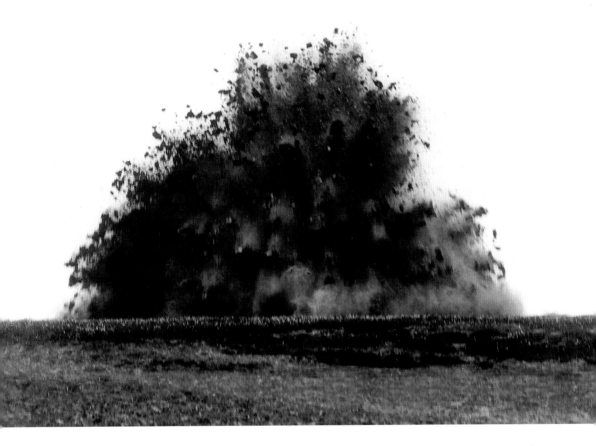

A mine explodes on the Western Front. Both sides employed former miners to dig tunnels beneath their opponent's front lines, where huge amounts of explosive would be stockpiled to be set off immediately prior to an attack. One observer described the explosion of a mine thus: "The ground where I stood gave a mighty convulsion. It rocked and swayed… Then for all the world like a gigantic sponge, the earth rose high in the air to the height of hundreds of feet. Higher and higher it rose, and with a horrible grinding roar the earth settles back upon itself, leaving in its place a mountain of smoke."

25th May, 1916

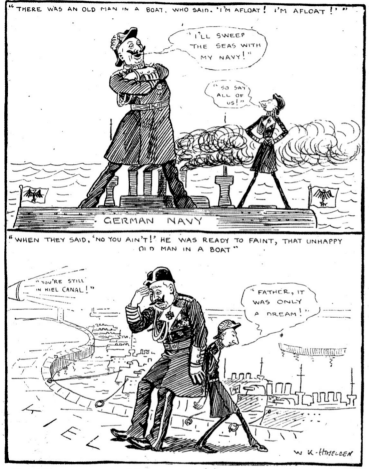

## BIG AND LITTLE WILLIES' NAVAL DREAM.

"THERE WAS AN OLD MAN IN A BOAT, WHO SAID, 'I'M AFLOAT! I'M AFLOAT!'"

"I'LL SWEEP THE SEAS WITH MY NAVY!"

"SO SAY ALL OF US!"

GERMAN NAVY

"WHEN THEY SAID, 'NO YOU AIN'T!' HE WAS READY TO FAINT, THAT UNHAPPY OLD MAN IN A BOAT"

"YOU'RE STILL IN KIEL CANAL!"

"FATHER, IT WAS ONLY A DREAM!"

KIEL

W K·HASELDEN

Big Willie was always fearfully proud of his navy. He used to dream of "sweeping the seas," and all sorts of nice things like that. Little Willie, too, had the loveliest dreams, and he and father just hate finding out that the only seas they can sweep are those of the Kiel Canal. Little Willie thinks the dream was much nicer.

The Battle of Jutland took place on 31st May and 1st June, 1916, between the German High Seas Fleet and British Grand Fleet in the North Sea, off Denmark. The German plan had been to destroy much of the Grand Fleet to break the blockade of Germany, while the British wanted to remove the threat posed by the High Seas Fleet to its merchant fleet. Both sides failed in their objectives, but that did not stop the British press from hailing it as a great victory for the Royal Navy, as indicated by this cartoon.
2nd June, 1916

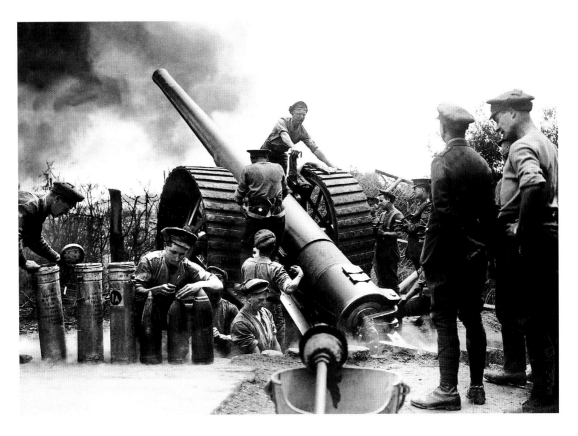

A British six-inch heavy gun fires on the German lines during the build-up to the Battle of the Somme, which would begin on 1st July, 1916 with an Allied attack along both sides of the River Somme in France.

**15th June, 1916.**

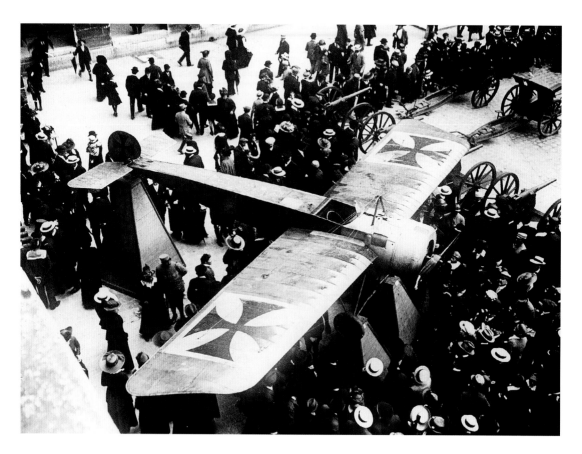

A German Fokker Eindecker shot down by a French airman on display in Paris. The Eindecker was the first fighter with synchronisation gear that allowed the pilot to fire a machine gun through the propeller arc without striking the propeller, making aiming easier. This gave the Germans air superiority from late 1915 to early 1916, a period known to British pilots as the 'Fokker Scourge'.
20th June, 1916

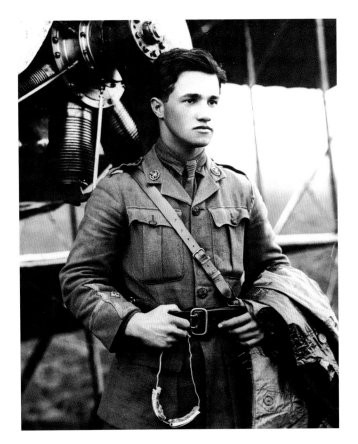

Lieutenant Albert Ball of the Royal Flying Corps, who had downed 44 enemy machines by the time of his death on 7th May, 1917. Preferring to fly alone, he would often attack formations of aircraft, despite being outnumbered. He was awarded the DSO and two bars, and the Military Cross for his achievements. Ball died during combat with Lothar von Richthofen, brother of the famous German ace known as the Red Baron, crashing into a field in France. For his courage, he was awarded the Victoria Cross posthumously. The Germans buried Ball with full military honours.

July, 1916

SUNDAY PICTORIAL, July 2, 1916.

# MR. WINSTON CHURCHILL WRITES IN NEXT ISSUE

# SUNDAY · PICTORIAL

CIRCULATION MORE THAN ONE-MILLION-EIGHT-HUNDRED-THOUSAND COPIES.

No. 69.    Registered at the G.P.O. as a Newspaper.    SUNDAY, JULY 2, 1916.    The Pages with "The Daily Mirror" Behind It.    One Penny.

## THE BIG ADVANCE: "ALL GOES WELL FOR ENGLAND AND FRANCE"

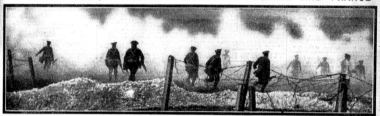

An advance by the British in France after preparing the way with smoke bombs.

One of the great guns firing on the German trenches.

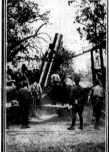
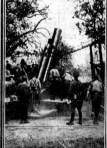

Our boys after the advance at St. Eloi.

A heavy British howitzer in action in the West.

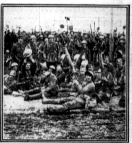

The "Fighting Fifth" after taking the German positions.

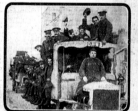

A British big gun in action during a big bombardment.

British troops hurrying up to the firing-line in motor-cars.

The nation was thrilled yesterday to hear that the Great British offensive on the western front had begun at last. Sixteen miles of German front trenches have been captured by our gallant soldiers to the north of the River Somme. Many prisoners have been taken. The French are also attacking with great success, while the terrible bombardment of the German trenches by the British artillery continues unabated. Thus it may be said that the great British offensive, for which we have waited so long, has started well. The photographs above illustrate incidents in previous British advances against the German lines in France and Flanders.

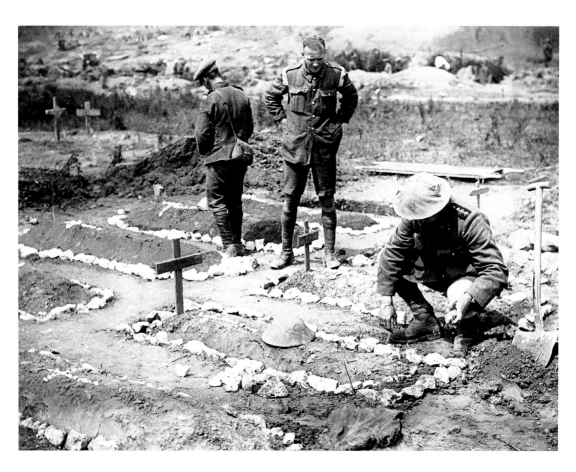

Left: The *Sunday Pictorial* announces progress in the Battle of the Somme, which would become one of the war's bloodiest battles. 2nd July, 1916.

An Army chaplain tends the grave of a British soldier who had been killed during the Battle of the Somme. 29th July, 1916

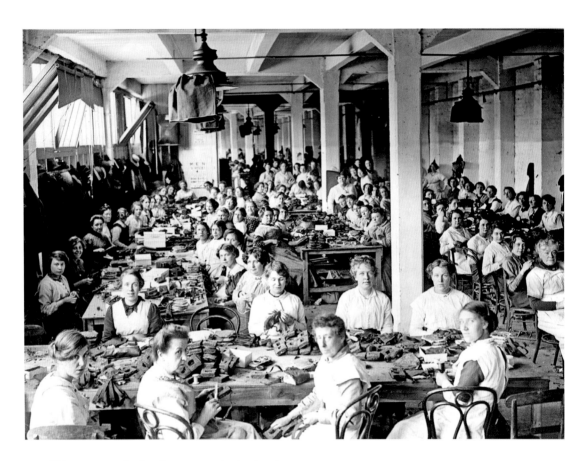

Women work in the converted stands
of Tottenham Hotspur football ground in
London, making gas masks, helmets and
other protective equipment for the troops.
3rd July, 1916

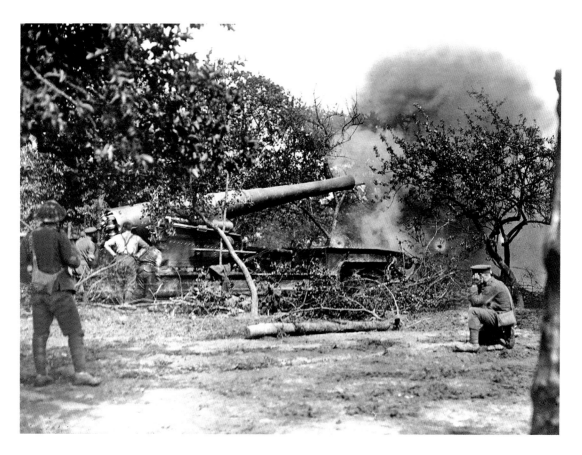

Hidden among trees, a British heavy artillery piece bombards German positions during the Battle of the Somme.
8th July, 1916

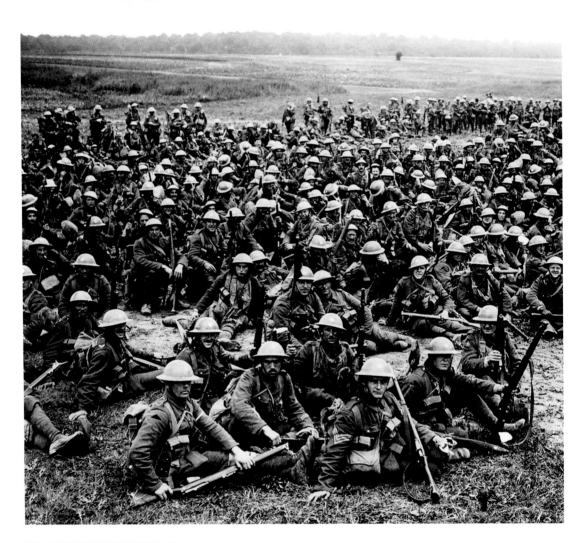

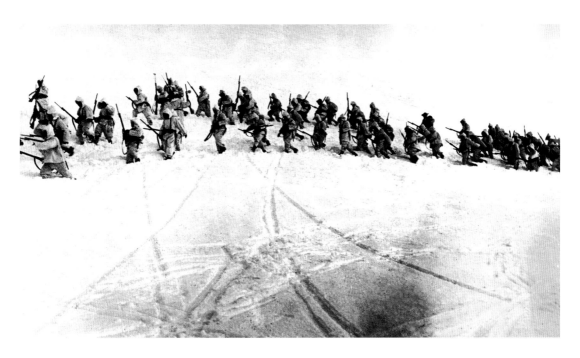

Left: Men of the Worcester Regiment rest prior to going into the line during the Battle of the Somme. Troops from this regiment were the first to carry out a trench raid in January, 1915, involving hand-to-hand fighting to clear out an opposing German trench. Nine VC winners came from the regiment.
14th July, 1916

Italian troops advance across a snowfield high in the mountains of the Isonzo district. A series of 12 battles took place in this region between the Austro-Hungarian and Italian armies, beginning in June, 1915 and ending in November, 1917. The Italians were seeking to strike into Austria and threaten Vienna, but they never succeeded in breaking their opponents' defence.
1916

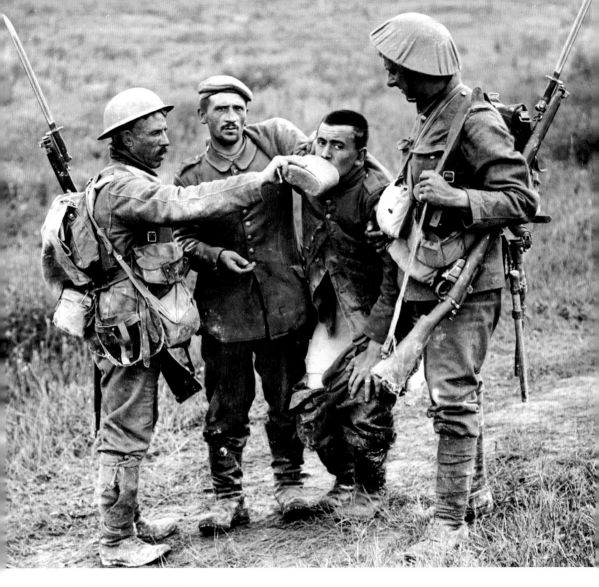

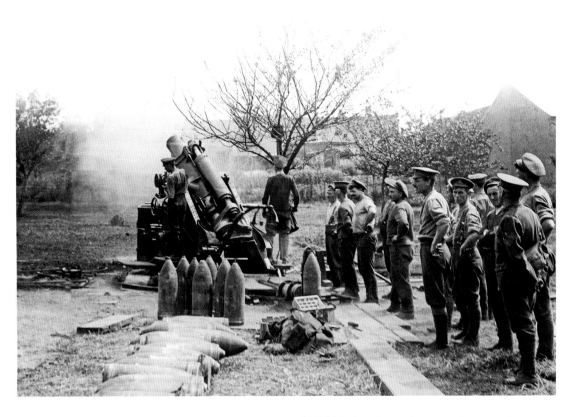

Left: A British soldier gives a wounded German prisoner a drink from his canteen.
17th July, 1916

A British howitzer fires on German lines during the Battle of the Somme. The steep trajectory of howitzer shells allowed them to be fired over intervening obstacles.
25th July, 1916

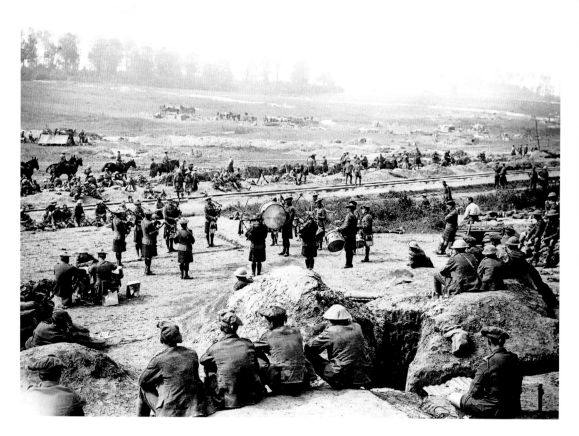

The band of the Black Watch entertains Scottish troops who were celebrating the capture of Longueval village during the Battle of the Somme.
28th July, 1916

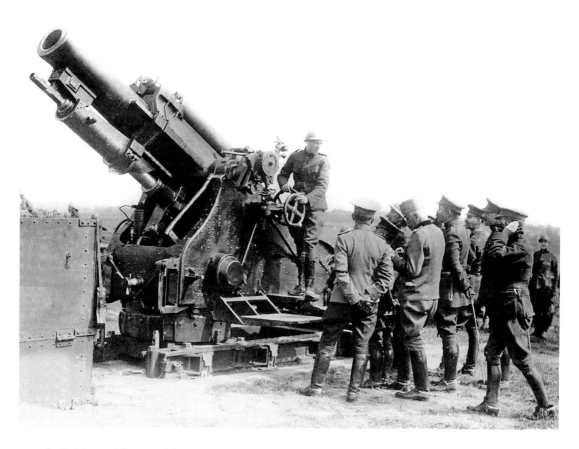

A Belgian soldier explains the finer points of a 210mm howitzer to a group of officers. Massive guns of this type had to be transported in pieces and assembled on site.
**30th July, 1916**

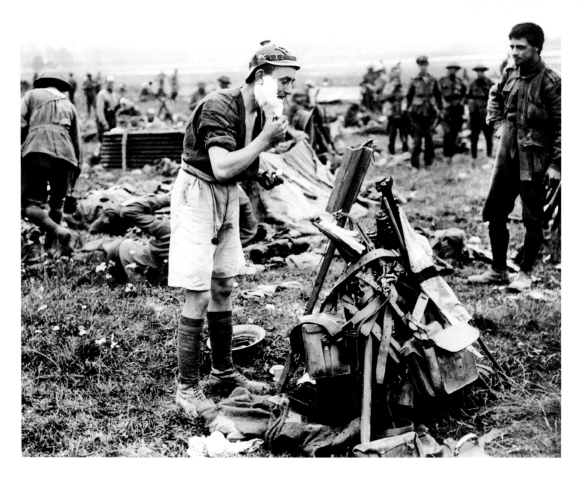

Wearing a captured German helmet, an Anzac soldier shaves off three days' beard growth after a spell in the trenches.
2nd August, 1916

Right: A British chaplain notes down the names of soldiers wounded during the Battle of the Somme.
7th August, 1916

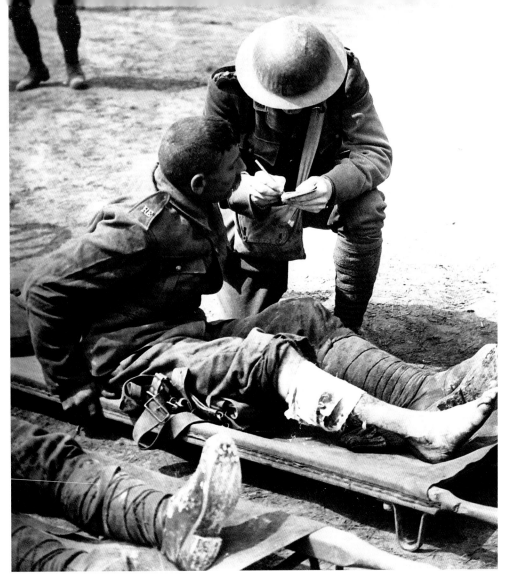

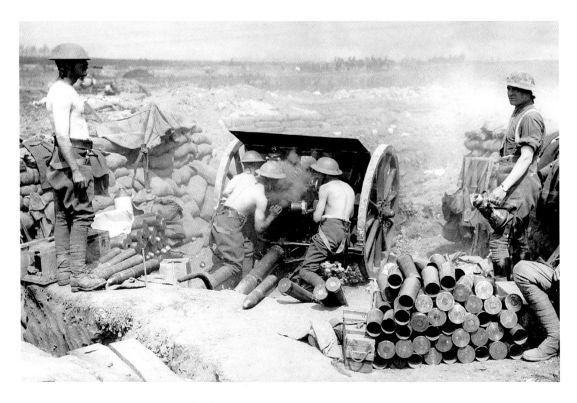

In the heat of summer, light field artillery pounds the German lines in support of a British advance on the Western Front.
8th August, 1916

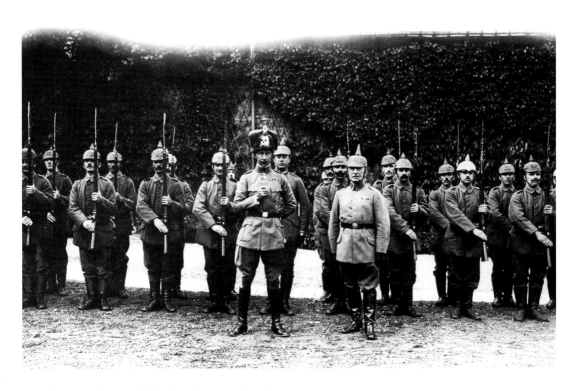

Crown Prince Wilhelm (centre L), the commander of the German Fifth Army and son of Kaiser Wilhelm II, poses with some of his troops during the Battle of Verdun.
1916

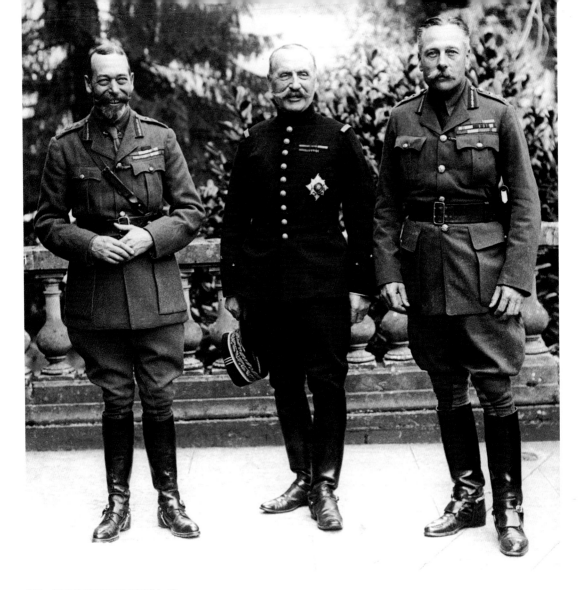

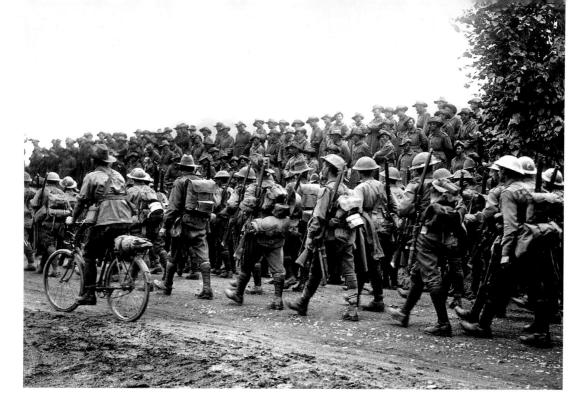

Left: King George V (L), General Ferdinand Foch (C) and Sir Douglas Haig at General Haig's headquarters at Beauquesne in France. Haig was commander in chief of the British Expeditionary Force from 1915 until the end of the war, while Foch was chief of the French general staff.

**12th August, 1916**

Australian soldiers return to the trenches on the Somme after a spell out of the line. Over a period of 42 days during the Somme Offensive, the Australians made 19 attacks against the German front line, 16 at night. They suffered 23,000 casualties, including 6,800 killed.

**29th August, 1916**

A group of Belgian soldiers provides entertainment for the troops by performing as a Corps de Ballet.
September, 1916

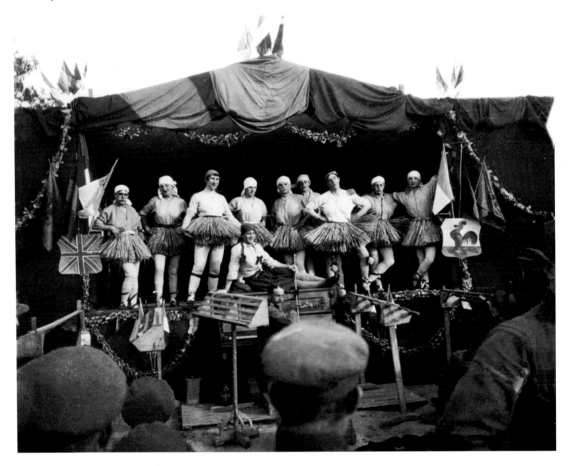

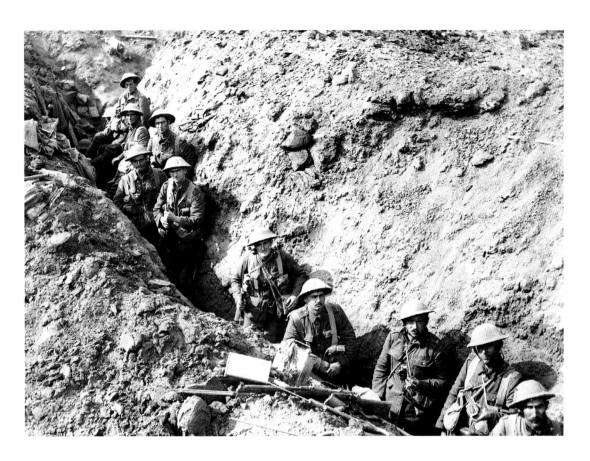

Soldiers from New Zealand relax in a reserve trench during a lull in the fighting. As a rule, men would spend a few days in the trenches at a time, then rest for a few days before returning.

September, 1916

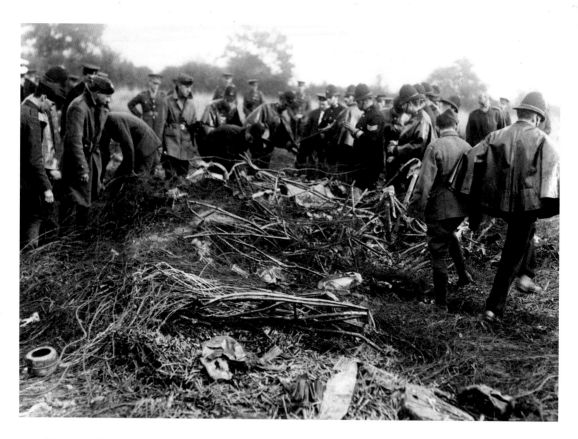

The wreckage of a German airship brought down in Cuffley, Hertfordshire. The machine had been on a bombing raid over London, but was shot down by Lieutenant William Robinson of 39 Squadron, RFC, with the aid of a new type of incendiary ammunition.
**4th September, 1916**

Right: The traces of star shells and an artillery barrage can be seen over the Somme battlefield in this time-lapse photograph.
**10th September, 1916**

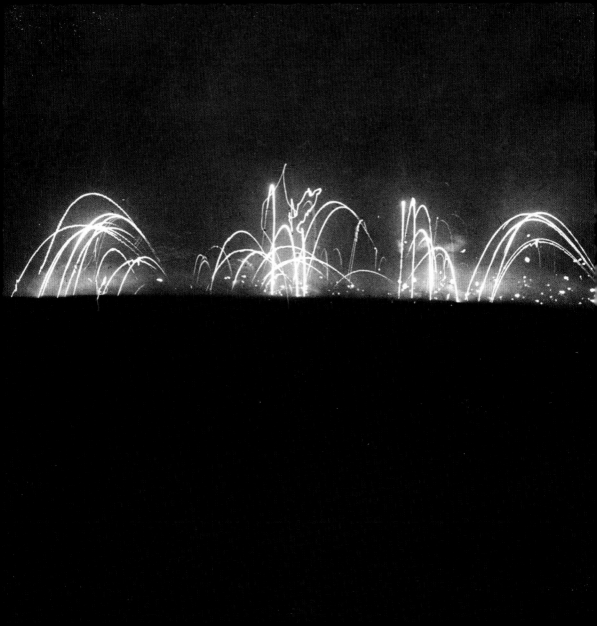

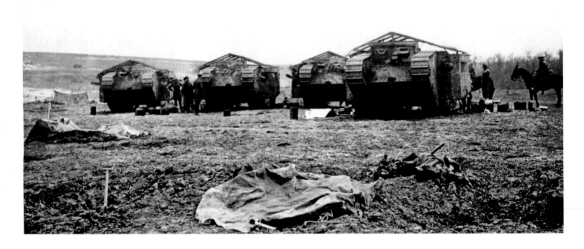

British Mark I tanks are prepared to go into action for the first time at the Battle of Flers-Courcelette during the Somme Offensive. Forty-nine of the machines were assembled for the attack on the German lines, but their crews were inexperienced and they were beset with mechanical problems as well as the difficulty of crossing the churned-up terrain of the battlefield. Only nine actually penetrated the German lines, but they conferred a great psychological advantage to the troops around them. By the end of the war, the tank would be developed into a fomidable weapon.

15th September, 1916

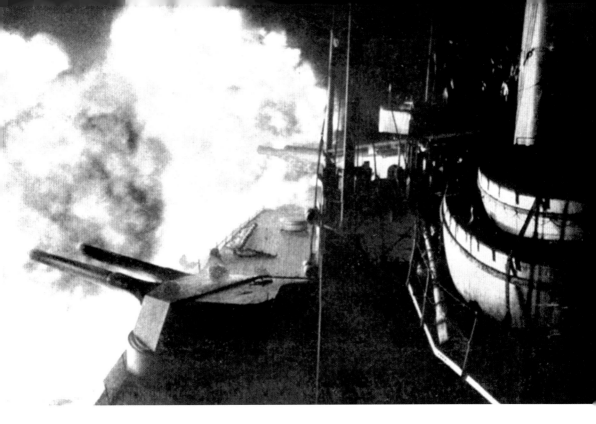

A broadside is delivered by the main 12-inch guns of HMS *Hercules*, lighting up the night. The Colossus-class battleship had been built in 1910 and had taken part in the Battle of Jutland, narrowly avoiding being torpedoed.
**October, 1916**

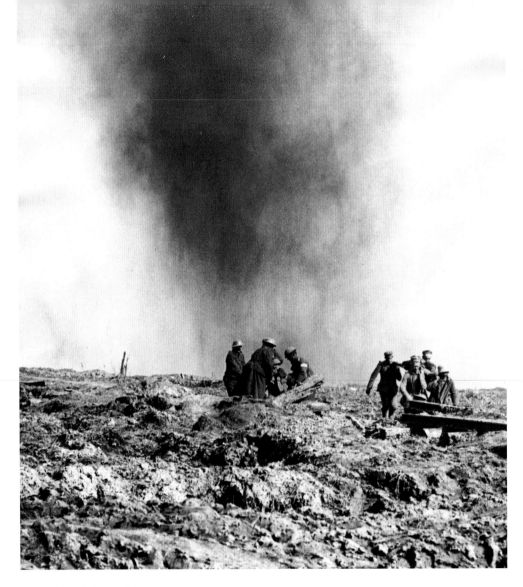

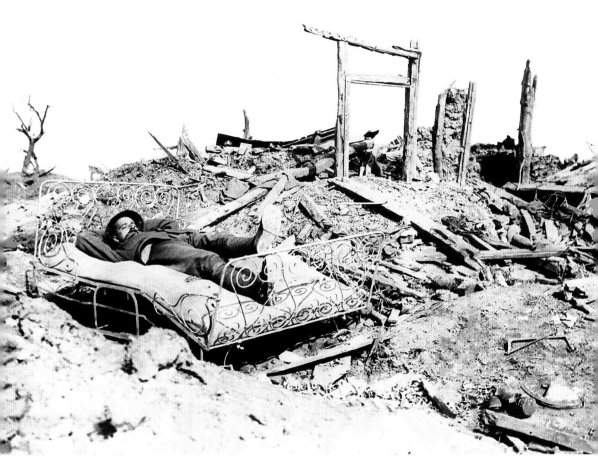

Left: British stretcher bearers rescue wounded soldiers from 'no man's land' while under fire.
5th October, 1916

A British soldier takes a nap on a bed found among the ruins of a French house.
9th October, 1916

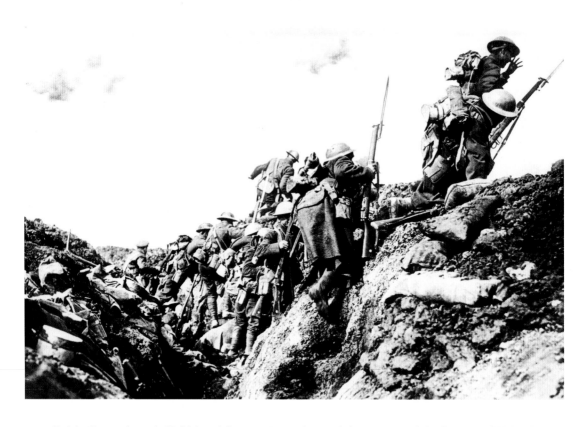

Originally captioned, "British soldiers go 'over the top' from a trench in France, 1916," this image was taken by Canadian official photographer Ivor Castle and widely published as a portrayal of a British attack. However, it was actually taken during a training exercise by Canadian troops near St Pol, France. The breech cover on the rifle of the soldier in the foreground had been edited out and the retoucher had added the shell bursts in the sky. After it was discovered that the image had been staged, Castle was recalled to London.

**October, 1916**

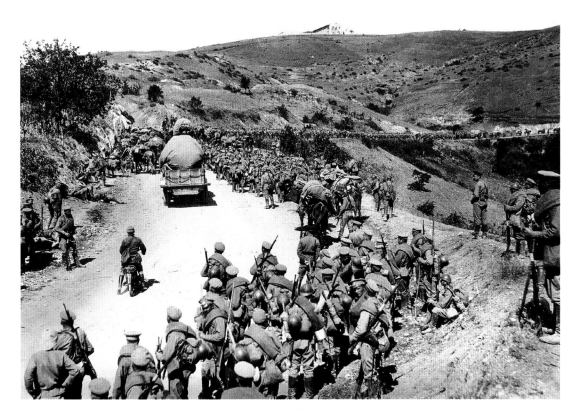

Russian troops march towards the front line near Salonika in Greece. They were part of a multi-national Allied force sent to the aid of Serbia, under attack by Austria-Hungary, Germany and Bulgaria. The other Allied nations involved were Britain, France, Italy and Greece.

14th October, 1916

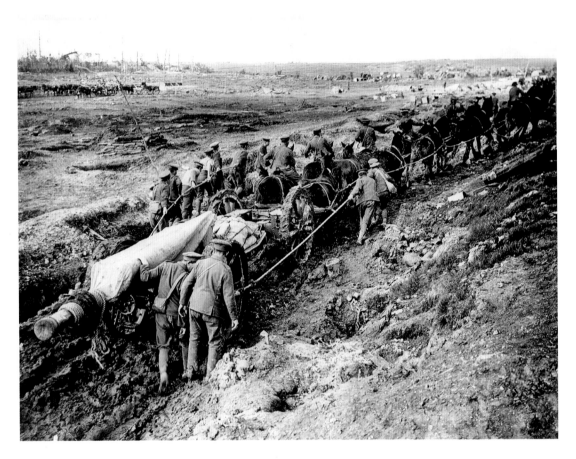

Men of the Royal Garrison Artillery reposition a large-calibre artillery piece with a 12-horse team during the latter part of the Battle of the Somme. The RGA had originally been given the task of manning the guns of British forts around the world, but in the First World War it provided the heavy artillery support for the Army in the field.

20th October, 1916

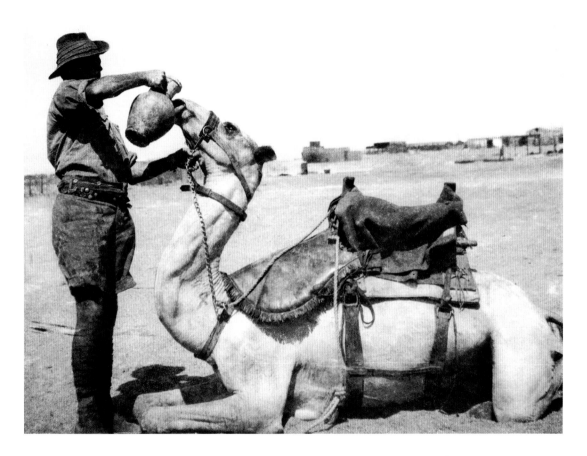

An Australian soldier of the Imperial Camel Corps gives his camel a drink of water. The corps acted as mounted infantry and comprised four battalions: one British, one New Zealand and two Australian. The fought in several campaigns in the Middle East as part of the Egyptian Expeditionary Force.

**4th November, 1916**

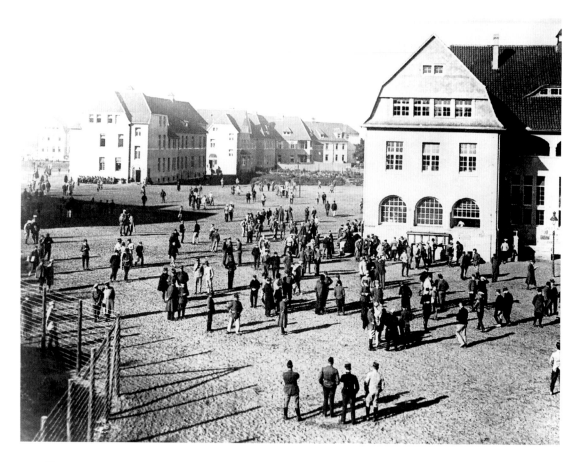

The Gütersloh prisoner-of-war camp in Westphalia, Germany. The camp, originally a sanatorium, housed Allied officers only. Life was reasonably comfortable – they were not required to work – but it could be tedious. They filled their time with sport, concerts, plays, lectures, debates and reading.

**23rd November, 1916**

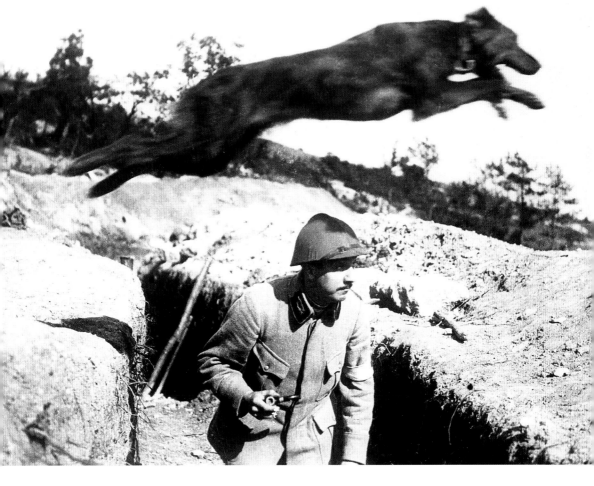

A French Army dispatch dog jumps over a soldier in the trenches as it leaves with a message tied to its collar. Dogs were used for this purpose by both sides in the war. They were quicker than a human, were a smaller target for snipers and could cross any terrain.
**23rd November, 1916**

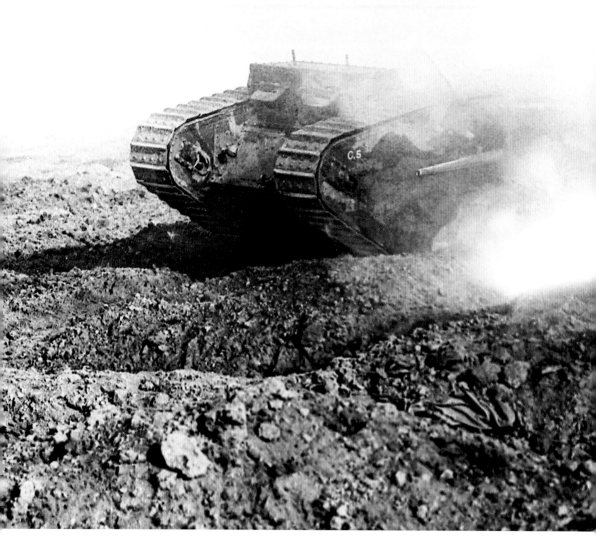

A British Mark I tank in action on the Western Front. Tanks were conceived as land 'battleships' and as a means of overcoming trenches and machine guns on the battlefield.

**23rd November, 1916**

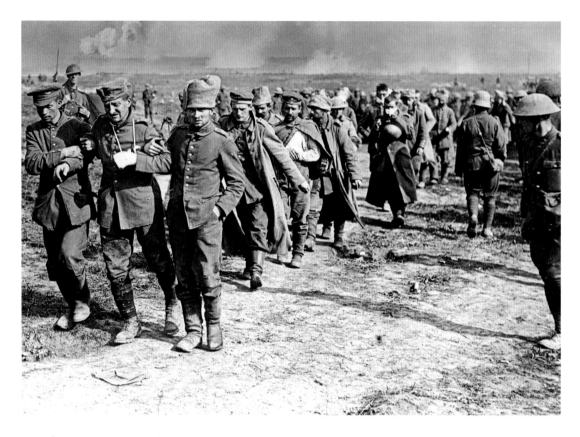

German prisoners of war help their injured
comrades as they are watched over by British
troops while the battle continues to rage in
the distance.
**9th December, 1916**

Right: British soldiers aboard a French railway
wagon wrecked by shellfire.
**18th December, 1916**

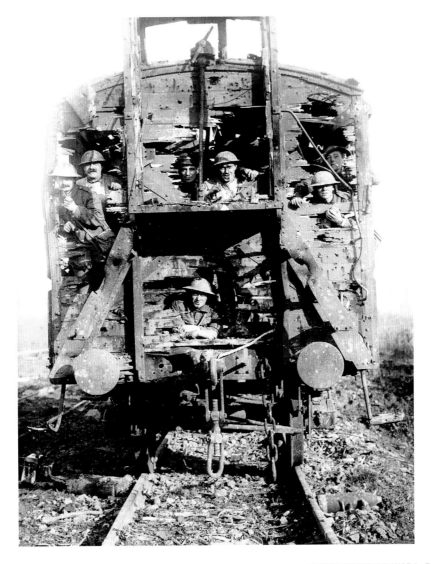

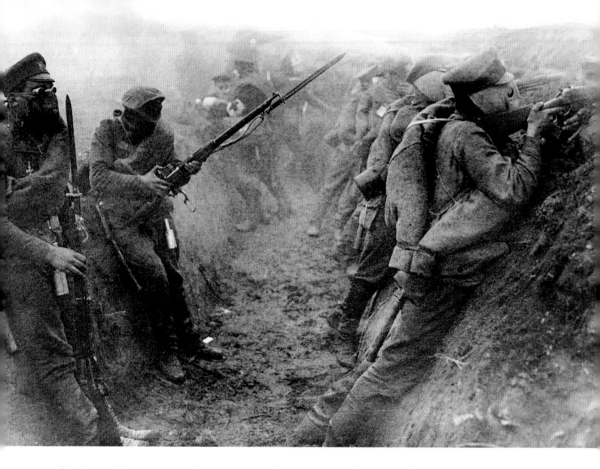

Russian soldiers prepare for a gas attack by wearing rudimentary fabric gas masks. They are equipped with American Winchester M1895 rifles, developed from the famous repeating rifle used in the American West during the late 19th century.

28th December, 1916

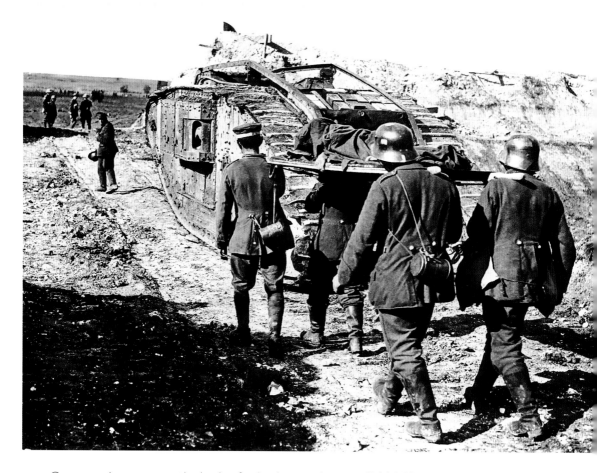

German prisoners carry the body of a dead comrade past a British Mark IV tank. The rails on the roof of the tank were designed to carry a large beam of wood, which could be attached to the tracks with chains to provide extra grip if the tank became stuck.

c.1917

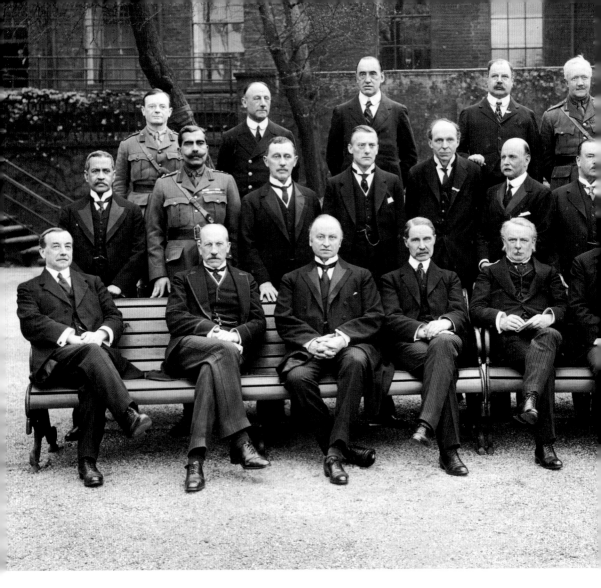

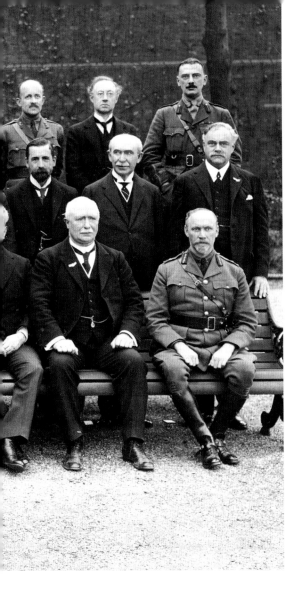

Britain's Imperial War Cabinet. Back row (L–R): Captain L.S. Amery, Admiral Sir John Jellicoe, Sir Edward Carson, Lord Derby, Major General F.B. Maurice, Lieutenant Colonel Sir M. Hankey, Henry Lambert, Major Storr. Middle row: Sir S.P. Sinha, the Maharajah of Bikanir, Sir James Meston, Austen Chamberlain, Lord Robert Cecil, Walter H. Long, Sir Joseph Ward, Sir George Perley, Robert Rogers, J.D. Hazen. Front row: Arthur Henderson, Lord Milner, Lord Curzon, Bonar Law, David Lloyd George, Sir Robert Borden, W.F. Massey, General Jan C. Smuts.
1917

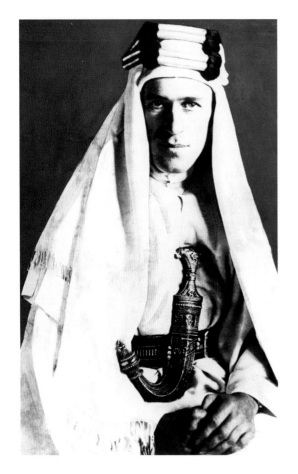

Lieutenant Colonel Thomas Edward Lawrence, an Army officer sent by the British to foment the Arab revolt against Ottoman Turkish rule on the Arabian Peninsula between 1916 and 1918. Popularly known as Lawrence of Arabia, he persuaded the Arab leaders to co-ordinate their actions in support of British strategy in the region, tying up large numbers of Ottoman troops.

1917

French guns light up the night sky as they pound the German lines.
**23rd February, 1917**

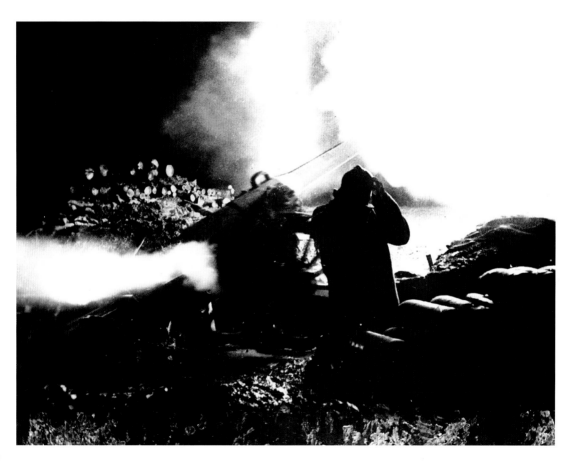

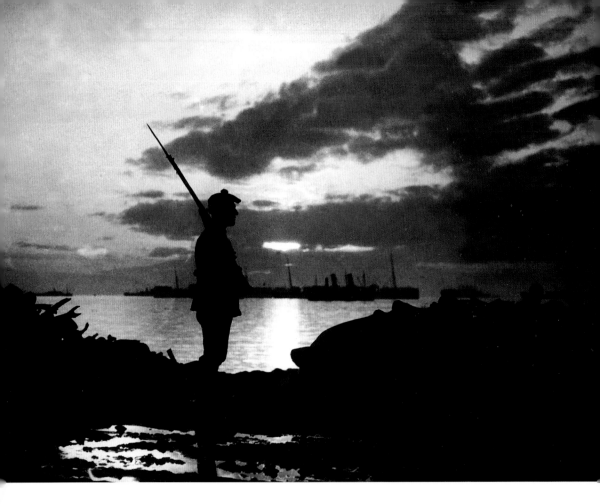

A Scottish sentry is silhouetted against the evening sky while guarding stores near Salonika in Greece.
**28th February, 1917**

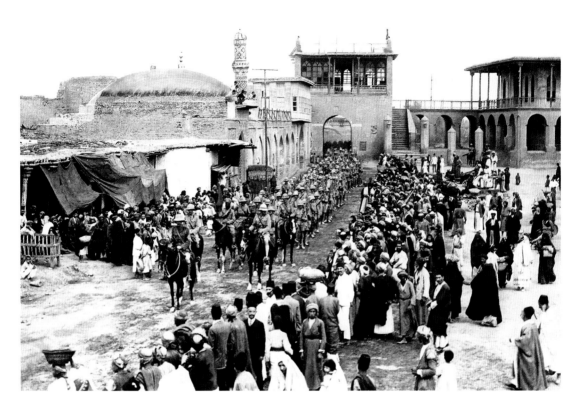

British troops under General Frederick Stanley Maude enter Baghdad in Iraq after a two-year campaign to capture the city from Ottoman forces. They took the city without a fight and were greeted enthusiastically by the residents. Maude announced that his army had not come as conquerors or enemies, but rather as liberators.

11th March, 1917

British Army officers cook a stew in an old steel helmet on the Western Front.
**21st March, 1917**

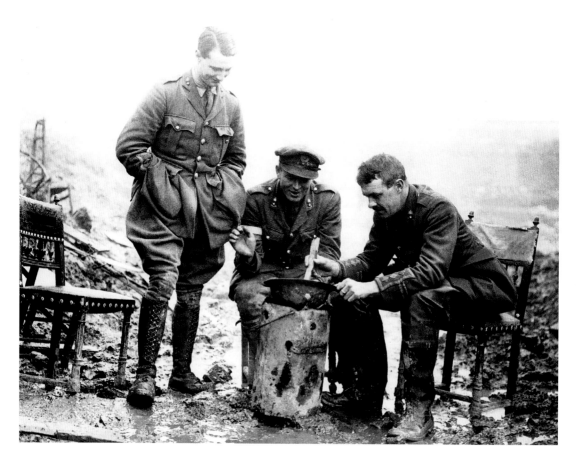

## A FEW SUGGESTIONS FOR TANKS.

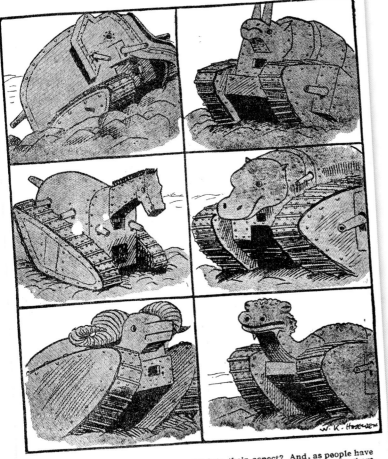

Could not " frightfulness " be brought into their aspect? And, as people have suggested the employment of fierce animals in the war, why not conciliate them by at least an appearance of this sort?

A newspaper cartoon suggesting how tanks might be used to strike additional fear into the enemy by giving them the appearance of frightening animals.
1917

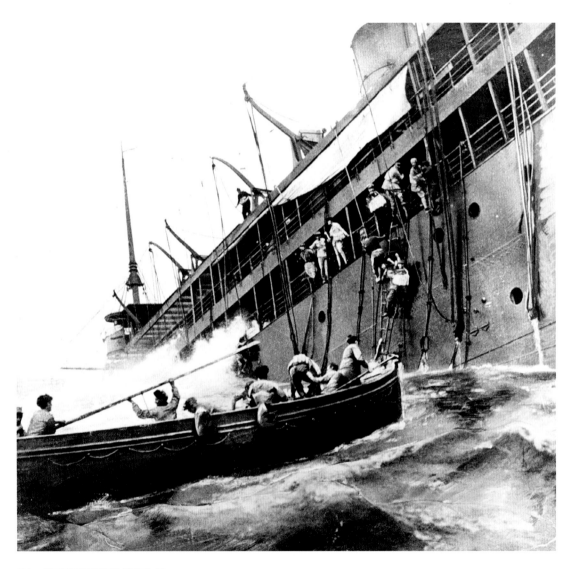

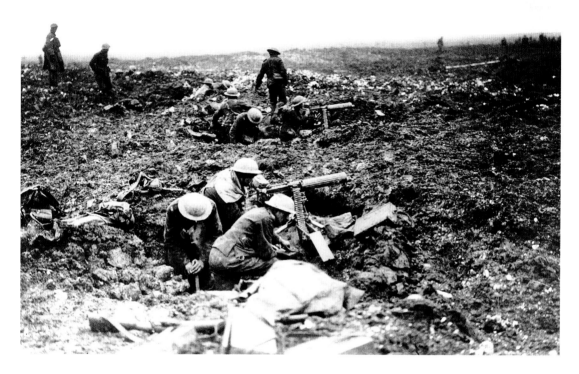

Left: A retouched photograph showing the sinking of the French steamer *Sontay*, torpedoed by a German U-boat in the Mediterranean, south-east of Malta. Forty-nine men were lost, including the captain.
**16th April, 1917**

Canadian machine gunners take over shell holes during the Battle of Vimy Ridge in France. Over the course of three days, the Canadians overcame substantial German resistance to capture the ridge.
**April, 1917**

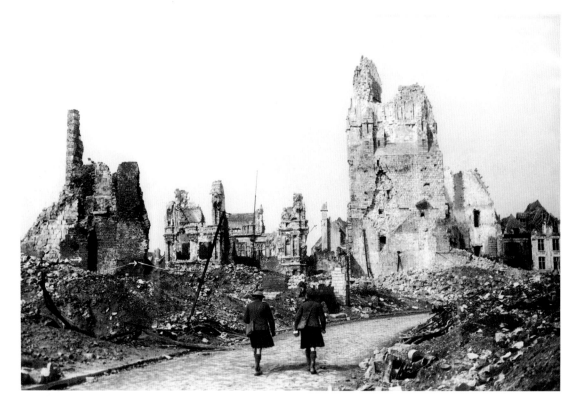

Scottish soldiers walk past the remains of the Hotel de Ville in the town of Arras, France. The Battle of Arras, which lasted from 9th April to 15th May, 1917, was part of a plan to break the stalemate of trench warfare and draw the German Army into a war of movement. It was hoped to end the war in 48 hours. Although significant advances were made, there was no breakthrough and stalemate returned.

May, 1917

Lady Hawbury Williams, Lady MaCready, Lady French, Lady Murray, Mrs Solates, Mrs Milne and Lady Allumby set off with their flag trays to raise war funds.
**3rd May, 1917**

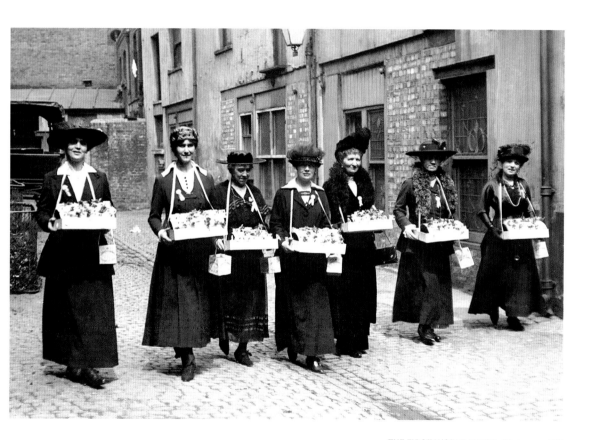

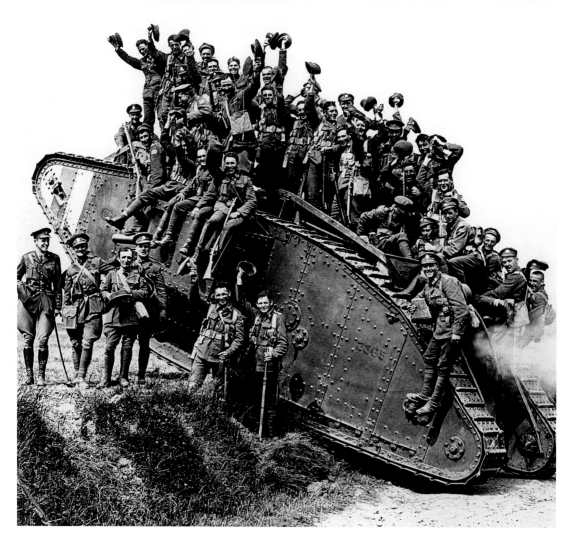

Right: British commander in chief Earl Haig (R) with General Arthur Currie during a visit to Canadian troops in France. Popularly known as 'Guts and Gaiters', Currie was the first Canadian to attain the rank of general, having risen through the ranks from the lowly position of gunner. He was also the first Canadian commander of the unified Canadian Corps during the First World War. Cool under fire, he was never afraid to question his orders or suggest alternative strategies. He was one of the most capable commanders on the Western Front.

c.1917

Left: Canadian troops on a training exercise find another use for a tank.

c.1917

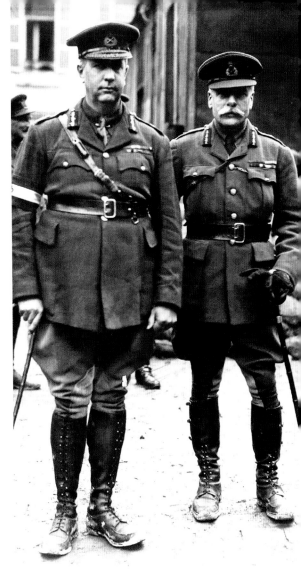

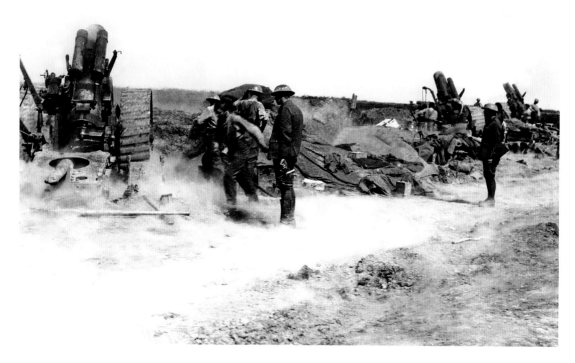

British howitzers open fire on the German front lines on the first day of the Battle of Messines. The attack targeted the Messines Ridge, a natural strongpoint near the Belgian town of Ypres. The offensive began with the explosion of 19 mines beneath the German lines, which killed 10,000 men and could be heard in London. Two mines were not detonated: one exploded in 1955, killing a cow; the other remains undetected, its precise location having been lost.
7th June, 1917

An Australian infantry officer watches the German lines through a periscope during the Battle of Messines in Belgium.
June, 1917

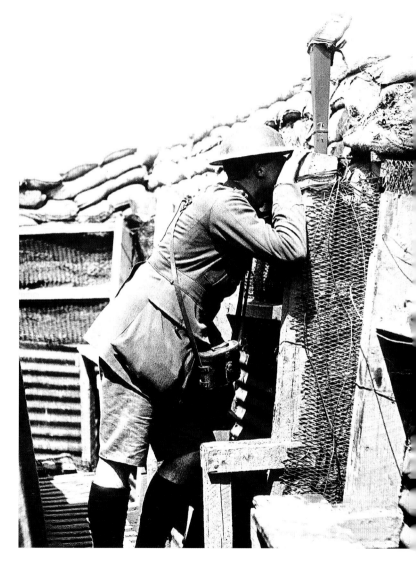

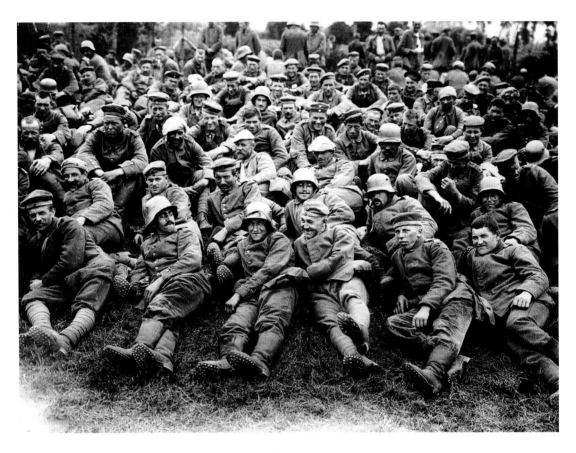

German prisoners taken during the Battle of
Messines in France. Most appear to be quite
happy, probably glad to be out of the horror
of the trenches.
June, 1917

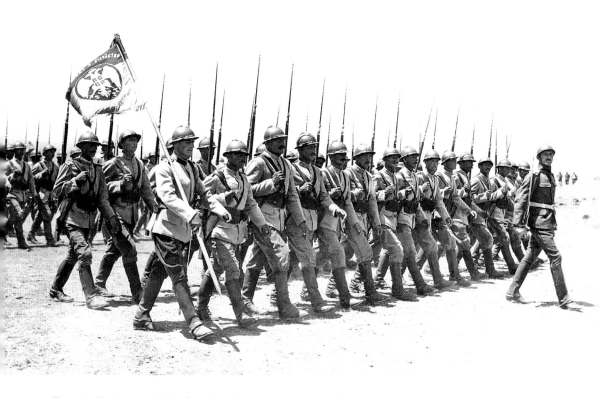

The 1st Regiment of the Serbian Army on parade in Salonika, Greece. These men were the remnants of the Army who had managed to escape when Serbia had been overwhelmed by the Central Powers' attack in 1915. However, with British and French support, they would eventually liberate their country two weeks before the end of the war in November 1918.
10th June, 1917

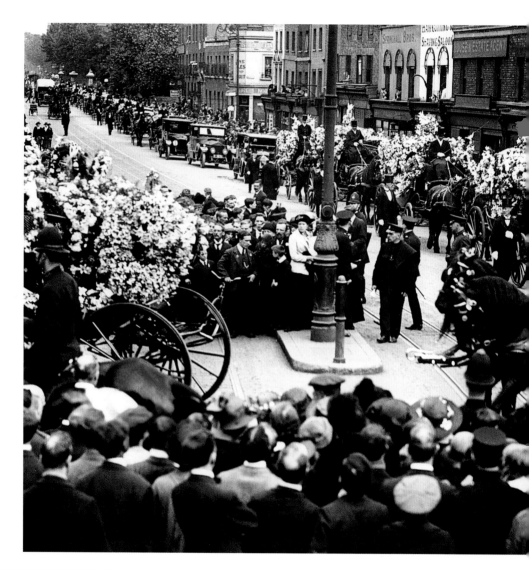

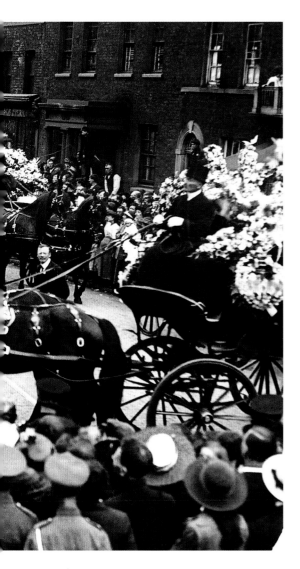

A procession of horse-drawn hearses carries schoolchildren killed during the first German daylight air raid over London. The raid had been carried out by 14 Gotha long-range, heavy bombers on 13th June, 1917, and had killed 104 people, including 16 five- and six-year-olds, in London's East End. Their deaths prompted an outpouring of grief throughout the area, and huge numbers of people turned out to watch the courtege pass on its way to the mass funeral at Poplar Parish Church.

**20th June, 1917**

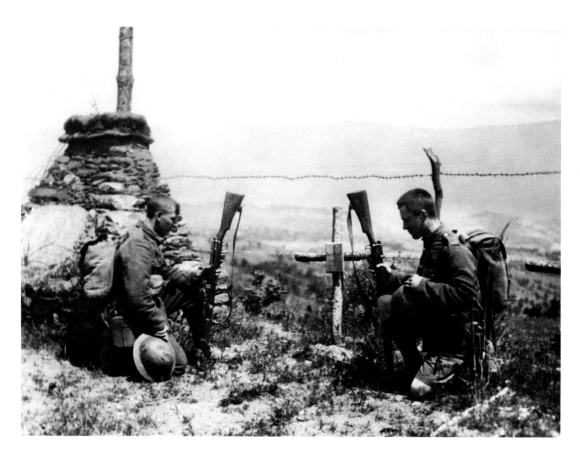

Two British soldiers pay their respects at the grave of a fallen comrade at a temporary grave site on the Salonika front in Greece.
**25th June, 1917**

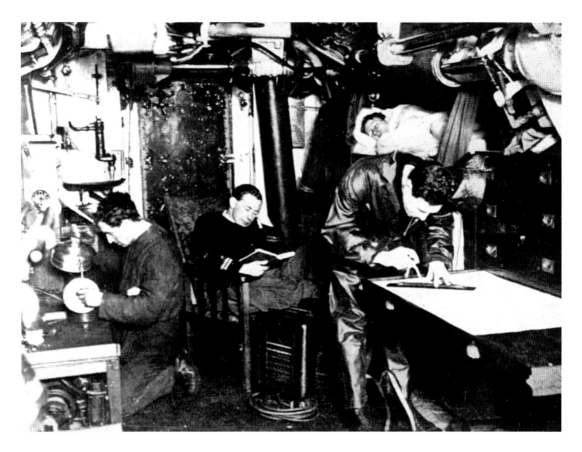

The cramped confines of the ward room of Royal Navy submarine *E34*. Lieutenant Pulleyne, the captain (second L), reads while the navigator plots a course and another officer takes his turn in the only bunk. E-series boats were the mainstay of the British submarine fleet. *E34* would sink the German U-boat *UB-16* in May, 1918, off Harwich, but she would strike a mine two months later off Texel, Holland, and sink with the loss of all hands.
July, 1917

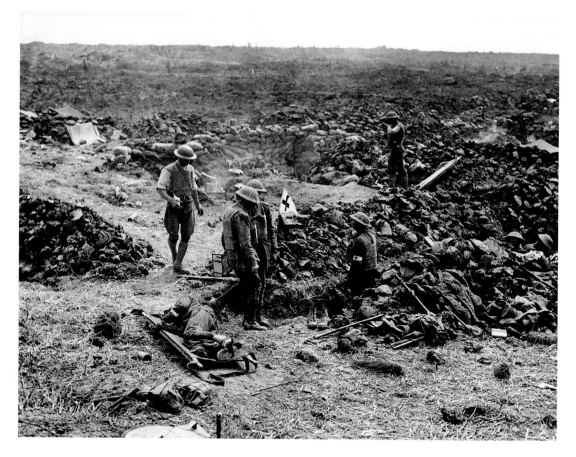

A British Army dressing station at Messines Ridge in Belgium, where wounded soldiers would be assessed and treated before being sent back to hospital.
31st July, 1917

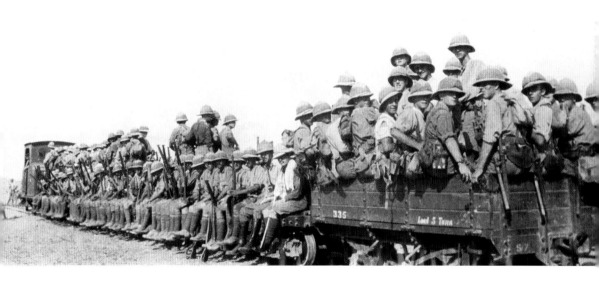

British troops in Palestine are transported to the front line on a narrow-gauge railway. Both sides used these light railways for hauling supplies, equipment and men to and from the front. They could be constructed quickly and easily. After the war, surplus equipment led to a boom in narrow-gauge railways for civilian use.

August, 1917

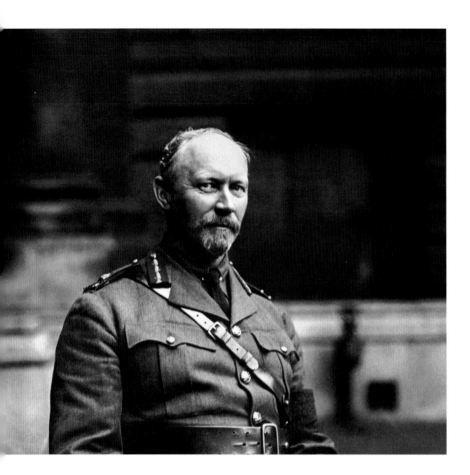

General Jan Christiaan Smuts, who led South African forces in the capture of German South-West Africa in 1915, then commanded the British forces fighting the Germans in East Africa.
c.1917

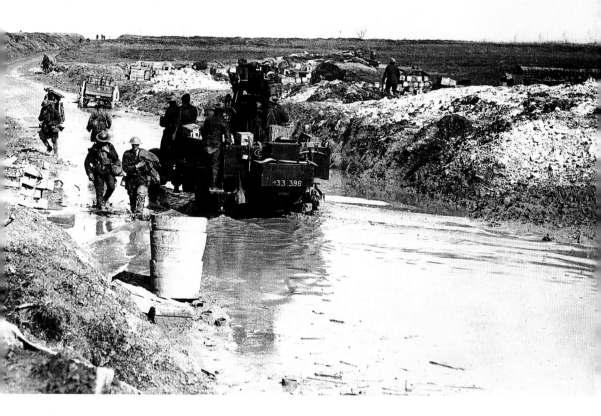

A mobile anti-aircraft gun is driven along a flooded road beside an ammunition dump near Ypres in Belgium. Most guns of this type used by the British Army were converted from 18-pounder field guns and mounted on lorries. Very few actually shot down an aircraft, but they were very effective in denying airspace to enemy machines.
6th August, 1917

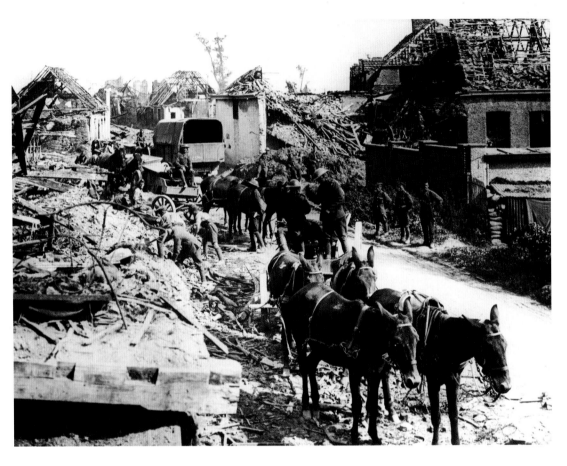

British Army sappers clear a road for transport in Flanders following a German barrage. Mule teams were invaluable for heavy haulage. They had greater stamina than horses and endured front-line conditions far better.

**September, 1917**

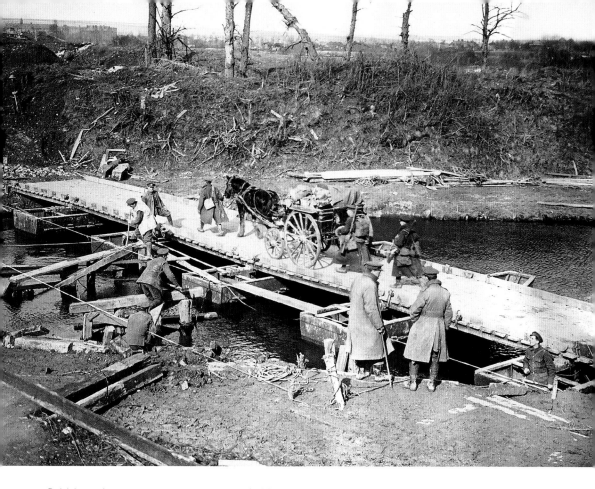

British engineers construct a pontoon bridge near Boesinghe in Belgium. The Royal Engineers had to be prepared to build a variety of bridges to cross both water and land obstacles during the war. They could even be called upon to carry out the work under fire.
**September, 1917**

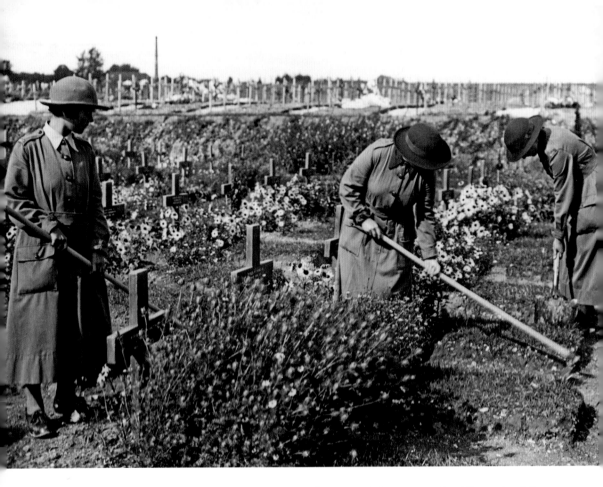

Gardeners from the Women's Army Auxiliary Corps tend the graves of soldiers who fell on the Western Front. The WAAC was formed in July, 1917, with the aim of releasing more men for the front; many were sent to France. There were four units within the corps: Cookery, Mechanical, Clerical and Miscellaneous. The WAAC was disbanded in 1921.
27th September, 1917

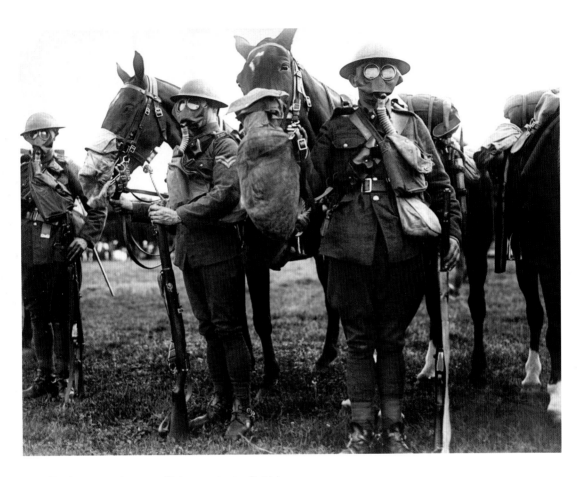

During an Army efficiency test, British cavalrymen and their horses demonstrate anti-gas measures.
**28th September, 1917**

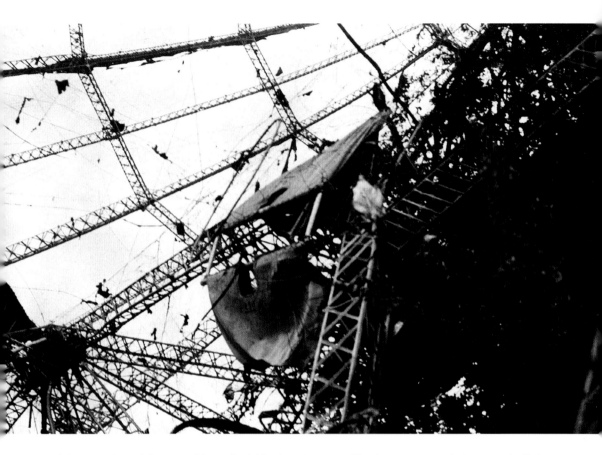

The remains of German Zeppelin *L48*, shot down at Therberton, near Leiston in Suffolk, by Captain Robert Saundby and Lieutenant Loudon Watkins of 37 Squadron, RFC, after bombing Harwich. Three of the crew managed to escape, but the remainder perished in the resulting fire, among them Viktor Schütze, deputy commander of the German Naval Airship Service.
18th June, 1917

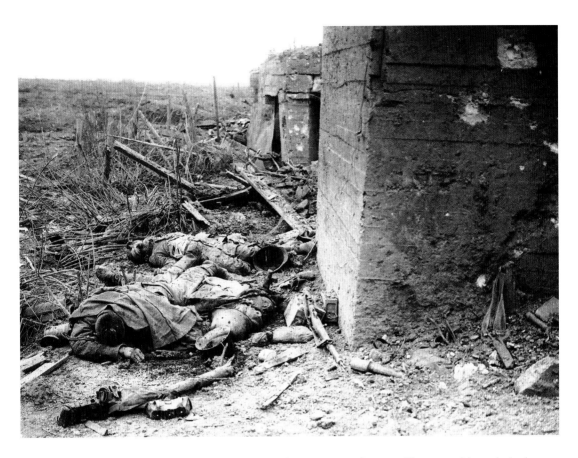

The bodies of German soldiers shot while trying to escape from a pillbox near Zonnebeke in Belgium. They had died during the Battle of Broodseinde, which was part of the British push to gain the ridge that ran through Passchendaele village. Australians and New Zealanders had borne the brunt of fighting in that sector, encountering stiff opposition from the pillboxes.
**6th October, 1917**

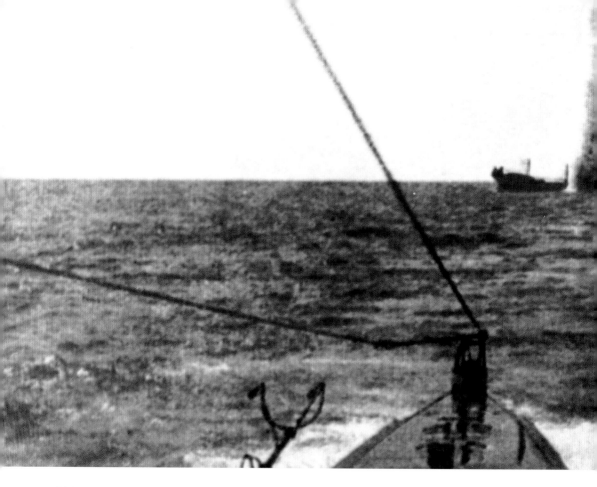

This photograph from a German newspaper shows a torpedo from a U-boat striking an Allied steamer. Early in 1917, Germany adopted a policy of unrestricted submarine warfare, whereby U-boats would sink ships without warning. Prior to that, they would surface, search a ship for contraband and ensure the crew were safe before sinking it.
25th October, 1917

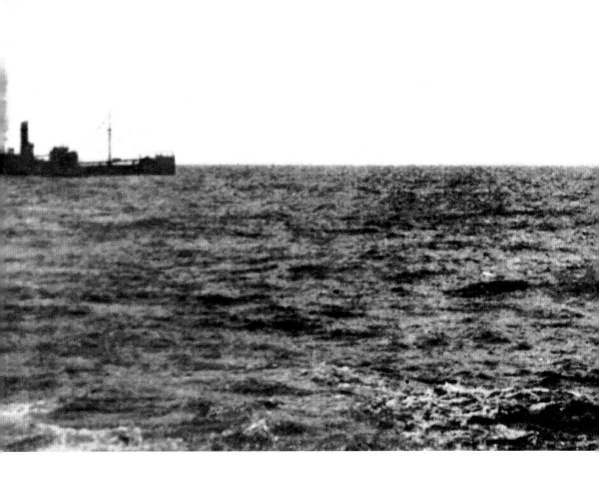

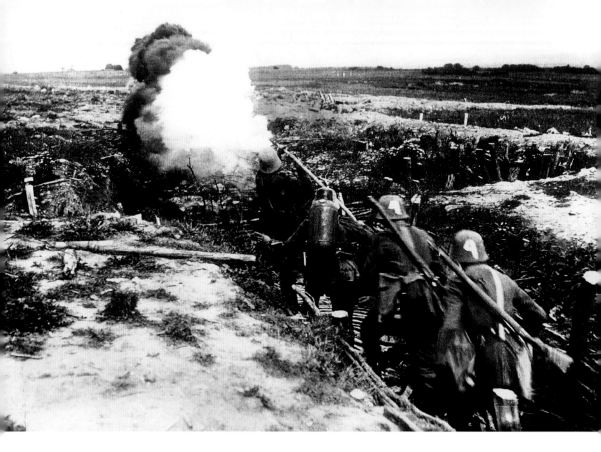

German troops in a trench practise an attack with a flamethrower. The device needed two men to operate it and was only useful over short ranges, where trenches were close together. Nevertheless it would often flush men into the open, where they could be shot.
26th October, 1917

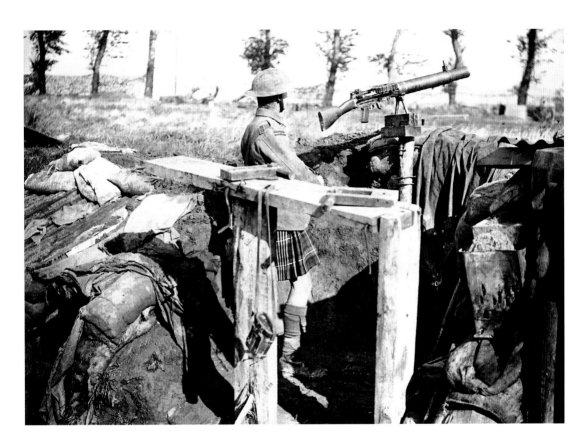

A Scottish machine gunner keeps watch from a front line trench. He is equipped with a Lewis light machine gun, which is equipped with a tubular cooling shroud around its barrel. Lewis guns were commonly used in aircraft without the shroud.

**3rd November, 1917**

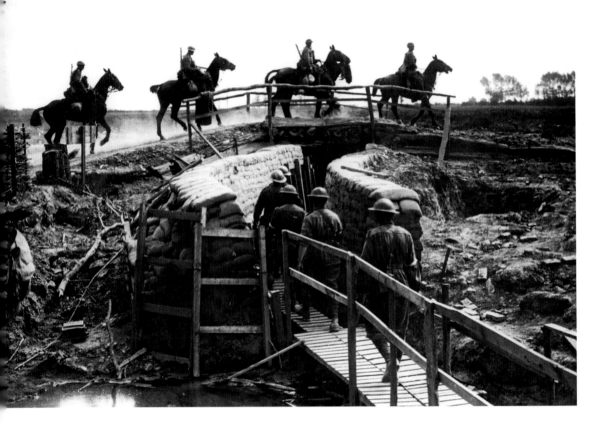

British cavalry cross a bridge thrown across a trench while infantry pass beneath it. Raised wooden walkways kept the men's feet out of the water, helping prevent the debilitating condition known as 'trench foot'.

**November, 1917**

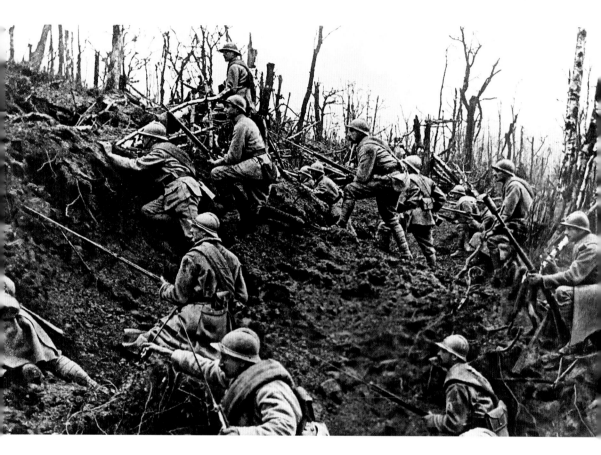

French troops recreate the moment when
they took the last crest at Mont des Singes,
Picardie in France. Artillery fire has blasted
all the trees into stumps.
**24th November, 1917**

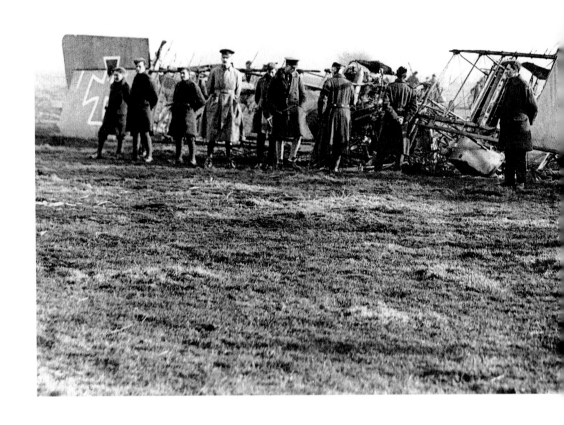

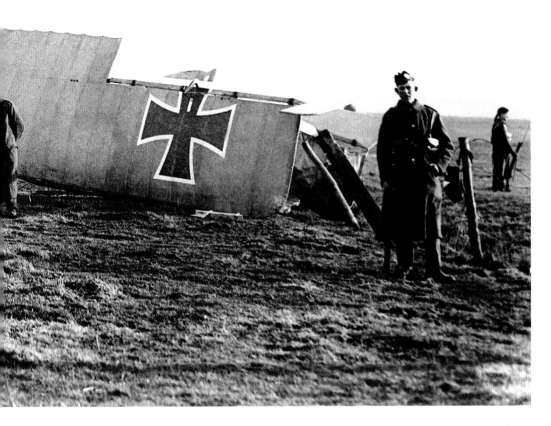

British troops guard the wreckage of a German Gotha heavy bomber that had crashed in a French field. The long-range machine was capable of bombing targets in Britain.

**8th December, 1917**

Australian artillerymen drag a field gun and its limber through the mud on the Western Front. Manoeuvring equipment over the churned-up conditions of the battlefield could be extremely difficult.

14th December, 1917

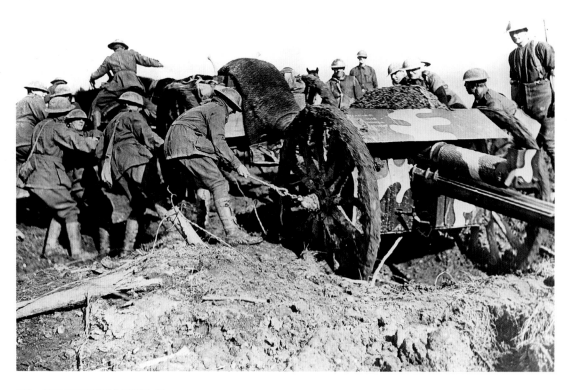

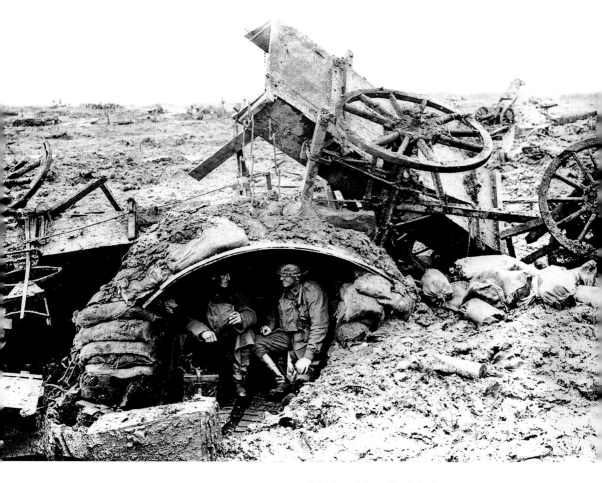

British soldiers find shelter on the Western Front, surrounded by the detritus of battle.
15th December, 1917

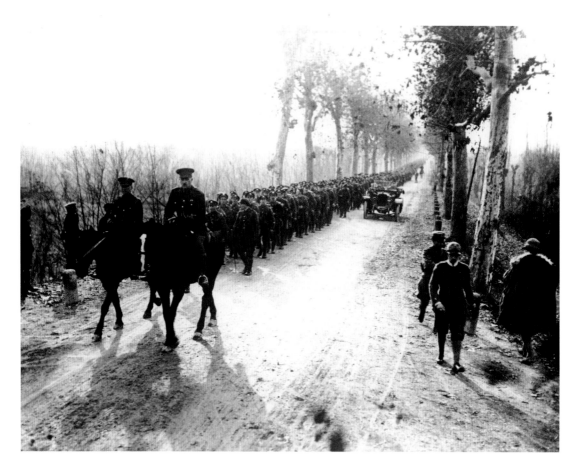

A column of British troops near Piave in Italy. At the urging of Prime Minister David Lloyd George, British troops were sent to Italy late in 1917 to prevent collapse of the country. In the following year, they took part in the final drive against Austria.
**20th December, 1917**

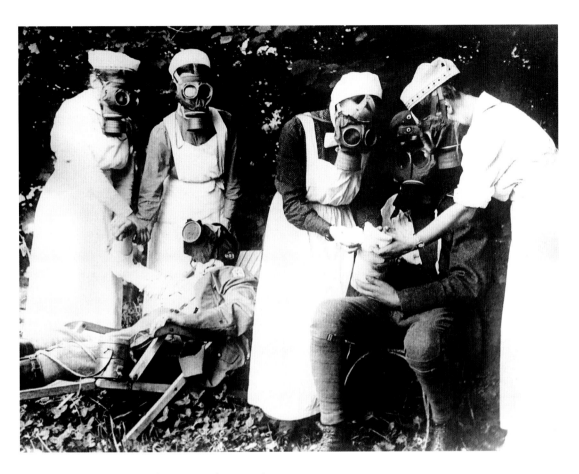

German nurses wearing gas masks attend to
the wounds of soldiers injured in fighting on
the Italian Front.
**26th December, 1917**

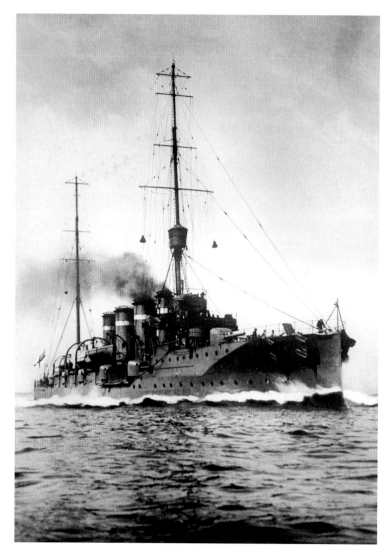

The Royal Navy cruiser HMS *Glasgow*, which took part in the Battle of Coronel with the German East Asia Cruiser Squadron, in the South Atlantic on 1st November, 1914, narrowly escaping with moderate damage. A month later, she helped sink the German cruiser *Leipzig* during the Battle of the Falkland Islands, and then helped corner the cruiser *Dresden* at Mas a Tierra Island. Short of ammunition, essential parts and supplies, the German ship was scuttled by her crew on 14th March, 1915.

c.1918

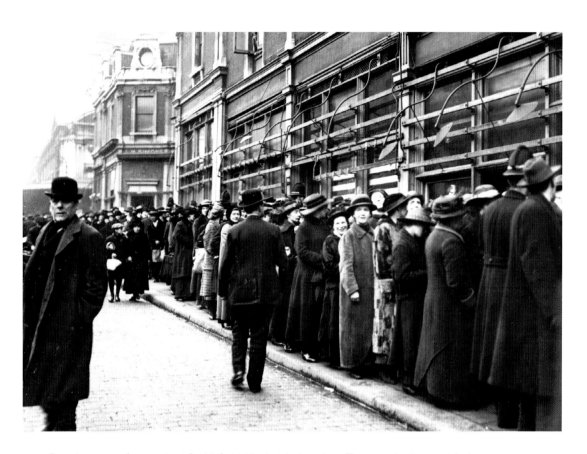

People queue for meat at Smithfield Market in London. The war had put added pressure on food production, while Germany's U-boat campaign had reduced food imports. The problem of shortages was overcome later in 1918 with the introduction of rationing.
**January, 1918**

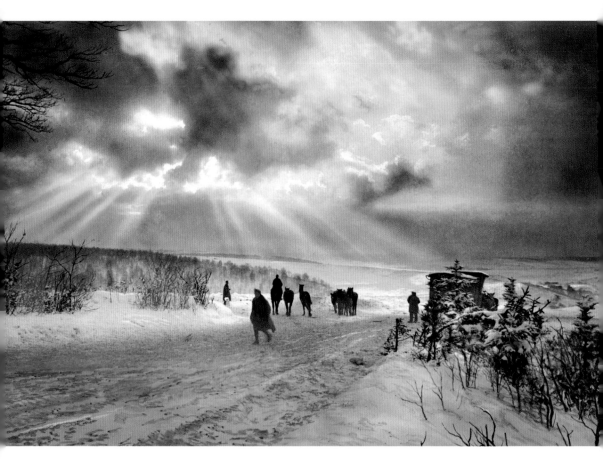

A wintery evening scene near Verdun, France, with troops and horses walking through the snow-covered countryside. That winter was extremely harsh, with temperatures falling to -22° celsius and adding a further ordeal to trench life.

21st January, 1918

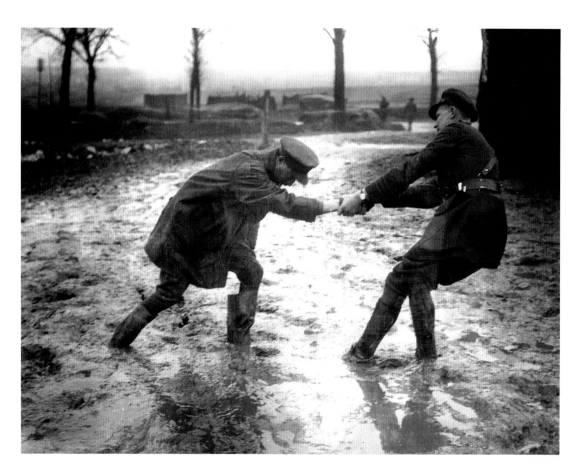

Mud was an ever-present feature of the Western Front. Here a British officer helps a fellow officer who's feet have become stuck while trying to cross a mud track.

**February, 1918**

American machine gunners in France. America had entered the war in April, 1917, in response to Germany's policy of unrestricted submarine warfare, which led to the sinking of American ships bound for Europe, and the German offer of a military alliance with Mexico in a war against the United States. Mexico rejected the offer.
**February, 1918**

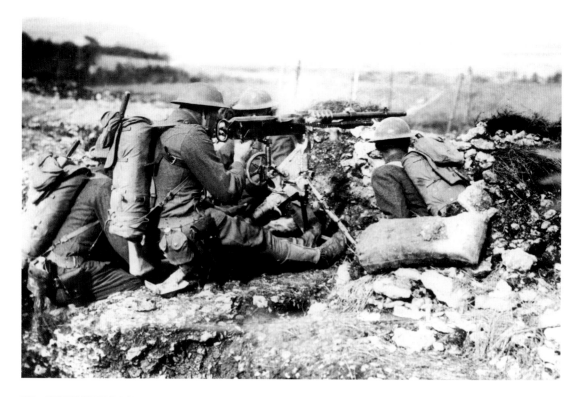

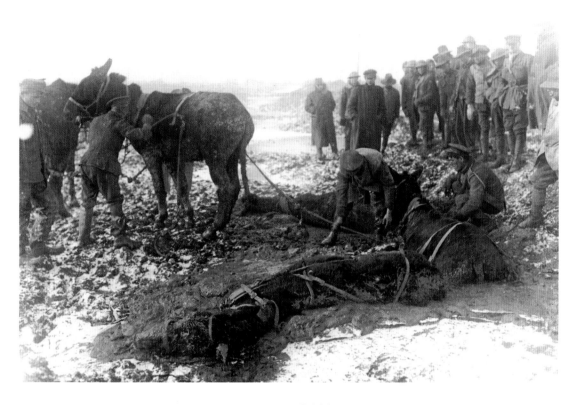

British troops attempt to rescue mules that have become bogged down in a sea of mud close to the front line in Northern France.
**3rd February, 1918**

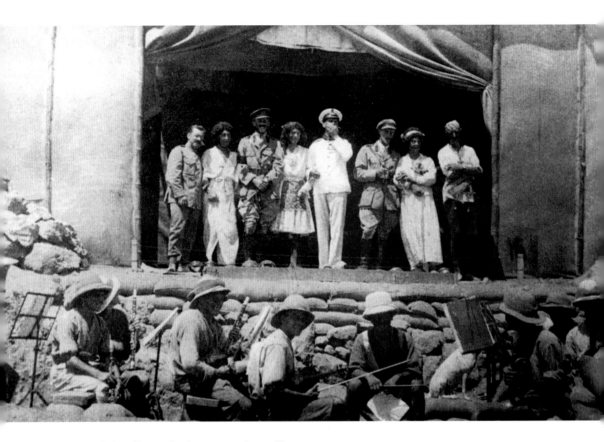

Men of the Essex Regiment perform *The Rose of Gaza*, the orchestra being housed in a sandbagged trench. Four battalions of the regiment were taking part in the Palestine Campaign to oust Ottoman forces from the Middle East.

12th February, 1918

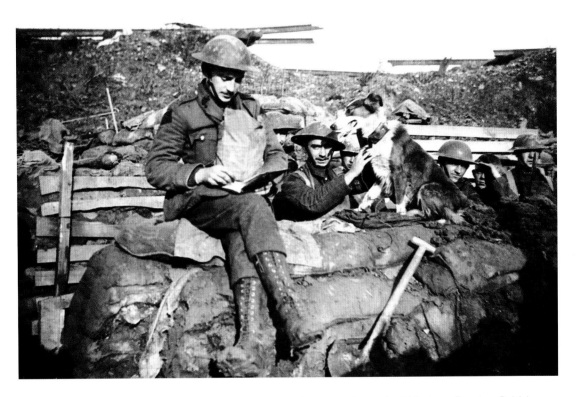

In a trench on the Western Front, a British messenger dog waits while an officer composes a message for dispatch. The dog's collar has a pouch for the message.

14th February, 1918

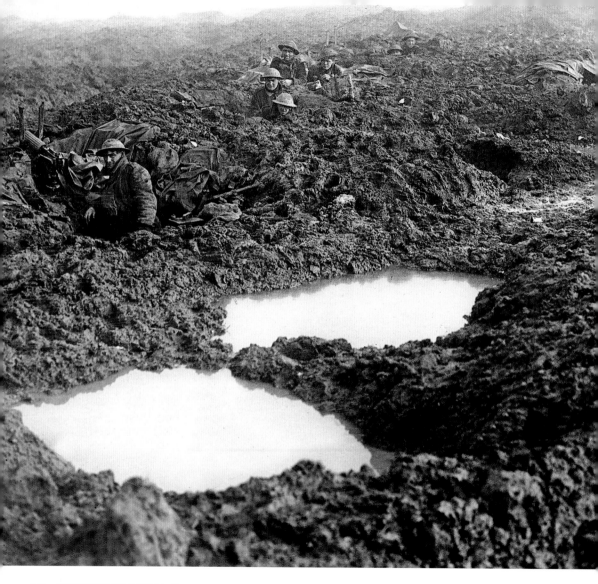

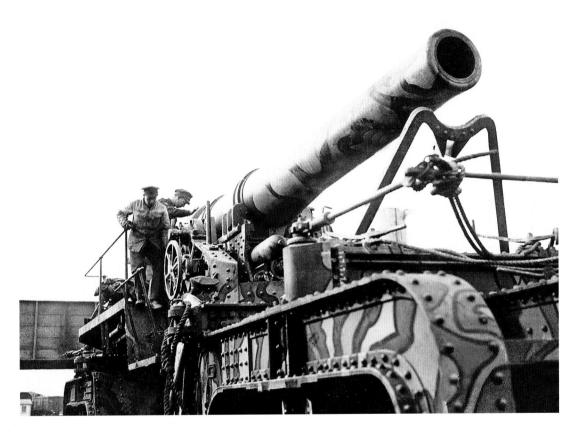

Left: Canadian soldiers hold the line at Passchendaele in Belgium, which they had taken in November, 1917 to end the Third Battle of Ypres, sometimes simply known as 'Passchendaele'. There are no trenches, just mud-filled shell craters.

**18th February, 1918**

British gunners prepare a massive railway gun in France. Such artillery pieces were usually former naval weapons mounted on special railway wagons.

**22nd February, 1918**

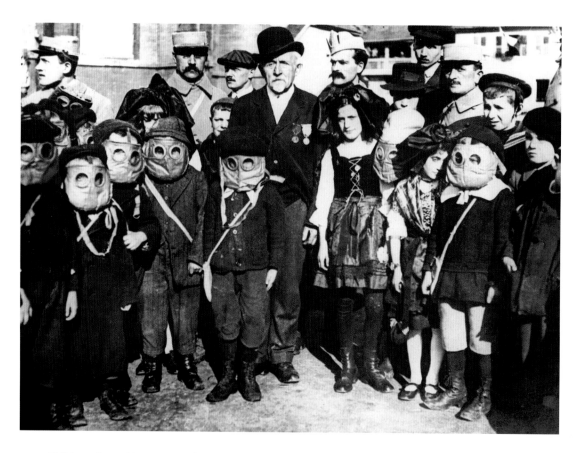

Children from Alsace, a territory between France and Germany and claimed by both, under French protection. They are waiting for the visit of Monsieur Georges Clemenceau, the French prime minister. Some have donned their gas masks, while an old veteran of the 1870 Franco-Prussian War, after which the German Empire annexed the region, stands among them.
**27th February, 1918**

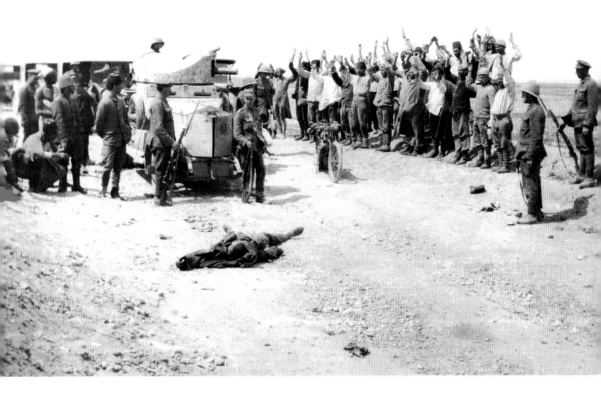

Turkish officers and men of the Ottoman Empire surrender to a British armoured car on the Euphrates River during the Mesopotamia Campaign.

March, 1918

Left: Three British Army officers who successfully escaped from the Kaserne Holzminden PoW camp in Germany, shortly after their return to England. L–R: Lieutenant Cecil Blain, Captain David Gray and Lieutenant Caspar Kennard. The three men were among a group of 29 who escaped through a tunnel. Only ten made it home.

**August, 1918**

Above and below right: Soldiers inspect the shattered remains of a German Gotha bomber that had crashed on British lines on the Western Front.

**9th March, 1918**

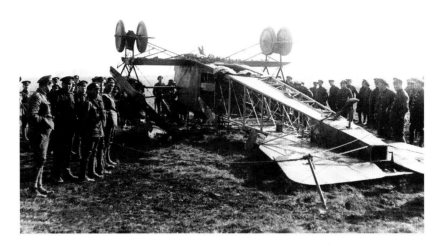

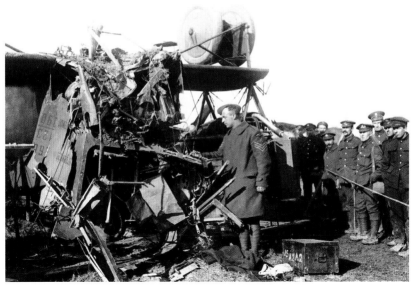

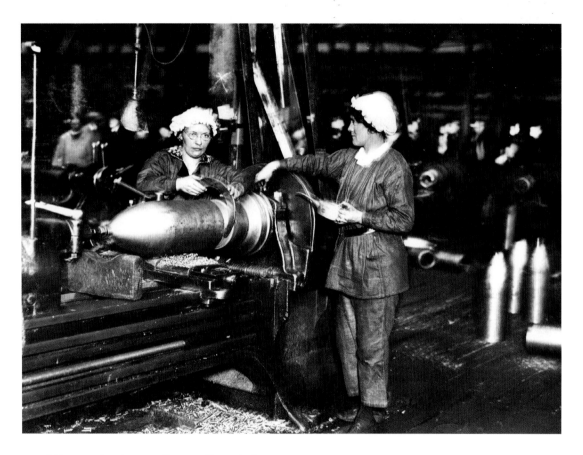

Women turn large-calibre artillery shells on
a lathe at a munitions factory.
**25th March, 1918**

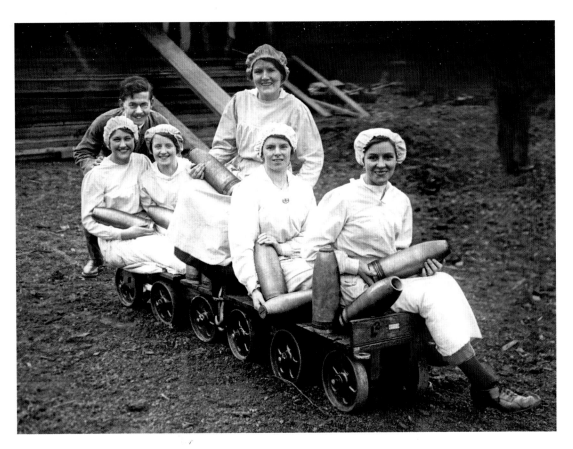

Munitions factory workers lark about for the camera with shell casings and the trolleys used to move them about the factory.
28th March, 1918

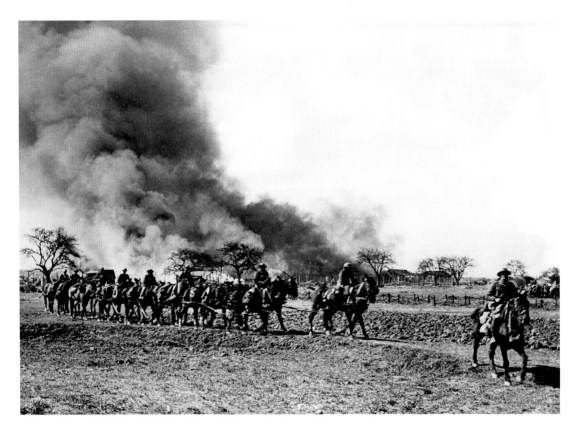

An ammunition dump on fire on the Western Front in France while British troops move to new positions, as the Germans advance as part of their Spring Offensive. The Germans knew that they had to defeat the Allies before the massive resources of the United States could be deployed fully, but while in places they made significant penetrations of Allied territory, the advance petered out because their supply lines became overstretched.
30th March, 1918

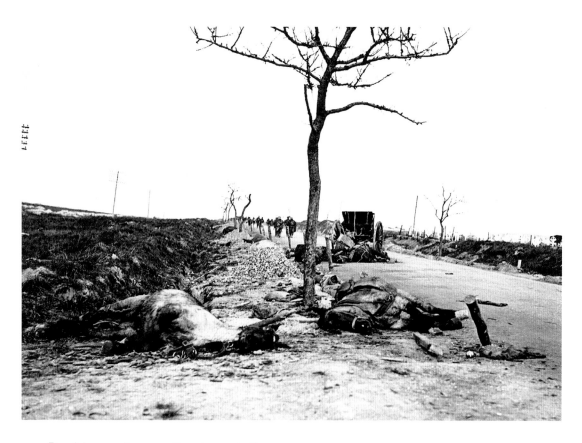

Dead horses lie on a French road after a German aircraft had straffed Allied troops. Many thousands of horses were lost in the carnage of the war.
April, 1918

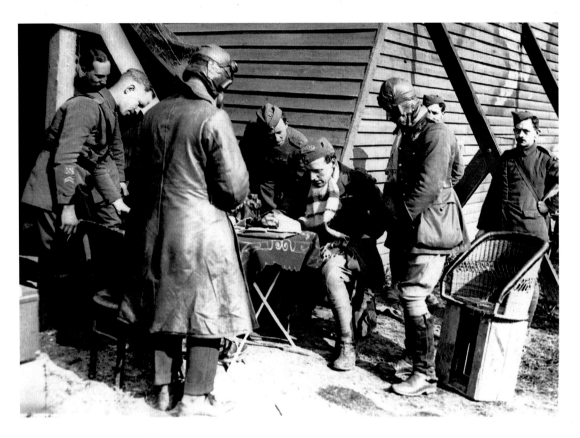

Pilots of the Royal Air Force report the positions of enemy troops on the Western Front. The RAF had been formed officially as an independent air service on the previous day by the amalgamation of the Army's Royal Flying Corps and the Royal Naval Air Service. It came under the control of a new Air Ministry, and permitted the more efficient use of men and machines as well as rationalising aircraft procurement.
2nd April, 1918

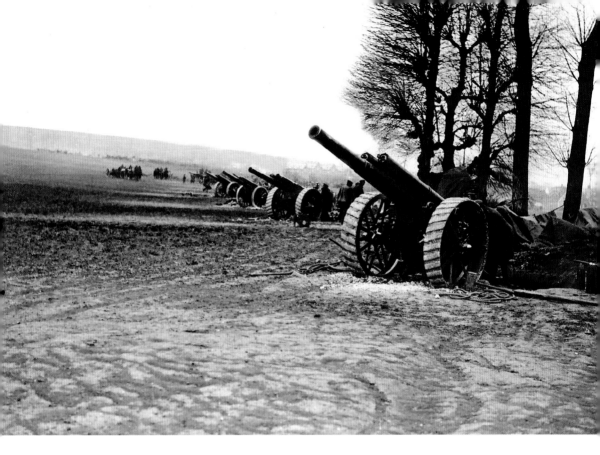

A battery of British heavy artillery lined up
and ready to go into action in support of
Allied objectives.
10th April, 1918

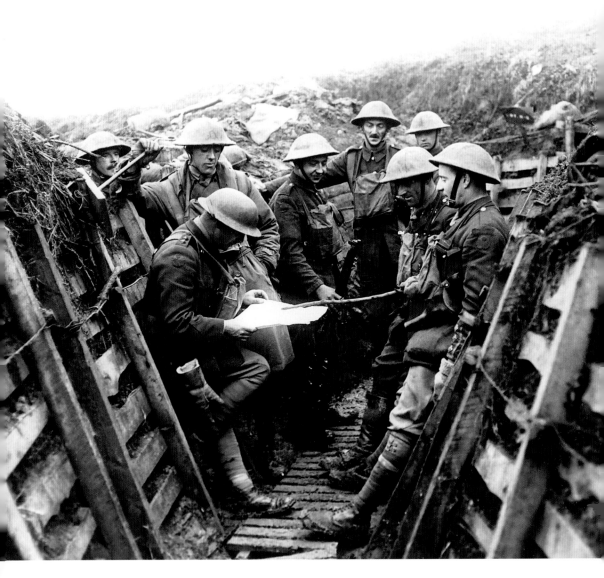

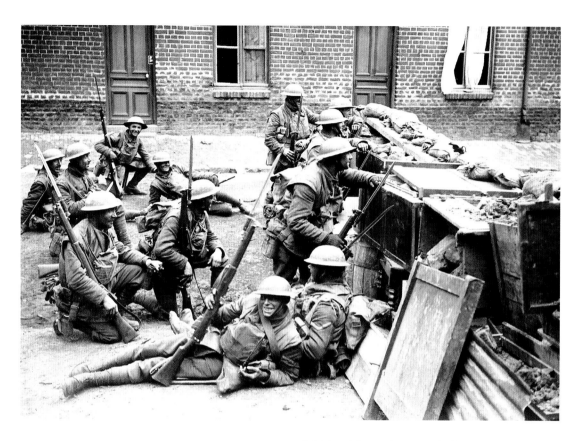

British soldiers take cover behind a makeshift barricade in Bailleul, France in anticipation of a German attack. The Germans later captured the town.
**13th April, 1918**

Left: Officers and men of The King's (Liverpool) Regiment listening to the news being read out as they wait in their trench.
**13th April, 1918**

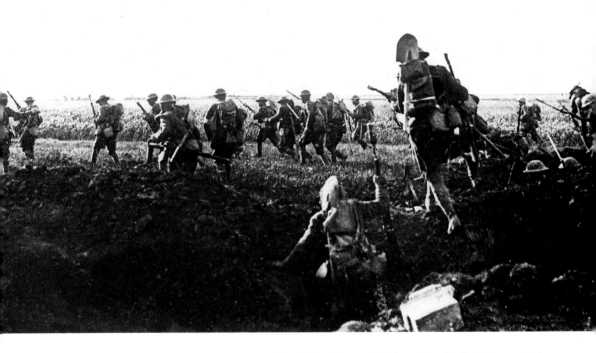

Troops of the American 1st Division, under Major General Robert Lee Bullard, leave their trenches for an attack on the village of Cantigny in France. This was the first sustained American offensive of the war. Aided by French artillery, tanks and flamethrower teams, the Americans took the village against strong resistance from the German 18th Army.

28th May, 1918

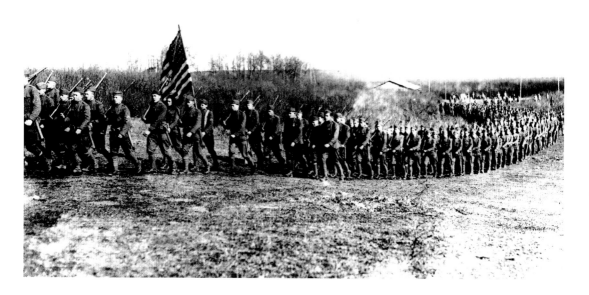

American troops on the march in France. By May, 1918, the American Expeditionary Forces numbered over a million soldiers, popularly known as 'Doughboys'. In June, 1918, American Army and Marine Corps units played a vital role in helping to stop the German thrust towards Paris during the Second Battle of the Marne.

**8th June, 1918**

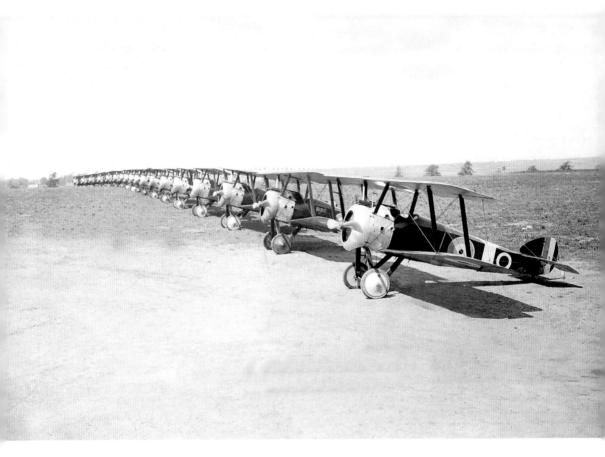

A line-up of Sopwith Camels of the RAF's 203 Squadron in France. A former RNAS squadron, 203 claimed 250 aerial victories and produced 23 aces during the war, 11 of them Canadian. A superb and manoeuvrable machine, albeit difficult to handle, the Camel shot down more enemy aircraft than any other Allied fighter of the war.

10th July, 1918

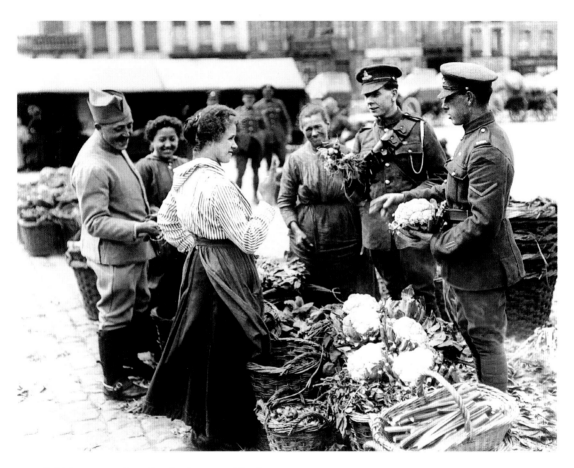

British troops shop for fresh vegetables in a
French market.
30th July, 1918

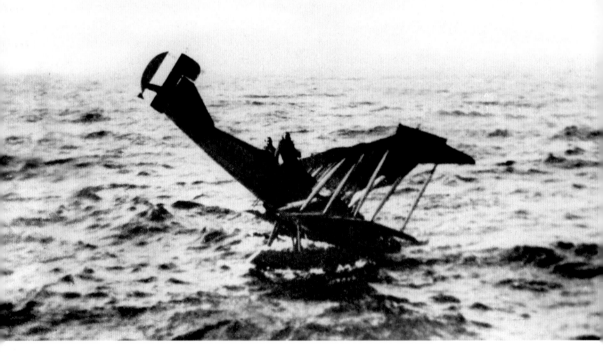

A German floatplane disguised in American markings, which was shot down by an American ship over the Mediterranean.

**8th August, 1918**

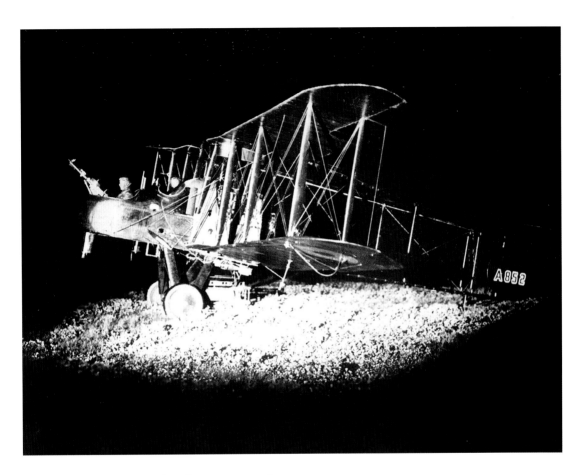

A British FE2 light bomber prepares for a night raid. The RAF had eight bomber squadrons operating this aircraft by the end of the war.
**10th August, 1918**

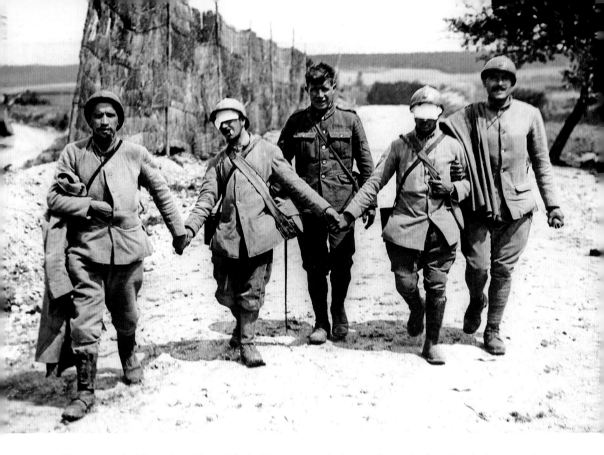

Two wounded French soldiers, blinded by gas, are led away from the lines by their comrades. Temporary blindness was a common effect of gas attack, particularly if chlorine or mustard gas was used. Death was slow and painful, although only three per cent of gas casualties developed fatal symptoms. Mustard gas particularly was effective, whether inhaled or through contact with the skin, high concentrations being capable of burning flesh to the bone.
12th August, 1918

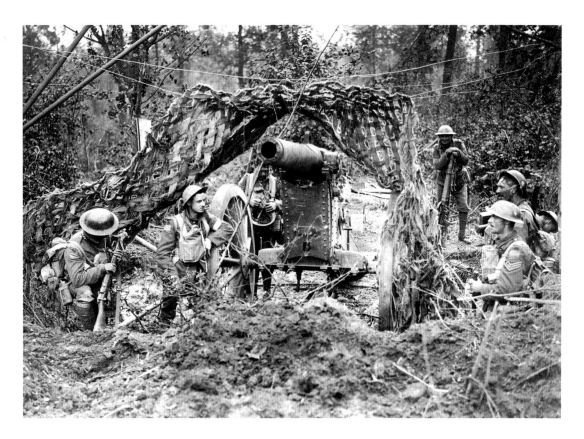

Canadian soldiers inspect a captured German gun. In this case, the Germans had blown away the muzzle of the gun before retreating, rendering it unusable.

14th August, 1918

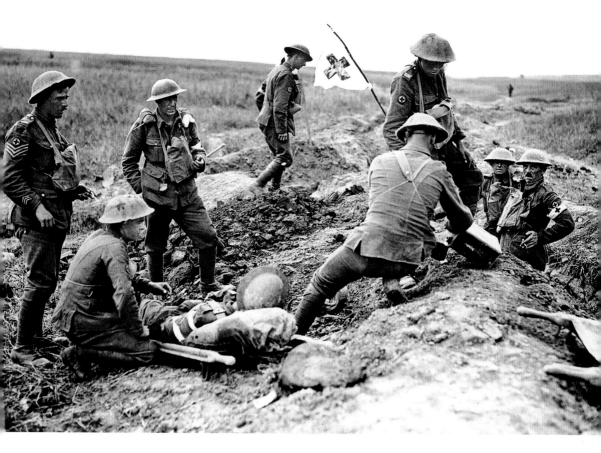

A regimental aid post is marked by a fluttering
red-cross flag. Medics and stretcher bearers
help give wounded soldiers first aid.
31st August, 1918

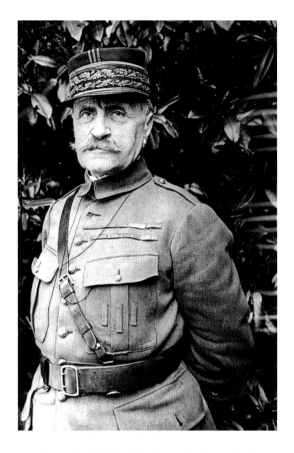

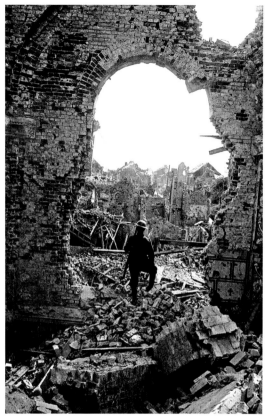

French Field Marshal Ferdinand Foch, supreme commander of the Allied armies. With Britain's Field Marshal Haig, he planned the Grand Offensive of September, 1918, which led to the German defeat.

**September, 1918**

A British soldier contemplates the ruins of Albert Cathedral, part of the Somme battlefield.

**3rd September, 1918**

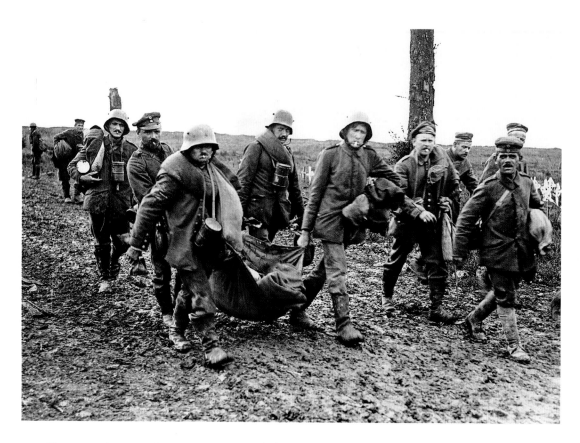

German prisoners of war carry a wounded
comrade with the aid of a blanket through a
landscape denuded of trees by artillery fire.
**9th September, 1918**

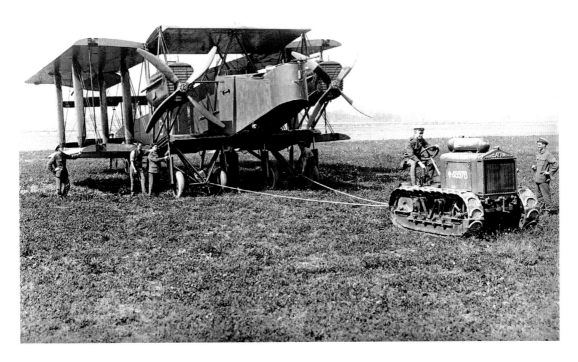

An RAF Handley Page O/400 heavy bomber with its wings folded back is towed across a French aerodrome. The massive machine was capable of carrying a 1650lb bomb. Such machines were used in support of ground forces during offensives and also for strategic bombing against long-range targets.

**20th September, 1918**

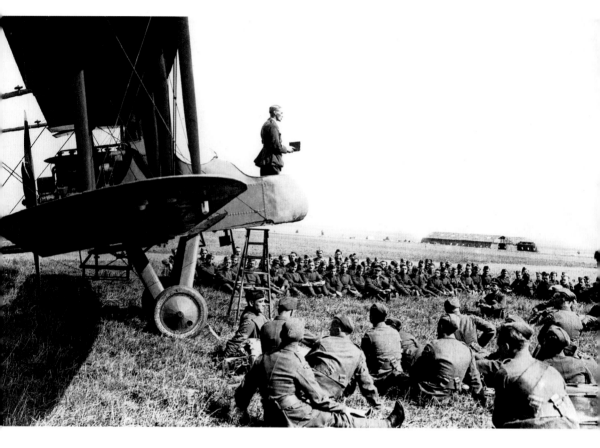

Royal Air Force personnel listen to a chaplain
delivering his Sunday service from the open
cockpit of an FE2 light bomber.
**25th September, 1918**

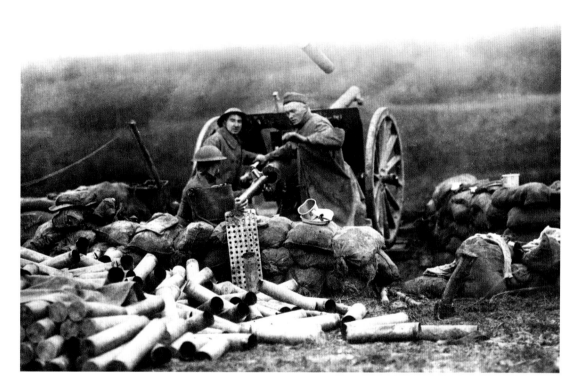

An empty shell case flies through the air as
it is ejected from the breech of an American
field gun in action in France.

**27th September, 1918**

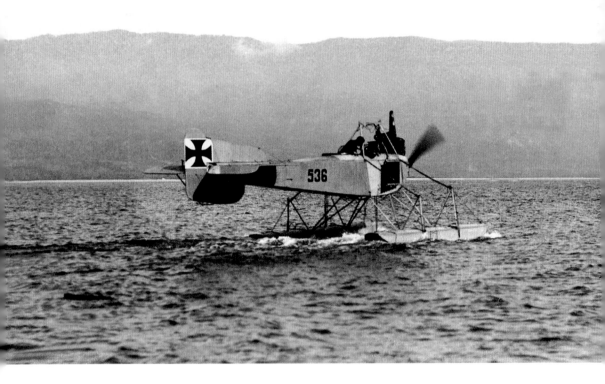

A German seaplane, minus its wings and
captured by British naval forces, is subjected
to power trials.
5th October, 1918

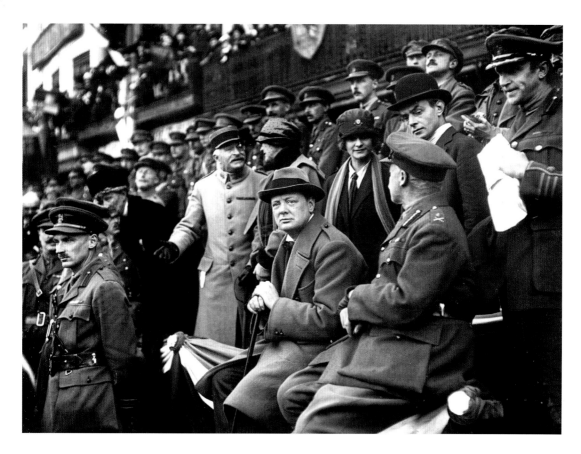

Minister of Munitions Winston Churchill (C) watches a victory parade of Allied troops at Lille, in northern France, following the liberation of the town near the end of the First World War. Standing in front of him is Lieutenant Colonel Bernard Montgomery (L, with moustache), with whom he would work closely in the next conflict, but whom he had not met at this date.
**October, 1918**

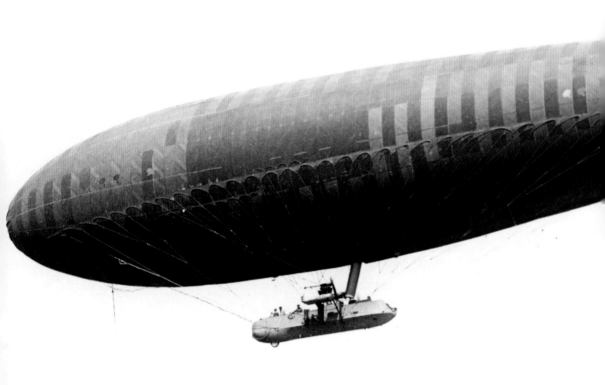

A French naval dirigible airship shortly after take off on a patrol of the English Channel. Airships were ideal for maritime patrols, since they could stay in the air for long periods. A dirigible had no internal framework, essentially being an airship-shaped balloon.

**10th October, 1918**

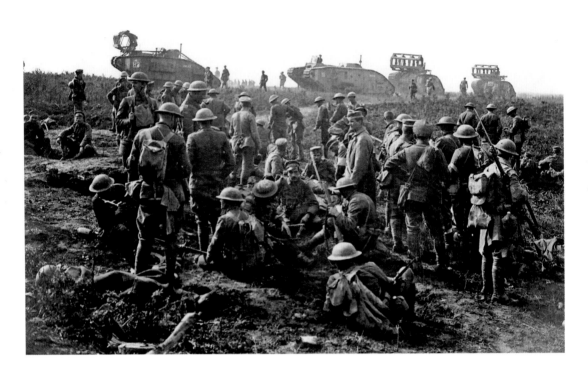

During the Allies' Hundred Days' Offensive, British soldiers round up German prisoners after an attack on the Hindenburg Line, a massive system of German fortifications built in north-east France, from Lens to beyond Verdun. In the background can be seen British tanks carrying fascines, bundles of timber that could be dropped into a trench or ditch to fill it and allow the tank to pass.

16th October, 1918

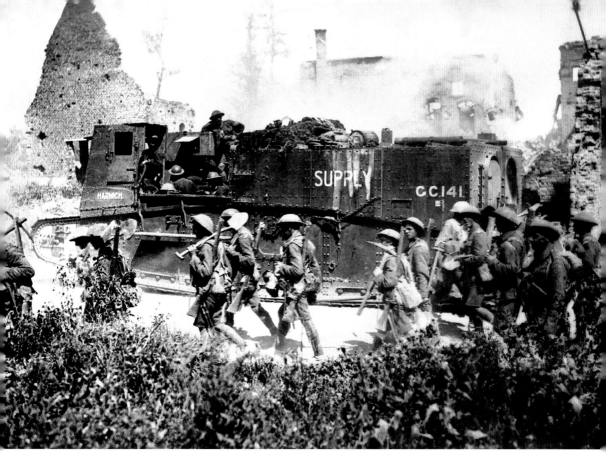

Troops carrying trenching tools march past a supply tank ferrying essential equipment and materials to tanks in the field. The huge machine had been designed originally to carry an artillery piece, but this proved impractical so most were converted to carry supplies.
16th October, 1918

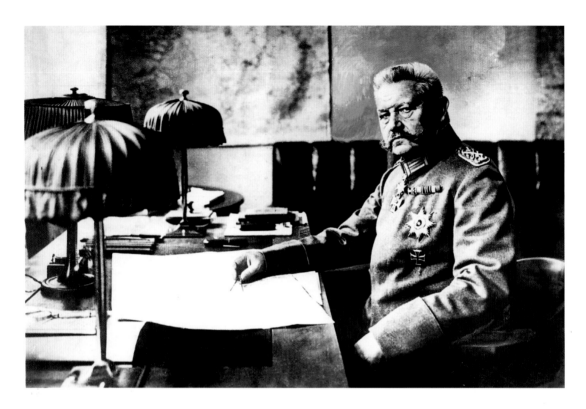

Field Marshal Paul von Hindenburg, commander in chief of the German armed forces from August, 1916 until the end of the war. Later he would be elected president of Germany and is remembered for making Adolf Hitler chancellor in 1933.
**29th October, 1918**

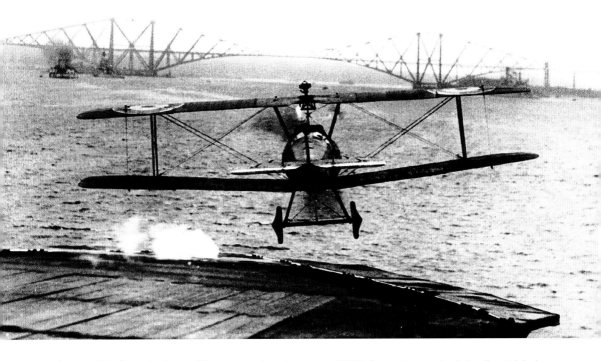

A Sopwith Camel takes off from the aircraft carrier HMS *Argus* during deck landing trials in the Firth of Forth. The *Argus* was the first vessel capable of launching and landing wheeled aircraft. Prior to that, ships launched seaplanes by lowering them into the water first and then retrieved them with a crane. Alternatively, wheeled aircraft were flown from platforms built over the decks of warships, but they could not land back on.

1918

# The German People Offers Peace.

The new German democratic government has this programme:

## "The will of the people is the highest law."

The German people wants quickly to end the slaughter.

The new German popular government therefore has offered an

### Armistice

and has declared itself ready for

### Peace

on the basis of justice and reconciliation of nations.

It is the will of the German people that it should live in peace with all peoples, honestly and loyally

What has the new German popular government done so far to put into practice the will of the people and to prove its good and upright intentions?

a) The new German government has appealed to President Wilson to bring about peace.

It has recognized and accepted all the principles which President Wilson proclaimed as a basis for a general lasting peace of justice among the nations.

b) The new German government has solemnly declared its readiness to evacuate Belgium and to restore it.

c) The new German government is ready to come to an honest understanding [about] Alsace-Lorraine.

d) The new German government has restricted the U-boat War.

No passengers steamers not carrying troops or war material will be attacked in future.

e) The new German government has declared that it will withdraw all German troops back over the German frontier.

f) — The new German government has asked the Allied Governments to name commissioners to agree upon the practical measures of the evacuation of Belgium and France.

These are the deeds of the new German popular government. Can these be called mere words, or bluff, or propaganda?

Who is to blame, if an armistice is not called now?

Who is to blame if daily thousands of brave soldiers needlessly have to shed their blood and die?

Who is to blame, if the hitherto undestroyed towns and villages of France and Belgium sink in ashes?

Who is to blame, if hundreds of thousands of unhappy women and children are driven from their homes to hunger and freeze?

## The German people offers its hand for peace.

Left: A leaflet setting out the German offer of peace, which was dropped over the Allied trenches. It refers to the new popular German government, which was established after the German revolution had led to the abdication of the Kaiser and the replacement of the imperial government with a republic.
November, 1918

Right: One newspaper's view of the German peace proposal.
November, 1918

THE GERMAN PEACE: HOW IT IS OFFERED.

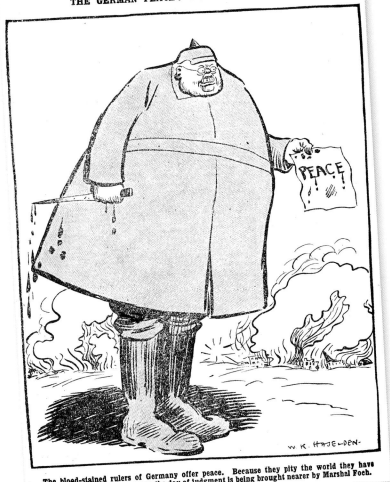

The blood-stained rulers of Germany offer peace. Because they pity the world they have tried to ruin? No. Because the day of judgment is being brought nearer by Marshal Foch.

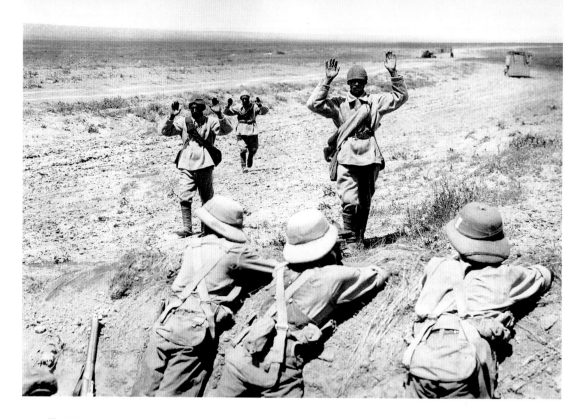

Turkish soldiers, with their hands raised, surrender to British troops in Mesopotamia. Although an armistice had been signed on 30th October, a force under General Alexander Cobbe continued to advance towards Mosul, entering the city on 14th November, when the war in Mesopotamia finally came to an end.

**2nd November, 1918**

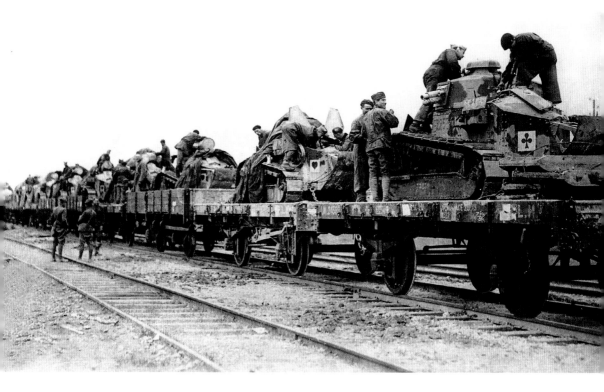

A train load of French Renault FT light tanks being transported by the American Army in France. Such had been the rush to move as many American troops to France as possible that they had left their heavy equipment behind, using British and French equipment instead, including these tanks. The FT was one of the most influential of tank designs, being the first to have its armament in a rotating turret and establishing the forward-mounted turret/rear-mounted engine layout that is employed to this day.

7th November, 1918

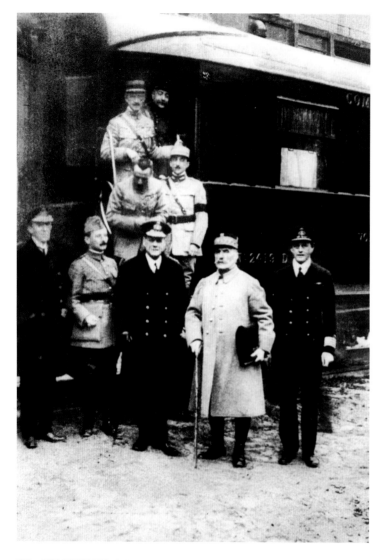

Left: Allied representatives at the signing of the Armistice that brought an end to the fighting in the First World War. The agreement was signed aboard the private train of Marshal Ferdinand Foch, on a siding in the Forest of Compiègne. Front row, L–R: Rear Admiral George Hope, General Maxime Weygand, Admiral Rosslyn Wemyss, Foch, Captain John Marriott.
**11th November, 1918**

Right: The front page of *The Daily Mirror* for 12th November, 1918, giving news of the Armistice that ended the fighting.
**12th November, 1918**

## ALLIES' DRASTIC ARMISTICE TERMS TO HUNS

# The Daily Mirror

CERTIFIED CIRCULATION LARGER THAN THAT OF ANY OTHER DAILY PICTURE PAPER

No. 4,696.    Registered at the G.P.O. as a Newspaper.    TUESDAY, NOVEMBER 12, 1918.    One Penny.

## HOW LONDON HAILED THE END OF WAR

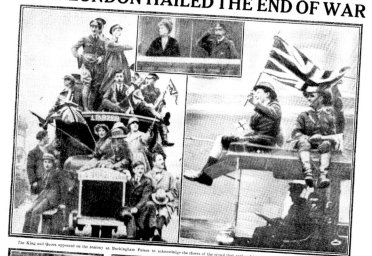

The King and Queen appeared on the balcony at Buckingham Palace to acknowledge the cheers of the crowd that gathered to congratulate their Majesties on the victory.

Home on short leave, but now safe for always from the dangers of Hun bullets and steel.

How news of the armistice signature came over the wire to the newspaper offices. A facsimile of it as automatically printed on the tape machine. The cheers which greeted it were the first to be raised.

An historic message as it came over the wire. It is dramatic that the last British war communiqué should proclaim our forces at Mons.

"Now entitled to rejoice" and doing it. Daddy has beaten the Huns and is coming home.

Nothing gave greater satisfaction to all of us than the news that the cessation of hostilities found the British armies once more in possession of Mons, where the immortal "Contemptibles" first taught the Huns what British valour and steadfastness could do. They left the town as defenders of a forlorn hope; they re-entered it conquerors indeed.

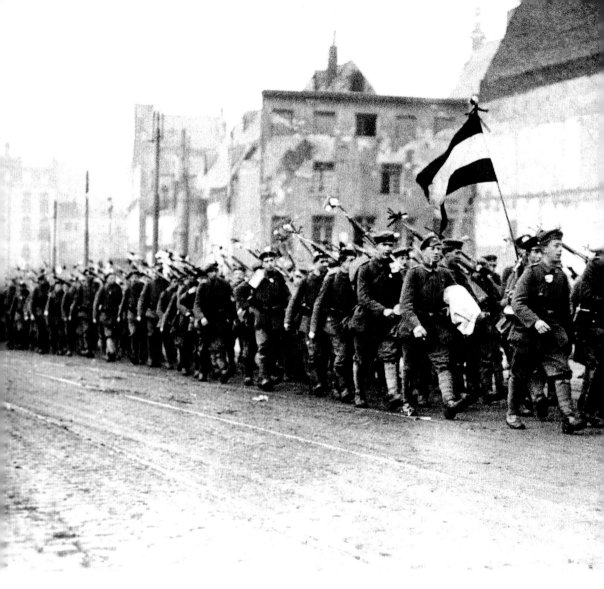

German soldiers march back into Germany after crossing the Rhine at Cologne, following signature of the Armistice. Note that they have retained their arms.

**November, 1918**

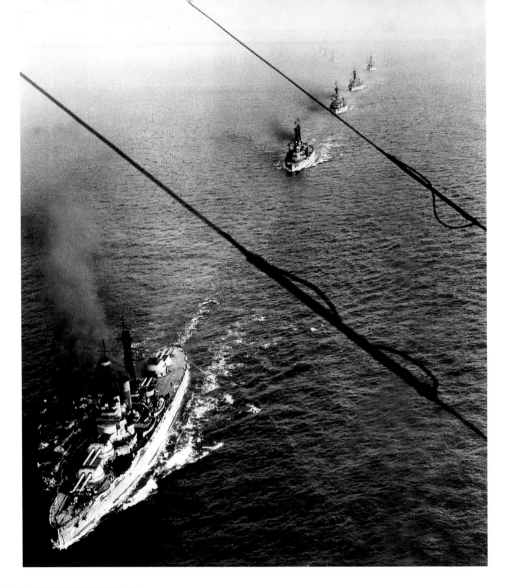

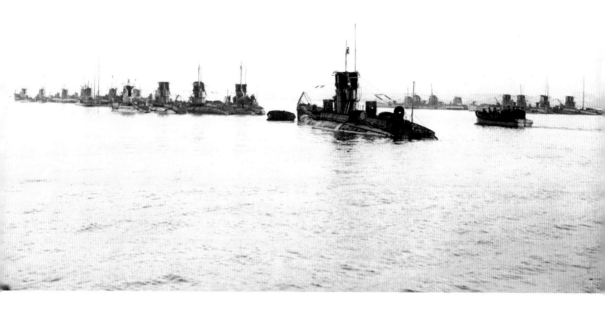

Left: The German High Seas Fleet being escorted to Scapa Flow by a US battleship after surrendering to the Allies at the end of the war. The photograph was taken from Royal Navy airship NS7.
**23rd November, 1918**

German submarines moored at Harwich shortly after they had surrendered. A precondition of the Armistice was that Germany cease her submarine campaign and surrender the boats.
**24th November, 1918**

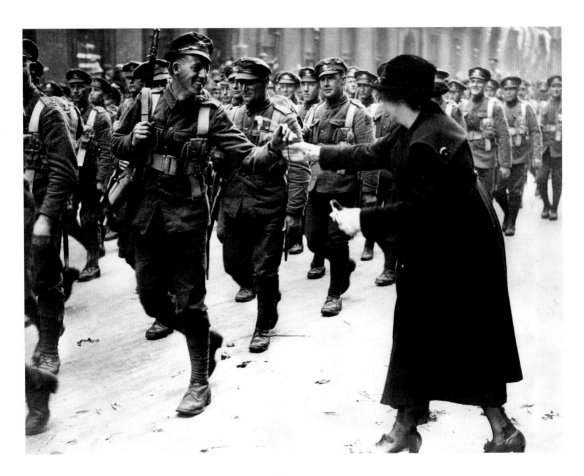

During a victory parade by British colonial
forces, along Victoria Street, London,
a woman spectator rushes up to give a
Canadian soldier a rose.
4th May, 1919

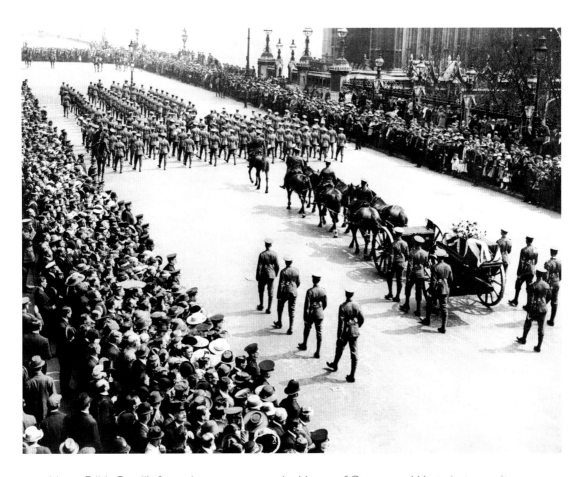

Nurse Edith Cavell's funeral cortege passes the House of Commons, Westminster, on its way to Liverpool Street Station before being taken by train to Norwich, where she was buried. She had been executed by the Germans for helping Allied soldiers escape from Belgium.
15th May, 1919

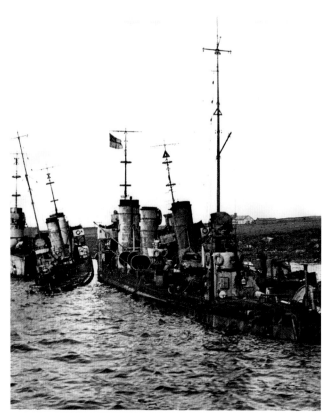

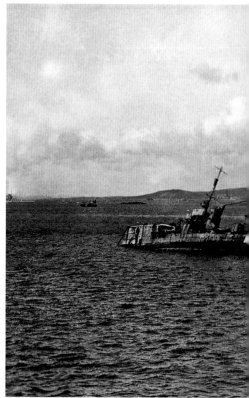

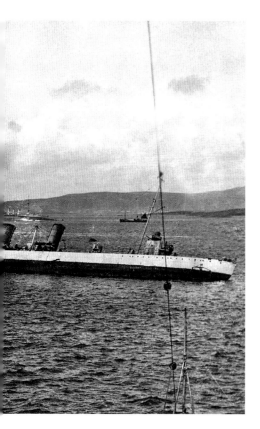
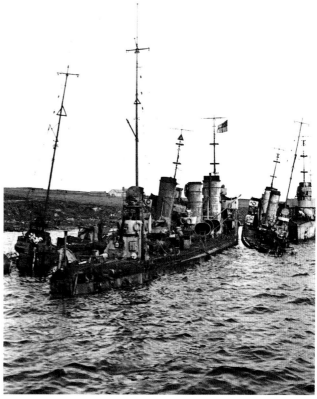

L–R: Ships of the German High Seas Fleet scuttled in the Royal Navy's anchorage at Scapa Flow off Scotland. After surrendering on 21st November, 1918, the German fleet of 74 ships was interned at Scapa Flow while their future was determined. Fearing that the vessels would be seized and distributed among the Allies, the commander, Admiral Ludwig von Reuter, ordered that they be scuttled on 21st June, 1919. Only 22 remained afloat or were saved by beaching.

June, 1919

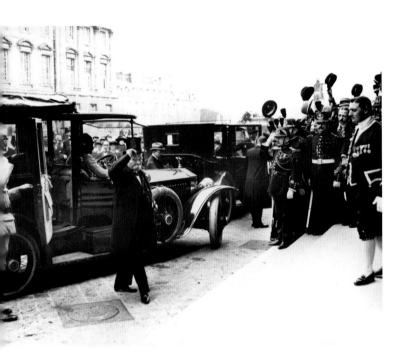

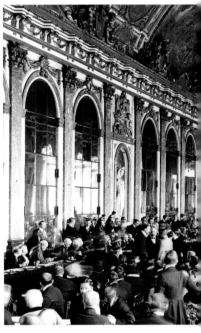

Cheering crowds greet French premier Georges Clemenceau as he arrives at the Palace of Versailles, just outside Paris, for the signing of the peace treaty that brought an official end to the First World War.
**28th June, 1919**

Above right: The treaty was signed in the Hall of Mirrors at the Palace of Versailles. It imposed reparations on Germany that many economists considered excessive and led to a growing resentment within Germany that eventually triggered the Second World War.
**28th June, 1919**

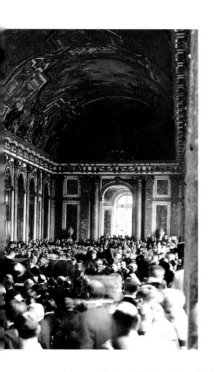

Above right: US President Woodrow Wilson leaves the peace conference at Versailles. A speech he had made in January, 1918, setting out a 14-point plan to ensure future peace in the world was influential in prompting Germany's surrender.

**28th June, 1919**

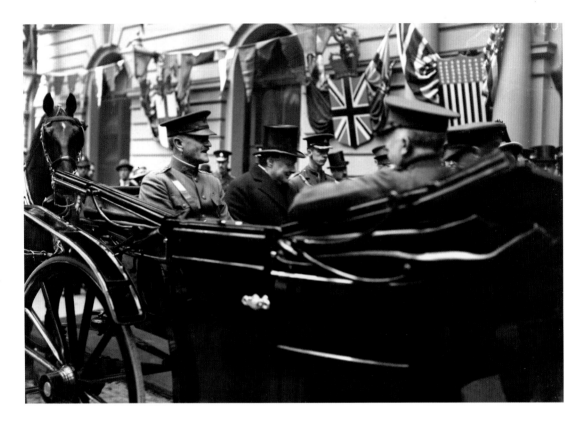

American General John J. Pershing, who had been commander in chief of the American Expeditionary Forces during the war, leaves Victoria station with Winston Churchill. Pershing was in London for the celebrations marking the official end of hostilities in the First World War.

July, 1919

Right: The memorial to the children of the Upper North Street School, Ilford, Essex, who were killed during a bombing raid on the capital by German Gotha bombers on 13th, June 1917. The memorial was dedicated in July, 1919.

5th July, 1919

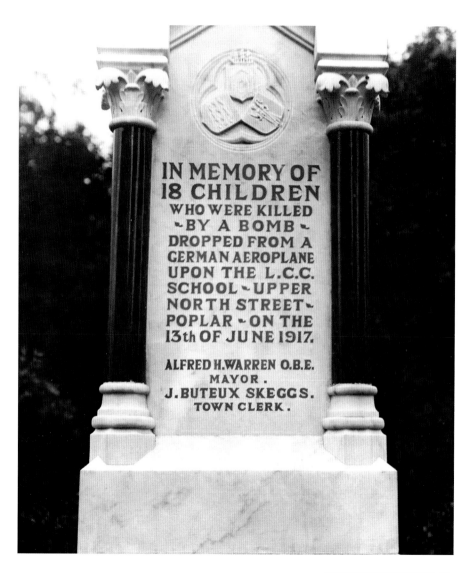

IN MEMORY OF
18 CHILDREN
WHO WERE KILLED
~BY A BOMB~
DROPPED FROM A
GERMAN AEROPLANE
UPON THE L.C.C.
SCHOOL~UPPER
NORTH STREET~
POPLAR~ON THE
13th OF JUNE 1917.

ALFRED H. WARREN O.B.E.
MAYOR.
J. BUTEUX SKEGGS.
TOWN CLERK.

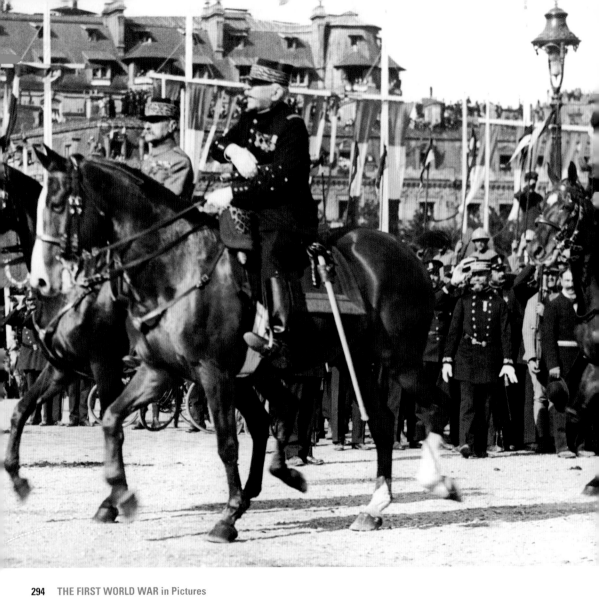

Left: Allied commanders French Marshals Ferdinand Foch (L) and Joseph Joffre lead the victory parade in Paris.
14th July, 1919

King George V and Queen Mary watch the celebrations in London's Hyde Park to commemorate the official end of the First World War.
19th July, 1919

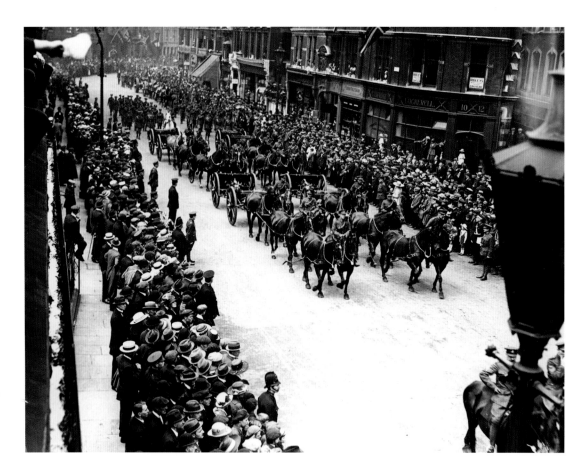

Troops of the Royal Horse Artillery pass through the streets of London during the Victory Parade, which was the first of four days of celebration.
19th July, 1919

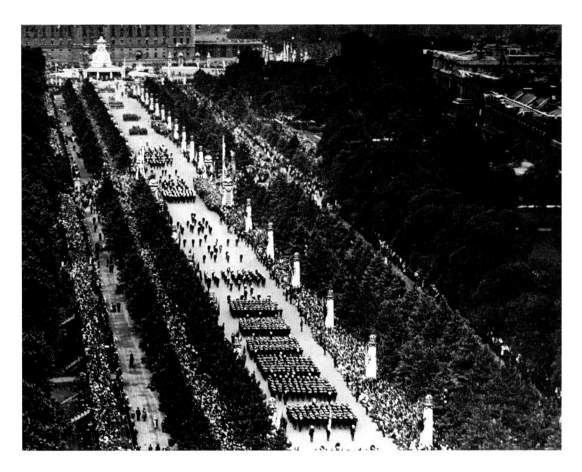

The Victory Parade passes down The Mall in London. Almost 15,000 troops took part in the march, the route passing Edward Lutyens' Cenotaph in Whitehall, which had been erected as a tribute to those who had died in the war.
**19th July, 1919**

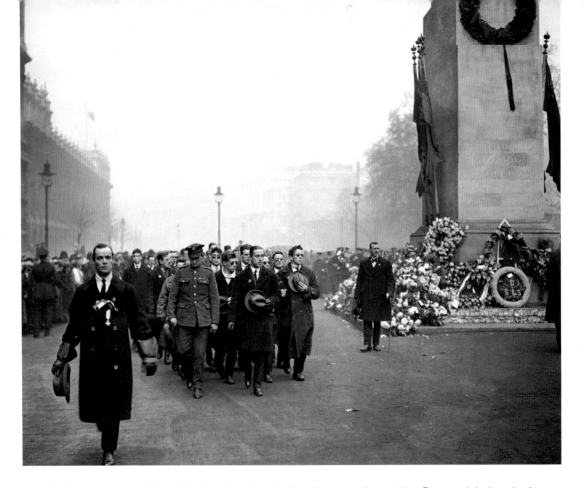

Soldiers, active and demobbed, salute the dead as they march past the Cenotaph in London's Whitehall on the first anniversary of Armistice Day. This is the original temporary structure, built from wood and plaster; later it was replaced with one constructed of Portland stone.
11th November, 1919

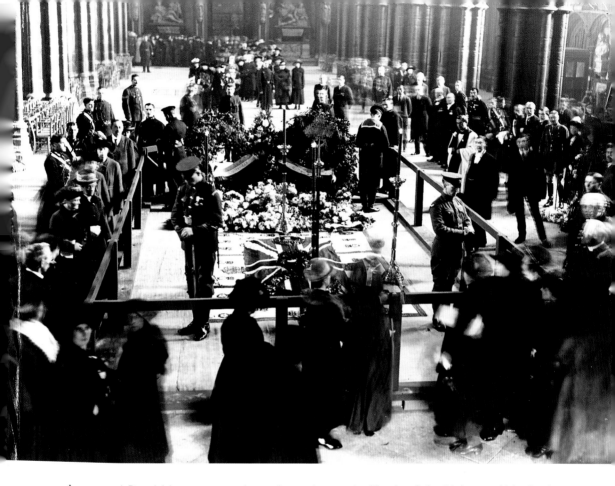

Army and Royal Navy personnel stand guard over the Tomb of the Unknown Warrior in Westminster Abbey following his state funeral. The body of the unidentified serviceman had been brought from France and entombed in the abbey to honour all the British Empire dead of the First World War.
11th November, 1920

The publishers gratefully acknowledge Mirrorpix, from whose extensive archives the photographs in this book have been selected.

AMMONITE
**PRESS**